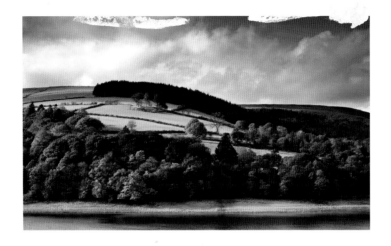

VIEWS ACROSS THE
LANDSCAPE

'Vision is the art of seeing the invisible'
JONATHAN SWIFT

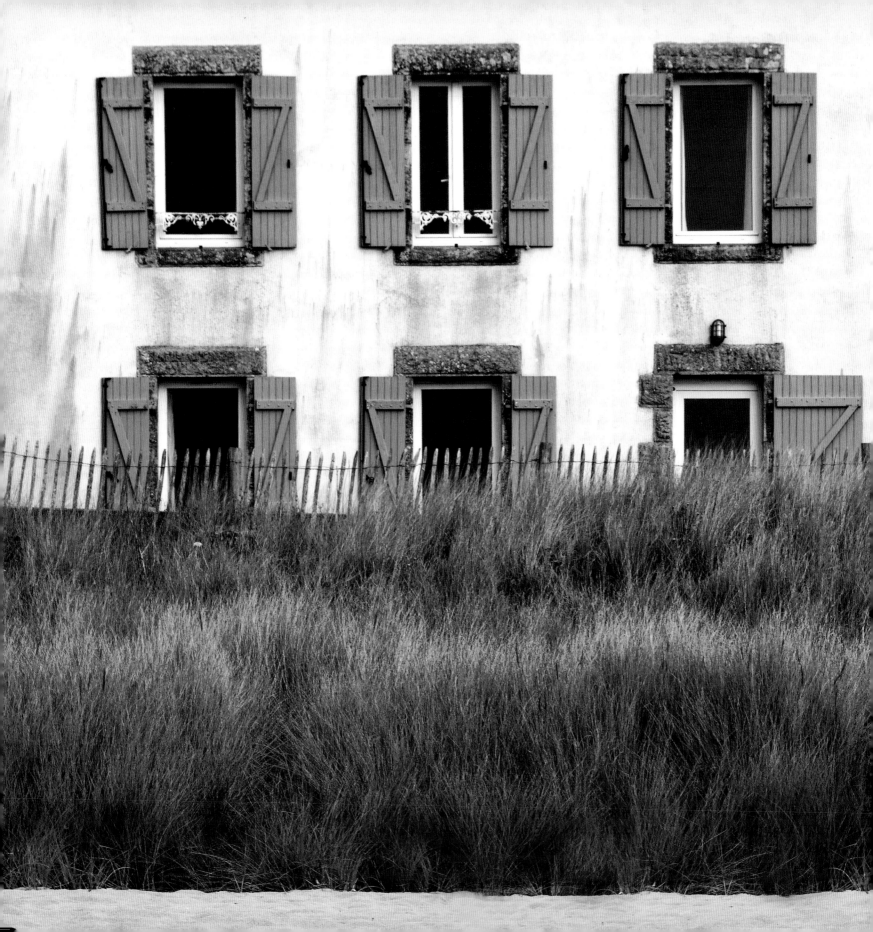

VIEWS ACROSS THE LANDSCAPE

An Essential Guide To Landscape Photography

PETER WATSON

AMMONITE
PRESS

First published 2013 by
Ammonite Press
An imprint of AE Publications Ltd
166 High Street,
Lewes, East Sussex, BN7 1XU

ISBN 978-1-90770-884-8

Publisher: Jonathan Bailey
Production Manager: Jim Bulley
Managing Editor: Gerrie Purcell
Senior Project Editor: Wendy McAngus
Editor: Nicola Hodgson
Managing Art Editor: Gilda Pacitti
Designer: Ginny Zeal

Set in Syntax
Colour origination by GMC Reprographics
Printed and bound in China

PAGE 1

Carreg Ddu, the Elan Valley, Wales

Camera: Canon EOS 7D
Lens: Sigma 17–70mm
Filter: 2-stop ND graduated
Exposure: 1/30 sec at f/9, ISO 100
Waiting for the light: 30 minutes
Post-processing: Colour balance
adjustment

PAGE 2

Le Pouldu, Brittany, France

Camera: Mamiya 645AFD with Phase
One digital back
Lens: Mamiya 150mm (telephoto)
Filter: Polarizer
Exposure: 1/2 sec at f/22, ISO 100
Waiting for the light: Immediate
Post-processing: Curves adjustment

RIGHT

Near Llanbedr, Snowdonia, Wales

Camera: Mamiya 645AFD with ZD
digital back
Lens: Mamiya 35mm (wideangle)
Filter: Polarizer
Exposure: 2 sec at f/18, ISO 100
Waiting for the light: Immediate
Post-processing: None

CONTENTS

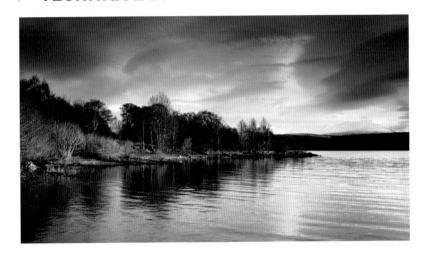

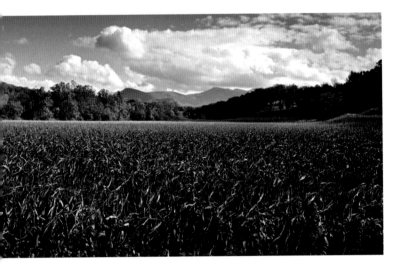

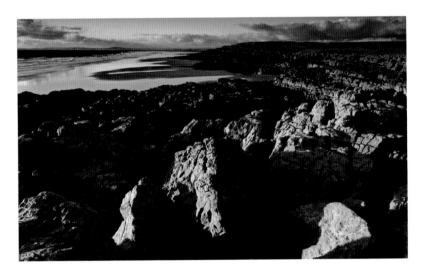

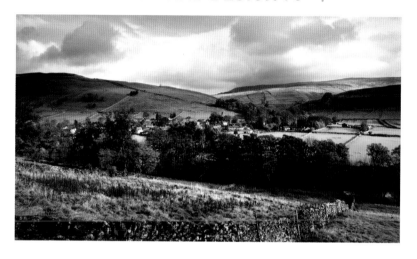
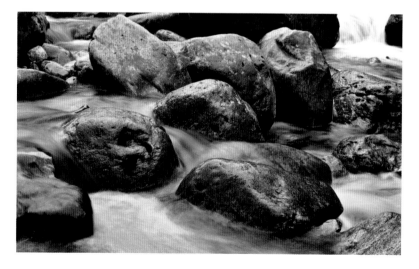
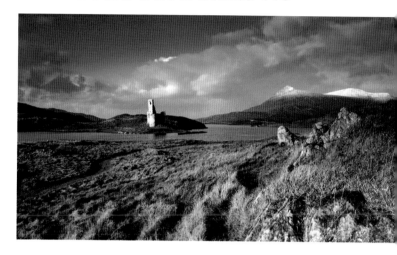

> INTRODUCTION

Recent developments in digital technology have simplified landscape photography. Many aspects of image-making that until recently required the facilities of a purpose-built darkroom can now be undertaken with an ever-expanding range of sophisticated software. Photographers now have control over the entire process, from the initial concept all the way through to the final print. Once the picture has been captured, the management of all aspects of its adjustment is at our fingertips; the ability to perform these functions is very empowering.

There now exists an opportunity for post-exposure creativity that once was beyond the wildest dreams of the film photographer. Empowering as the technology is, however, there are limits to what can be achieved. As with any computer-based application, what ultimately emerges from the process will only be as good as the initial raw material. This is commonly known as 'rubbish in, rubbish out'; digital photography is no exception to this rule. Despite all the advances over recent years, successful image-making still depends upon the quality of the contribution made by the photographer.

Photographically speaking, the landscape is a demanding, unpredictable environment; digital cameras have facilitated a huge step forward in meeting the challenge of capturing those fleeting displays of magnificence. However, in order to maximize the potential benefits that digital capture offers, it is necessary to adopt techniques that require only minimal post-exposure adjustments. Important as it is, post-processing should be considered the icing on the cake, not the main recipe. To reap the rewards, we must work in partnership with digital technology, using it to our advantage but understanding its limitations. The working practices that this involves are fully explained and demonstrated in this book.

Step by step, we explore the process of making distinctive pictures, from the early stages of research and planning through to final completion of the best possible image. The book addresses all aspects of photographing the landscape, including making appropriate post-processing adjustments, together with an explanation of why the adjustments were made. However, this is not a technical reference manual: successful pictures are made with a click of the shutter, not a click of the mouse. The aim of this book is to help you develop your skills and equip you with the knowledge and inspiration to embark on your own rewarding journey capturing views across the landscape.

A dull, overcast day suddenly looked a lot brighter the moment I discovered a perfectly rounded boulder in the flowing waters of this river. Reflections from its wet surface were reduced by the use of a polarizing filter. To compensate for a blue cast in the subdued daylight, a minor adjustment was made to the colour balance in post-processing.

River Coe, Glen Coe, the Highlands, Scotland

Camera: Mamiya 645AFD with Phase One digital back
Lens: Mamiya 35mm (wideangle)
Filter: Polarizer
Exposure: 1 sec at f/22, ISO 100
Waiting for the light: 40 minutes
Post-processing: Colour balance adjustment

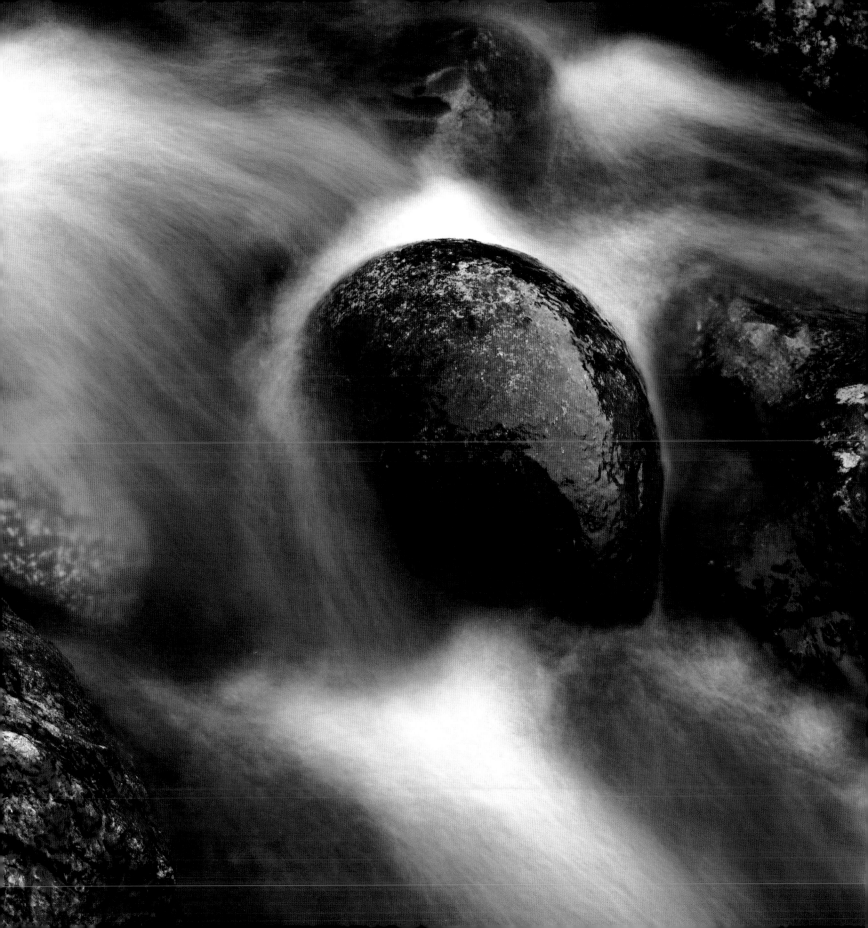

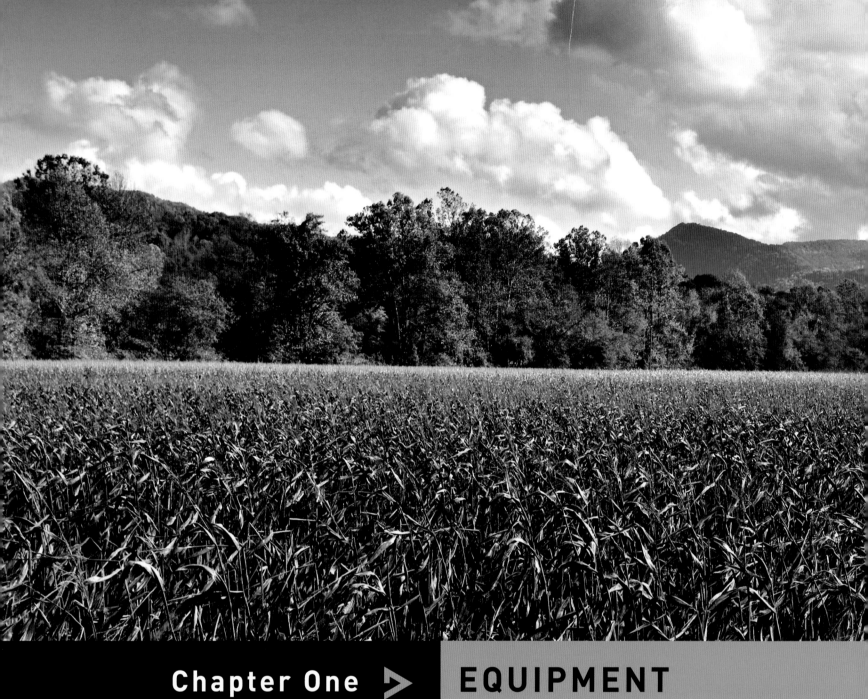

Chapter One ▷ EQUIPMENT

Near Blairsville, Georgia, USA

I have just rummaged through my camera bag and – not including the camera and lenses – I counted 23 items. Evaluating their usefulness, I found I could not discard a single one. Everything has a purpose, having been assembled as a result of experiences and situations that have arisen over the years. The paraphernalia includes adhesive tape, compass, magnifying glass, plastic bin bag and tape measure, showing that apart from your camera, lenses and filters, you don't need to pack your bag with expensive, bespoke equipment.

THE CAMERA

Deciding what camera to buy is both simple and complex. Simple because, in terms of features and functions, landscape photography requires a fairly basic camera; complicated because there is a vast and confusing range to choose from, and you need to get the decision right. There is nothing worse than being burdened with a camera that doesn't suit you. Make the right choice and your camera will become your faithful friend and ally on your journeys across the landscape. So, how do you make the right choice?

COMPACT AND DSLR CAMERAS

There are two basic types of camera: compact and DSLR (Digital Single-Lens Reflex). Compact cameras are not ideal for landscape use for a number of reasons. The main one is that they lack a viewfinder that shows the image as seen by the lens – an essential feature for accurate framing and composition of your photograph, particularly when using filters. Another drawback is the limited number of interchangeable lenses for these cameras. Therefore, a DSLR is the only real option for capturing high-quality images in the landscape environment.

You then need to consider the size of camera, or, more specifically, the size of sensor. Image sensors come in three basic sizes: small, medium and large. We need to be certain that the size feels right and suits our requirements. Small sensors are known as APS-C. There is no specific size for these sensors, but they are all of relatively modest dimensions and measure approximately 24 x 16mm. They have an aspect ratio of 3:2, which is identical to 35mm. The next size up is known as a full-frame sensor. This relates to 35mm cameras because the sensor measures 36 x 24mm, which is also the size of 35mm film.

A step up from these is medium-format; these sensors equate to larger-format film cameras such as Mamiya and Hasselblad. Once again, they have no absolute fixed size, but are typically twice as large as 35mm, being in the region of 48 x 36mm. Their aspect ratio is usually 4:3.

Deciding on a particular size of camera is a personal choice. The larger sensors produce the highest-quality images, but the latest APS-C DSLRs also give excellent results. Unless you are planning on producing very large prints, this sensor should be perfectly adequate. As well as the initial lower cost, there are a number of other advantages of APS-C cameras. Their smaller size means they can be supported by a smaller tripod; this can be a blessing when making long journeys over rugged terrain. In addition, the compact size of the lenses means they produce relatively long depth of field, which is very useful for landscape subjects.

MEGAPIXELS

Next we have to consider megapixels (mp). This is the number of pixels, in millions, that are packed into the image sensor. So a 16mp camera has a sensor that contains 16 million pixels. The number of pixels is important because this determines the size of prints that can be produced. For example, a 16mp sensor will produce prints up to about 16 x 11in (40 x 28cm), while a 24mp sensor will give you a maximum size of just over 20 x 13in (51 x 33cm). Higher pixels counts also mean that greater degrees of cropping are possible, which can sometimes be an advantage. It is a common misconception that higher pixel counts produce higher-quality pictures, but this is not the case. To a degree, image quality is determined by the type of camera, but is mainly the result of a combination of the photographer's technique and the optical quality of the camera lens; in this respect, pixel counts are largely irrelevant.

IMAGE STABILIZATION

The latest cameras offer many other features, and one that may be beneficial in the landscape environment is image stabilization (also known as optical stabilization, vibration reduction or vibration control). This allows the camera to be handheld at slower shutter speeds than would normally be possible. I do not advocate using a camera without a tripod as a regular practice. However, there are occasions when a sudden picture-taking opportunity presents itself; if an immediate grab shot is the only option to capture a fleeting moment then image stabilization can make this possible. I have this function on one of my lenses and have found it extremely helpful. An example of a photograph taken using image stabilization can be seen opposite. Image stabilization is usually a feature of the lens, but can also be found on some cameras.

SENSOR CLEANING

It is also an advantage if the camera has an integrated sensor-cleaning system. These are not the complete solution to maintaining a dust-free sensor, but they certainly help to produce clean images.

So, to summarize, my personal choice would be an APS-C (or larger) DSLR camera with image stabilization compatibility, integrated sensor cleaning and a pixel count of 16mp upwards from an established camera manufacturer. My own equipment consists of a Mamiya 645 medium format camera and, as back-up, a Canon 7D APS-C. This combination suits my needs; other manufacturers offer similar alternatives.

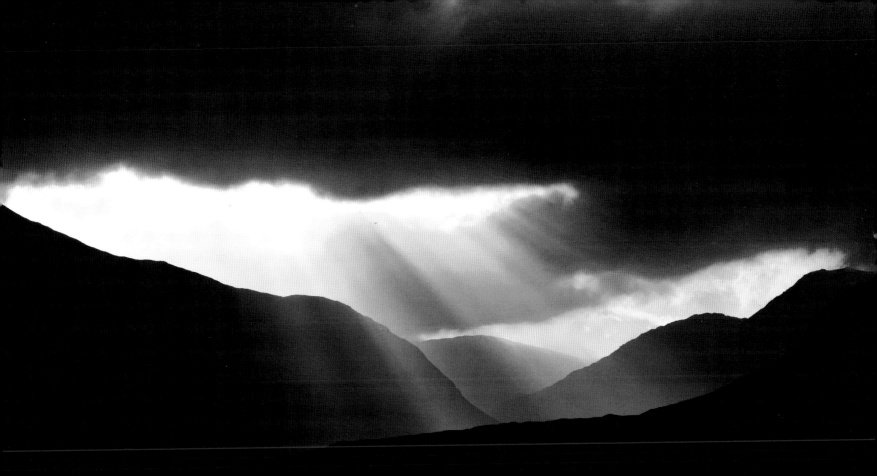

Near Glen Coe, the Highlands, Scotland

Camera: Canon EOS 7D

Lens: Sigma 17–70mm OS

Filter: None

Exposure: 1/30 sec at f/11, ISO 100

Waiting for the light: Immediate

Post-processing: Curves and shadows/highlights adjustment

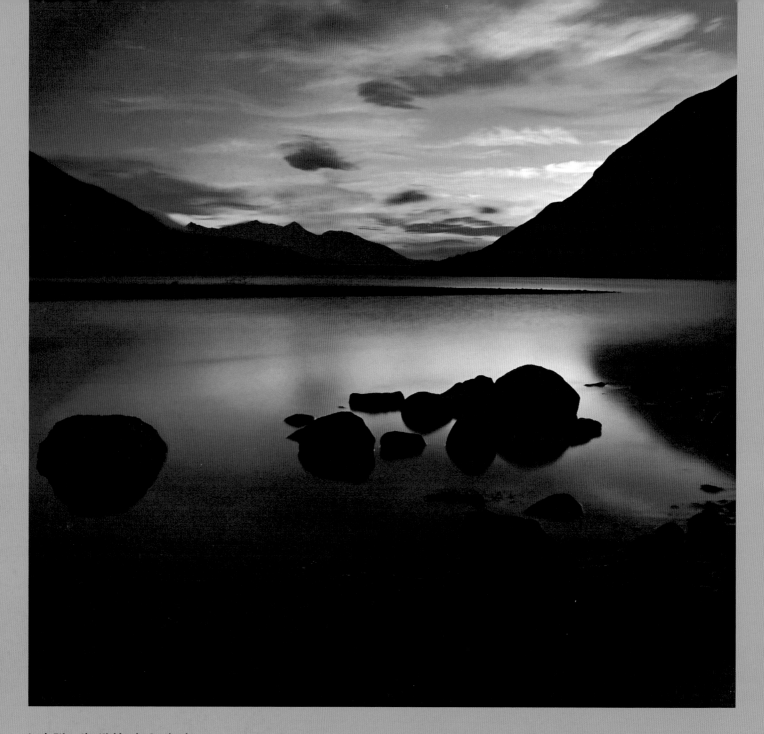

Loch Etive, the Highlands, Scotland

Camera: Mamiya 645AFD with ZD digital back
Lens: Mamiya 35mm (wideangle)
Filter: 1-stop ND graduated
Exposure: 60 sec at f/22, ISO 50
Waiting for the light: 6 days
Post-processing: Colour balance and shadows/highlights adjustment

❯ LENSES, FILTERS AND TRIPODS

Lenses, filters and tripods are all vital components of your landscape photography kit bag. Choose them with care and they will prove to be faithful companions on your adventures.

ZOOM AND PRIME LENSES

Zoom lenses are now commonplace and are often supplied as part of a camera and lens kit. Until fairly recently, they were optically inferior to prime (fixed focal length) lenses, but the difference in quality has narrowed to such an extent that the best zooms produce images that are virtually identical to those taken with prime lenses. Zooms tend to have a smaller maximum aperture than primes; this means they are not as suitable for night and low-light photography, although this is not a serious drawback for landscape work. Zooms are heavier and bulkier than prime lenses, but this is offset by the fact that one zoom lens can replace several primes. I find that their only real disadvantage is the lack of a depth-of-field scale on the lens barrel. This information is helpful when focusing; its absence leads to a degree of guesswork when trying to establish the hyperfocal distance. However, weighing up the pros and cons, I believe top-quality zoom lenses are the best choice for landscape photographers.

New cameras are frequently sold with an inexpensive zoom lens. These 'kit' lenses are a budget option; if you wish to achieve higher-quality or higher-resolution images you will need to invest in a more expensive lens. Pin-sharp photographs require the very best optics, and these come at a price. It is often the case that a top-quality lens costs more than the camera body; this might seem extravagant, but a superior lens will be a good investment and should provide you with many years of excellent service. My advice is to buy the best lens your budget permits. In addition to the main camera manufacturers, there are specialist lens producers who make lenses compatible with the majority of camera bodies. Sigma, Tamron and Tokina are long-established companies and offer a wide range of lenses ideal for landscape use. If image stabilization appeals to you, look for lenses identified as IS (Canon), VR (Nikon), OS (Sigma) or VC (Tamron).

FILTERS AND FILTER SYSTEMS

Despite developments in image-editing software, some filters still have an important role to play. There are two that are still indispensable to the outdoor photographer: the neutral density (ND) filter and the polarizer.

THE NEUTRAL DENSITY FILTER

The purpose of this filter is to absorb unwanted light. It does not (or should not) create a colour cast; as its name implies, it is completely neutral in this respect. This can be useful when a long exposure (i.e., slow shutter speed) is required, for example when blurring flowing water in a waterfall. Long exposures can also be used creatively to enhance a sky (particularly at dawn or dusk), often to a magical extent. An example of this can be seen opposite.

These filters are available in a range of densities from 1/3-stop all the way up to 10 stops or more. The degree of density is indicated on the surface of the filter, starting at 0.1 (which absorbs 1/3 stop), followed by 0.2 (= 2/3 stop absorption), 0.3 (= 1 stop), and so on. Extreme effects on movement and drifting cloud can be created by using very long exposures. The results can be dramatic, if unpredictable, and it is interesting to experiment using different types of subjects.

There is a graduated version of this filter, which is mainly used for reducing the level of brightness in the sky. The graduation consists of a dark portion that gradually fades to leave a completely clear section. It is therefore capable of darkening a sky without affecting the exposure of the land beneath it. As will be seen in Chapter 2, this is very important in creating correctly exposed images. Because it is so effective, the graduated ND, or grey grad as it is commonly known, is the most widely used filter in landscape photography.

THE POLARIZER

A polarizer is an important accessory because it can increase colour saturation by suppressing highlights and reducing the amount of light reflected from wet or damp surfaces. The appearance of foliage and vegetation can therefore be improved, as can the clarity of water. An example of this can be seen on page 157. This filter is also frequently used to darken a blue sky without affecting the brightness or luminosity of clouds. This can be very effective; a sky with a scattering of white clouds can really be brought to life by polarization. The filter absorbs approximately 2 stops of light; this isn't always helpful, but can be beneficial in some situations.

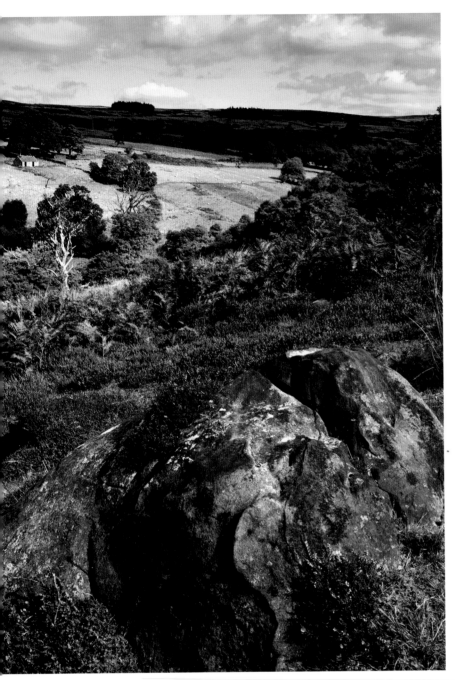

Commondale Moor, North Yorkshire, England

Camera: Mamiya 645AFD with Phase One digital back
Lens: Mamiya 35mm (wideangle)
Filter: 1 stop ND graduated
Exposure: 1/2 sec at f/22, ISO 100
Waiting for the light: 1 hour
Post-processing: Colour balance and saturation

FILTER SYSTEMS

There are two main systems used to attach filters to a lens: screw-in systems and slot-in systems. The screw-in method uses circular filters that screw directly onto the thread of the lens. This is a long-established system, but is not suitable for ND graduated filters because screw-in filters cannot be moved vertically in front of the lens. The transitional density of the ND grad, as it fades from dark to light, requires that it be raised or lowered to be accurately positioned over the part of the image that requires darkening. It therefore requires a filter holder to be attached to the front of the lens into which the filters are slotted. ND graduated filters, which are either square or rectangular, can be raised or lowered in the holder as desired and can also be rotated. Lee and Cokin are the main manufacturers of slot-in systems and are commonly used by landscape photographers.

THE TRIPOD

The tripod ranks alongside the camera and lens as an essential piece of equipment that must be chosen with care. An unsuitable or inferior tripod can seriously affect both the quality and creativity of a photographer's work; the importance of using the right type of camera support should not be underestimated. The key requirements are stability and adaptability. Weight is also an important consideration, but the avoidance of camera shake is the main purpose of a tripod and one that is flimsy and lightweight can create more movement than it prevents. The solution, if weight is a concern, is to choose a carbon-fibre model. They are more expensive than their metal equivalents, but might prove a worthwhile investment in the long term. I know several photographers who initially bought a heavy metal tripod only to replace it with a lighter carbon-fibre version once they had experienced the reality of trekking across rough terrain with the equivalent of a small child on their back! My advice is to take a hands-on approach and physically handle, carry and examine a tripod before buying one.

TRIPOD HEAD

Some tripods have an integrated head, but in my experience it is preferable to buy the head separately. The ball-and-socket style of head is very convenient, particularly when fitted with a quick-release plate. This enables the camera to be mounted onto the tripod and positioned in virtually any direction and angle very quickly; when seconds matter – as they often do in the landscape – this is an important feature. The security and stability of the head's engagement and locking mechanism are also important. A lot of damage is caused by cameras and/or heads falling off; this can be disastrous, particularly when working in water or on steep terrain. Make it a habit to check that all fittings are secure every time you use your camera.

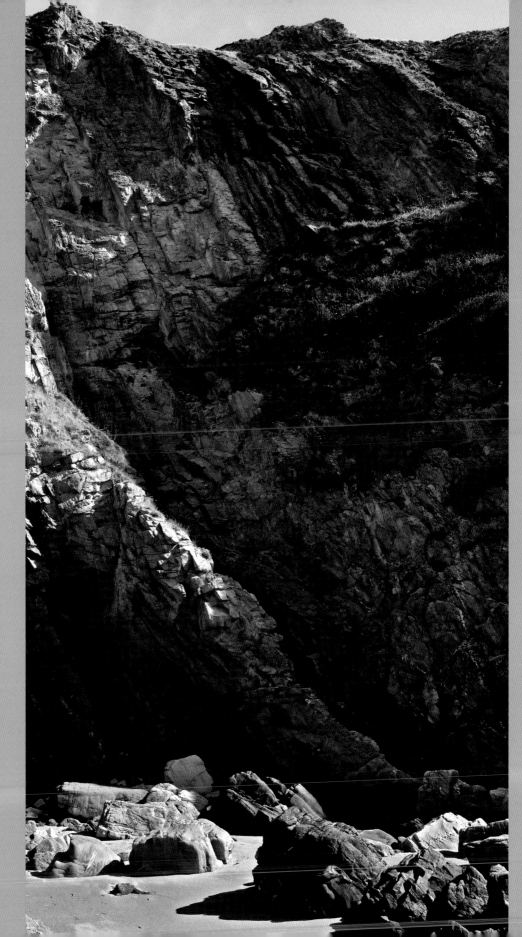

**Freshwater West,
Pembrokeshire, Wales**

Camera: Mamiya 645AFD with Phase
One digital back
Lens: Mamiya 35mm (wideangle)
Filter: Polarizer
Exposure: 1/4 sec at f/22, ISO 100
Waiting for the light: 1 hour
Post-processing: Cropping

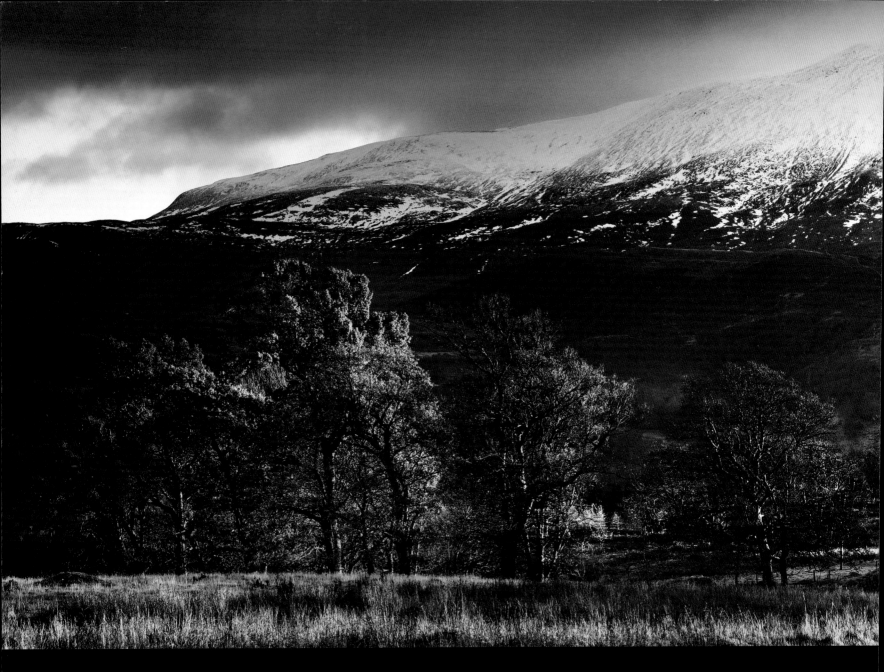

Near Glen Errochty, Perthshire, Scotland

Camera: Mamiya 645AFD with Phase One digital back
Lens: Mamiya 80mm (standard)
Filter: 2 stop ND graduated
Exposure: 1 sec at f/22, ISO 100
Waiting for the light: 6 days

OTHER EQUIPMENT

There is no point carrying around equipment that will lie unused in your kit bag. There are, though, a few accessories that are definitely helpful and well worth including.

CABLE RELEASE

With your camera mounted on a sturdy tripod, the risk of camera shake is very small. However, to reduce the risk still further, a cable release is a wise investment. For a modest outlay you can virtually eliminate any risk of vibration caused by physically pressing the shutter-release mechanism; if this saves just one image from being spoiled then it is money well spent (they also look impressive!).

SPIRIT LEVEL

Mounted on the camera's accessory shoe, a spirit level is beneficial when photographing straight lines such as coastal horizons and buildings. Some tripods also have an integrated spirit level.

VIEWFINDER

I acquired the habit of using a separate handheld viewfinder in my early years as a large-format landscape photographer and have used one ever since. I like to be able to separate the viewing and the actual taking of a photograph. This enables me to take a slower, more considered approach to composition and subject selection and I strongly advocate their use. I use the Linhof Multifocus Viewfinder.

BATTERIES

The digital age has brought with it our inescapable reliance on battery power. On a perfect's day shooting, when conditions are just right and photographs are queuing up to be taken, you can guarantee that your camera batteries will lose energy long before you do. The solution is simple: always carry a spare set.

MAPS

Where would we be without them? Large-scale maps are an essential tool for planning and research. They are packed with enticing information and, at a scale of 1:50,000 or larger, reveal the locations of everything a photographer could wish to see, such as lakes, rivers, bridges, waterfalls, footpaths, forests, historic buildings and land contours. Studying a map can be totally absorbing and is sound preparation when planning a trip.

CAMERA BACKPACK

A good-quality backpack specially designed to carry photographic equipment will protect your camera and accessories and will ease the burden of carrying your kit. It is important to choose a bag that is the right size. The contents should be held securely, but be readily accessible, with every item in its right place. There are times when lightning-quick reactions are required if that fleeting moment is to be captured; a methodically packed, correctly sized bag can save precious seconds and increase the chances of success.

OUTDOOR CLOTHING

The photographer's day can be long and demanding, so it is important to be comfortably dressed and adequately prepared for changeable weather. Sturdy, waterproof footwear is essential. By a strange quirk of nature, the best viewpoints are always in the wettest, most inhospitable places, so make sure you are suitably attired to withstand arduous conditions.

CAMERA MAINTENANCE

Maintaining and cleaning your equipment is very important. The surface of a lens is delicate and can be easily scratched. Lenses should always be protected by correctly fitting lens caps and should be regularly inspected for dust and scratches. Filters should also be inspected and cleaned as necessary (they are prone to finger marks). It is also good practice to inspect the camera sensor from time to time. Any dust can be removed using a good-quality sensor brush, but it has to be done with care. A scratched sensor is prohibitively expensive to replace.

The cleaning items I carry in my bag are: micro-fibre lens cloth, lens brush, soft filter cloth, Arctic Butterfly sensor brush and Giottos Rocket air blower.

EQUIPMENT USED

For a list of the equipment used in the making of the photographs in this book, see page 189.

Chapter Two ▷ TECHNIQUE

Loch Rannoch, Perthshire, Scotland

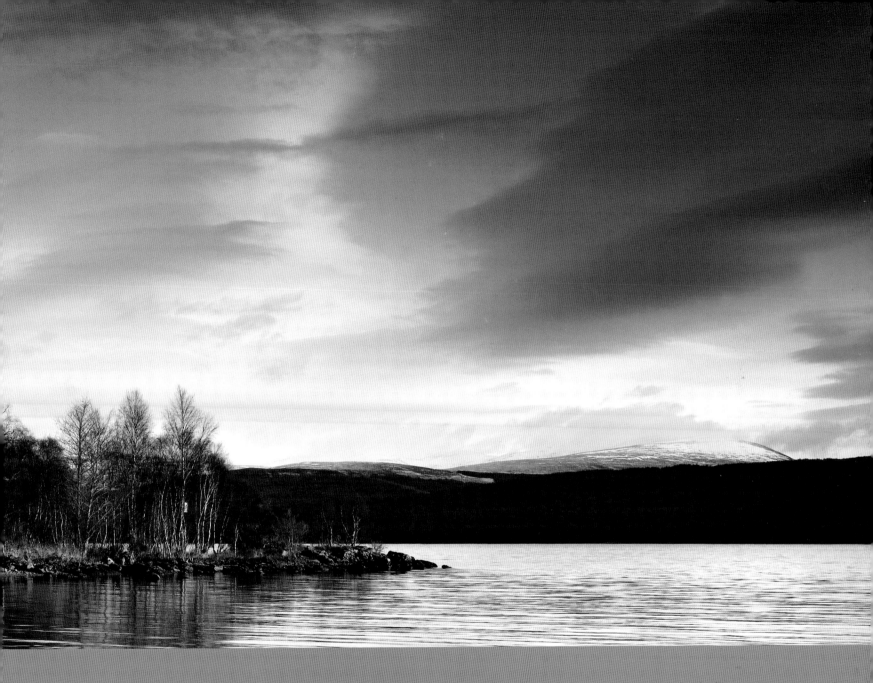

Successful landscape photography requires keen observation, visualization and imagination. Equally important as these creative aspects is a sound technical approach; the production of pin-sharp, perfectly exposed, high-resolution photographs is now a basic requirement. In this chapter we address both these aspects of making photographs and explain how to successfully apply the techniques out in the field. We also look at the benefits of the latest technology and the role the photographer plays in maximizing its potential.

THE DIGITAL IMAGE

What is a digital image? If you ask a photographer and then a scientist you are likely to receive two very different answers. I don't profess to be a scientist, so I will give you the photographer's answer: digital images are photographs recorded on a light-sensitive sensor that is built into the camera as a replacement for film. Instead of relying on silver halide crystals to capture our pictures, we now rely on pixels.

The word 'pixel' derives from a combination of the words 'picture' and 'element', and a pixel is the basic element of the digital pictures we take. If you look at an image on a computer screen at 1,000 or 1,200% magnification, the pixels can be easily seen as square blocks of colour (note, only one colour per pixel). What you are looking at is the digital equivalent of a piece of film emulsion magnified many times. This is the digital image. What matters is not so much its basic construction but how, post-exposure, it is subsequently processed.

For most of my life I worked with colour transparency film (and still do to a certain extent); I have always worked in an environment where 'what you photograph is what you get'. In those halcyon days, it was a straightforward procedure; we exposed the film in our camera, deposited it with the photo lab, had it E6-processed, then took it home and examined it on a lightbox. Like them or loathe them, we had our pictures and were stuck with them; there was no fine-tuning or adjusting, and the processed transparency was the final, finished article. The concept of shoot now, adjust later was unheard of.

In some respects, the process of physically capturing the image is simpler than it used to be, but in other ways it has become more demanding. In addition to the need to visualize and create the photograph in-camera, a degree of adjustment to the digital image is often necessary in post-processing.

The camera, lens and processing software can all have an effect on the appearance of the final picture. If the photograph is to be a faithful reproduction of the subject, then colour balance, and possibly also contrast and saturation, might need to be modified. I discovered this when I was testing various lenses with the same camera body. Each lens produced slightly divergent colour rendition and in some cases also a small variation in contrast; using different cameras produced even more pronounced colour shifts.

When I added to the mix different processing software, there were further changes to the final image. All the variations were relatively minor but they were quite noticeable and post-processing adjustments were therefore necessary.

FILE FORMATS

Most DSLRs offer a choice between shooting RAW and JPEG files; often there is an option to save the image as both a RAW and a JPEG (this is my preferred shooting mode). There is usually no option to shoot TIFF files; they need to be produced from RAW files (hence the use of processing software mentioned above).

Most landscape photographers advocate shooting in RAW mode, as RAW files produce the highest-quality pictures. They contain more data than JPEGs; this means better colour depth and higher dynamic range and therefore more detailed highlights and shadows. The main drawback of shooting RAW files is speed. They are slower to process in-camera and require converting to TIFF, which can be time-consuming. Speed is not of paramount importance for landscape work – quality reigns supreme – which is why RAW is the choice of most photographers.

Capturing simultaneously in both RAW and JPEG mode is an option on most DSLRs and is helpful when you review your images at the end of a day's shooting and decide which to keep and which to discard. The JPEGs are a quick reference aid and speed up the editing process.

JPEGs can be saved in different sizes and quality levels. Most DSLRs offer three quality levels – fine, medium and basic – and also three sizes of image. The number of options provided reflects the fact that JPEGS can be used for many different purposes.

If they are intended to act simply as a quick and convenient indication or record of what has been captured, then the smaller, lower-quality files will be adequate. If they are to be used as the final image, such as when photographing sporting events or wildlife (when fast, continuous shooting is required) then larger, higher-quality files would be more suitable.

Near Franklin, North Carolina, USA

Camera: Mamiya 645AFD with ZD digital back
Lens: Mamiya 300mm (telephoto)
Filters: None
Exposure: 1/4 sec at f/22, ISO 100
Waiting for the light: Immediate
Post-processing: None

APERTURE AND SHUTTER SPEED

Picture quality is of the utmost importance. Even the most spectacular photograph, if poorly focused or blurred, will be a disappointment. Rescuing such images is beyond the capability of even the most advanced editing software; it is the photographer's technique that matters most. It is essential that correct working practice is followed so the highest quality is maintained every time the shutter is released.

Fortunately, the correct technique is not hard to master. Assuming you have a sturdy tripod and, ideally, a cable release, pin-sharp photographs simply require accurate focusing and adequate depth of field. At first glance, the technicalities of shutter speed, f-numbers and depth of field can seem confusing. They are not actually that complicated, and digital cameras have greatly simplified matters. The most important point to remember is that the higher the f-number (i.e., the smaller the aperture), the greater the depth of field. Using the camera in aperture priority mode enables the aperture to be manually selected, with the correct shutter speed being automatically applied by the camera's exposure metering system. For maximum depth of field, a small aperture, for example f/22, should be selected. Because the aperture is small, a fairly long shutter speed might be necessary; sometimes it might be 1 second or even longer, but as the camera is on a tripod this doesn't really matter. By shooting in aperture priority mode, you can be certain of having correctly exposed pictures, as well as sufficient depth of field to give sharp images from the near foreground to the far distance. This, of course, depends on accurate focusing.

APERTURE

The aperture is the opening in the diaphragm inside the lens that controls the amount of light reaching the camera sensor. The size of the opening is adjusted according to the exposure value of the subject. These sizes are referred to as f-numbers. The range of numbers can vary slightly, but typically read f/2.8, f/4, f/5.6, f/8, f/11, f/16 and f/22 (other numbers can appear within this range). As the f-numbers increase, the size of the aperture reduces in size. In the sequence shown, f/2.8 is therefore the largest aperture and transmits twice as much light as f/4, which in turn lets in twice as much as f/5.6, and so on. The shutter controls the length of time the sensor is exposed to the light, and it is the combination of aperture and shutter speed that determines exposure. By changing aperture, a corresponding adjustment to shutter speed must also be made. By shooting in aperture priority mode, the camera automatically adjusts the shutter speed according to the aperture selected. For example, if we choose f/22 as our working aperture, the camera's exposure metering system might calculate a shutter speed of 1 second. If we then change the aperture to f/16 the shutter speed will automatically be adjusted to 1/2 second to compensate. So an exposure of 1 second at f/22 is equivalent to 1/2 second at f/16, which is also equivalent to 1/4 second at f/11, and so on.

FOCUSING

We can now turn our attention back to focusing. It is important to focus accurately; to be certain that the depth of field covers the entire subject, it is preferable to focus manually rather than relying on autofocus. There are two methods of focusing. If you have a prime lens with a fixed focal length there is likely to be a depth-of-field scale on the lens barrel. You can then focus the lens according to this scale. By turning the focus dial until the infinity symbol (∞) is just inside your chosen f-number, you know that the very furthest point in the image (i.e. infinity) will be in focus. At the other end of the scale, the distance shown above (or below) your chosen aperture will indicate the limit of near focus; it might, for example, be 3–4ft (approximately 1–1.2m). The depth of field (the range of distance that will appear acceptably sharp when photographed) therefore extends from 3–4ft (1–1.2m) to infinity.

Zoom lenses have no depth-of-field scale, which means the lens must be focused on the hyperfocal distance to achieve maximum depth of field. The position of this focus point is determined by a combination of the camera sensor size, lens focal length and aperture size. With an APS-C sensor, a lens of 20mm focal length set at an aperture of f/16 produces a hyperfocal distance of 4.17ft (1.27m). By focusing at 4.17ft, everything from 2.085ft (the near focus point is always half the hyperfocal distance) to infinity will be in focus. Below is a chart showing hyperfocal distances for APS-C and full-frame sensors. There are various other tables available online and a useful depth-of-field calculator at www.dofmaster.com.

Some cameras have a depth-of-field preview button that enables you to see the depth of field at a pre-selected aperture. There is also now Live View, a function that displays, in advance of taking the picture, a magnified view of image sharpness and depth of field on the camera's LCD screen. I find this facility a great aid to focusing.

Hyperfocal distance (ft/m) for APS-C sensors

	12mm	16mm	20mm	24mm
f/8	3.2/1	5.4/1.6	8.8/2.7	12.3/3.7
f/11	2.3/0.7	3.8/1.2	6.2/1.9	8.8/2.7
f/16	1.7/0.5	2.6/0.8	4.3/1.3	6.2/1.9

Hyperfocal distance (ft/m) for full-frame sensors

	17mm	24mm	28mm	35mm
f/11	3/0.9	5.9/1.8	7.8/1.8	12.4/3.8
f/16	2.2/0.7	4.2/1.3	5.5/1.7	8.7/2.7
f/22	1.6/0.5	2.9/0.9	3.9/1.2	6.2/1.9

UNDERSTANDING HISTOGRAMS

These days, DSLRs can virtually think for themselves; however, they are not foolproof and cannot read the photographer's mind. You must pay close attention to what the camera is doing to avoid being surprised or disappointed by the results of the camera's automated functions. Manual intervention is sometimes required, particularly when exposure is being calculated. Automated metering is generally fairly accurate, but it is important to look at – and understand – the histogram.

A histogram is a graphical representation of the distribution of data; in photographic terms, this means the distribution of pixels. In other words, it shows the exposure and tonal range of an image. The horizontal scale indicates exposure latitude; the vertical scale measures pixel quantity. The darkest pixels are normally on the left and then become progressively lighter as they move to the right.

There is no correct, or perfect, histogram as such, but preventing extensive clipping of pixels will improve an image. High contrast is more difficult to adjust than exposure in post-processing; the best solution might be to change your viewpoint at the time of capture and try to avoid the lightest and darkest parts of the landscape or, alternatively, wait for softer light.

EXPOSING TO THE RIGHT

Digital sensors capture more tonal levels toward the brighter end of the histogram. This is worth knowing because higher tonal levels can improve the appearance of an image and also reduce levels of noise. A photograph can benefit from increasing the exposure so the histogram moves slightly to the right. This has to be done with care: you must avoid clipping the highlights by moving the graph too far. The picture might look too light on the camera screen, but a slightly overexposed RAW file can be adjusted at the processing stage.

Experimenting with different exposures and the effect they have on the appearance of the image is not an essential part of the learning curve; it is something that can be done as you gain experience. The important point to remember is that a RAW file that is a little too light is better than one that is too dark.

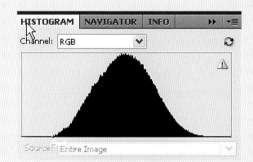

This histogram indicates that the image is correctly exposed and has fairly low contrast because the majority of the pixels are in the mid-tone area.

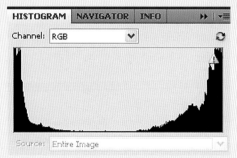

The graph shows high contrast, with pixels stacked in both the darkest and brightest areas. The clipping of the pixels shows that the contrast is so great that information is being lost in both the shadows and highlights.

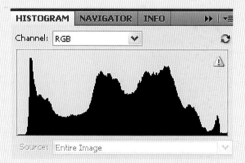

Here the pixels are evenly spread, which indicates a good tonal range and correct exposure.

THE ROLE OF FILTRATION

Look at any filter catalogue and you will see pages of filters in a wide variety of colours and special effects; however, most of them are of no interest to the landscape photographer. As explained in Chapter 1, there are just two types of filter that, if used correctly, can greatly enhance the appearance of a landscape image: the neutral density filter and the polarizer.

THE NEUTRAL DENSITY FILTER

This filter has become popular in recent years as an aid to creativity. Its purpose is to absorb light and this can be useful because it enables long exposures to be made. The creative aspect arises when the movement of objects, such as clouds and water, is recorded over a period of, say, 20–30 seconds, or even as long as several minutes. This can give skies, particularly at dawn and dusk, a breathtaking, ethereal quality and can make eye-catching images. However, digital noise can be a problem when using long exposures. Its presence will cause a photograph to look grainy and speckled, and it becomes more noticeable at fast ISO speeds. For exposures of more than 30 seconds, I would recommend using an ISO speed of no more than 200. This shouldn't cause any difficulties; as you will already be using a long exposure, a faster ISO speed will probably not be a requirement.

The appearance of long-exposure photographs can be difficult to predict. At dawn and dusk, the colour of the sky, the cloud structure and the speed and direction of its movement all contribute to the final image. With practice and experience you will get a feel for what looks promising. But as is the case with every sunrise and sunset, it is difficult to predict how the sky will develop.

All you can do is be in the right place at the time, open the camera's shutter and keep your fingers crossed. Take care to avoid camera shake. There is a high risk of it occurring during long exposures, and a sudden gust of wind could ruin a picture. If that happens, instead of closing the shutter, simply cover the lens until the wind drops (a dark cloth is ideal for this or, in emergencies, your hand will suffice). Interrupting a very long exposure in this way won't affect anything, but remember to count how long you keep the lens covered to enable you to maintain the original exposure time.

In post-processing, if noise and grain are apparent in an image they can be improved by using noise-reduction software. They are unlikely to be completely eliminated, but can certainly be reduced.

THE GRADUATED NEUTRAL DENSITY FILTER

There are times when it is desirable to darken a specific part of an image; more often than not, this will be the sky. Invariably it is always lighter than the landscape (even one that is heavy and cloud-filled is likely to be in the region of 1 stop brighter than the land beneath it), so it will usually benefit from a degree of darkening. This is done by raising or lowering the filter to position its dark portion over the sky. The point where it meets the horizon, or landscape, is where the graduation from dark to light should be placed. If this point is not horizontally level, the filter can be rotated at an angle as necessary.

The density of filter I most commonly use is 0.6 (2-stop); this gives good results for most situations. However, a density of anywhere between ½ and 3 stops might be required. You can determine this by initially using a 2-stop filter and then viewing the image and its histogram on the camera LCD screen. If the sky looks too dark or too bright, the photograph can either be retaken with the appropriate strength filter or adjusted in post-processing. A combination of using both the Curves and Shadow & Highlight tools usually gives good results. The secret to success is to keep adjustments to a minimum. The objective is to produce a picture as flawless as possible at the time of capture. Editing software is best used for delicate fine-tuning, not major adjustments.

THE POLARIZING FILTER

As discussed in Chapter 1, the polarizer is an important tool in landscape photography, particularly as its effects cannot be realistically simulated in post-processing. A useful property of the filter is its ability to darken a blue sky without affecting the appearance of clouds (an example can be seen on the opposite page). A polarizer can give a sky real impact, but it has to be used with care. In certain conditions it can overdarken an attractive sky and turn it into a dark, featureless expanse. Fortunately, the strength of the filter can be controlled by rotating it and viewing the effect as you do so. Sometimes half-polarization is the better option. Beware also of uneven darkening, particularly when using a wideangle lens. Clouds can help in this respect; alternatively, if one corner is darker than the other, a low-density (1-stop) ND graduated filter can be placed at an angle in the opposite corner to balance the darkening. The polarizer can also be used to improve the transparency of water. This can be particularly effective, for example, when photographing a lake with a foreground of pebbles just below the water's surface (see page 139).

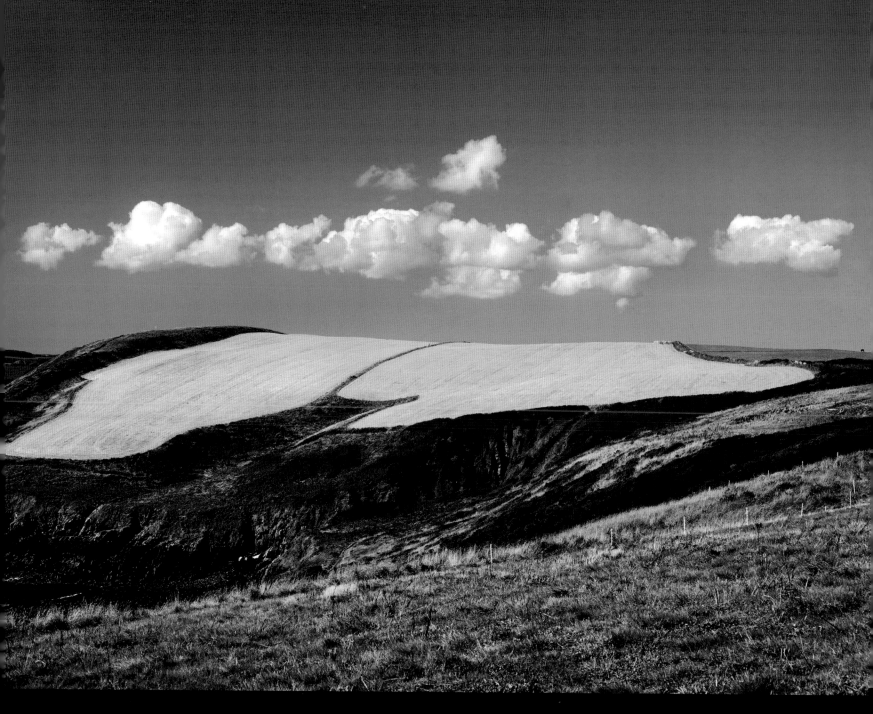

Manorbier, Pembrokeshire, Wales

Camera: Mamiya 645AFD with ZD digital back

Lens: Mamiya 80mm (standard)

Filter: Polarizer

Exposure: 1/8 sec at f/18, ISO 100

Waiting for the light: Immediate

Post-processing: None

▶ FINDING THE BEST VIEWPOINTS

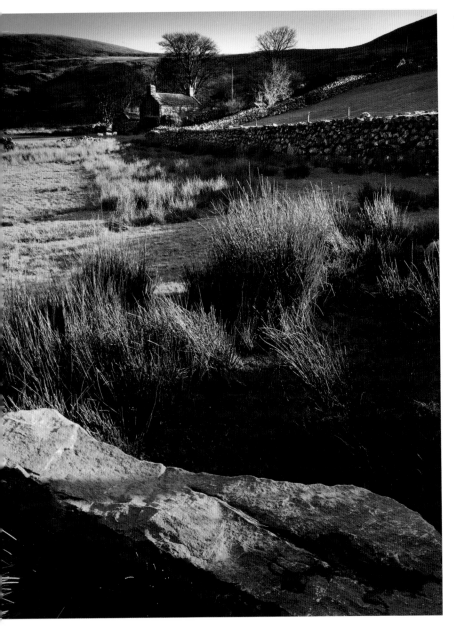

A well-composed photograph will engage the viewer; it will draw the eye and invite closer scrutiny. With the right light, the picture will have impact and make a lasting impression. This assumes that the image portrays an attractive location that has been captured from a strong viewpoint. Choice of location and viewpoint are fundamental to achieving success.

To find the most promising locations, a little research and planning can go a long way. The internet can help you choose a place that suits the type of photography you have in mind. Google Earth enables you to 'fly' to almost anywhere in the world and look at photographs taken in the area (the pictures can be of variable quality, but are a useful guide to what to expect). There is a plethora of photographic websites such as flickr.com and alamy.com that show a broad spectrum of images from worldwide locations. Books are helpful and your local library can be worth a visit. Maps are important too; time spent studying them is always time well spent. Large-scale maps contain a wealth of information and are an indispensable aid to research; they are also useful when the time comes to actually take the photographs.

Choosing a suitable area is just the first step; what then matters is that the location is photographed to maximum effect. Even the most spectacular subject will fail to impress if it is poorly captured. It is important to find a strong vantage point – somewhere that allows the picture to be composed in an eye-catching way and that also portrays the character of a subject.

Sometimes there is an obvious viewpoint, but often the best spot takes a little seeking out. Take your time and consider all the options. When capturing a distant view (always the most difficult subject to photograph successfully), look for somewhere that has attractive foreground, ideally in an elevated position that allows the foreground to flow away from the camera towards the distance. Make a thorough search, because a change in position of just a few yards can make a huge difference. View the scene in both landscape and portrait formats; if you're not sure which one looks better, take both. If, after careful thought and contemplation, you are still not sure what the best composition is, return at a different time of day. It might be the light that is the problem, and a change in its direction might open up other options. Searching for suitable viewpoints becomes easier with experience. With practice you should gradually develop a sixth sense and be able to home in on the best composition.

Near Llanbedr, Snowdonia, Wales

Camera: Mamiya 645AFD with ZD digital back
Lens: Mamiya 35mm (wideangle)
Filter: Polarizer
Exposure: 1/4 sec at f/22, ISO 100
Waiting for the light: 1½ hours
Post-processing: Curves adjustment

USING LIGHT

Light is the photographer's raw material. As the painter applies paint to the canvas so the photographer applies light to the image sensor. Without light there would be no picture; but, essential as it is, it has to be used sparingly and with the care and precision of an Impressionist painter. Inferior light will lead to inferior images. It is for this reason that the quality of light is the most important element in a photograph.

Throughout this book the use of light in different situations is addressed. It is the foundation of every photograph and can be used to create mood, atmosphere, tranquillity, harmony, drama, impact, balance and depth. The quality of light is constantly changing – its strength, colour, angle and distribution – and this endless variation enables it to be used creatively in the making of images. Like the landscape itself, light has its own character; it is the marrying together of light and land in an appropriate manner that forms the basis of every successful landscape photograph.

Visit a location at different times of day and year and there will always be subtle changes in its appearance. This will largely be due to the effect of light. Observe this at first hand and you will gain invaluable experience. Time spent simply watching light is never time wasted. Learn to appreciate its qualities and the results will show in your photography.

> POST-PROCESSING

The post-processing information that accompanies each picture is intended to act only as a brief explanation of the adjustments made to the original image. The tools and methods used to make the adjustments reflect my own working practices and preferences; in many cases, there are other methods of achieving the same results. Many of the adjustments can, for example, be made to the RAW file prior to the image being converted. The processing software used was Photoshop CS6. The RAW files were converted to TIFF format using Capture One software.

**Near Robin Hood's Bay,
North Yorkshire, England**

Camera: Mamiya 645AFD with ZD digital back
Lens: Mamiya 35mm (wideangle)
Filter: Polarizer, 1 stop ND graduated filter
Exposure: 1/6 sec at f/22, ISO 100
Waiting for the light: 30 minutes
Post-processing: Colour balance adjustment

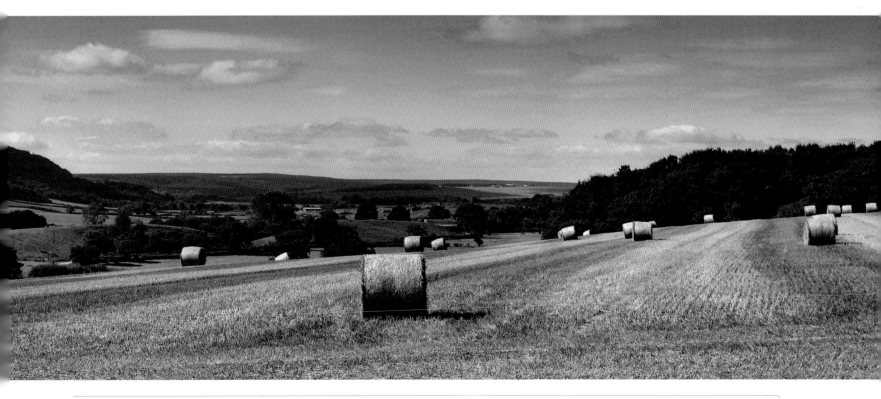

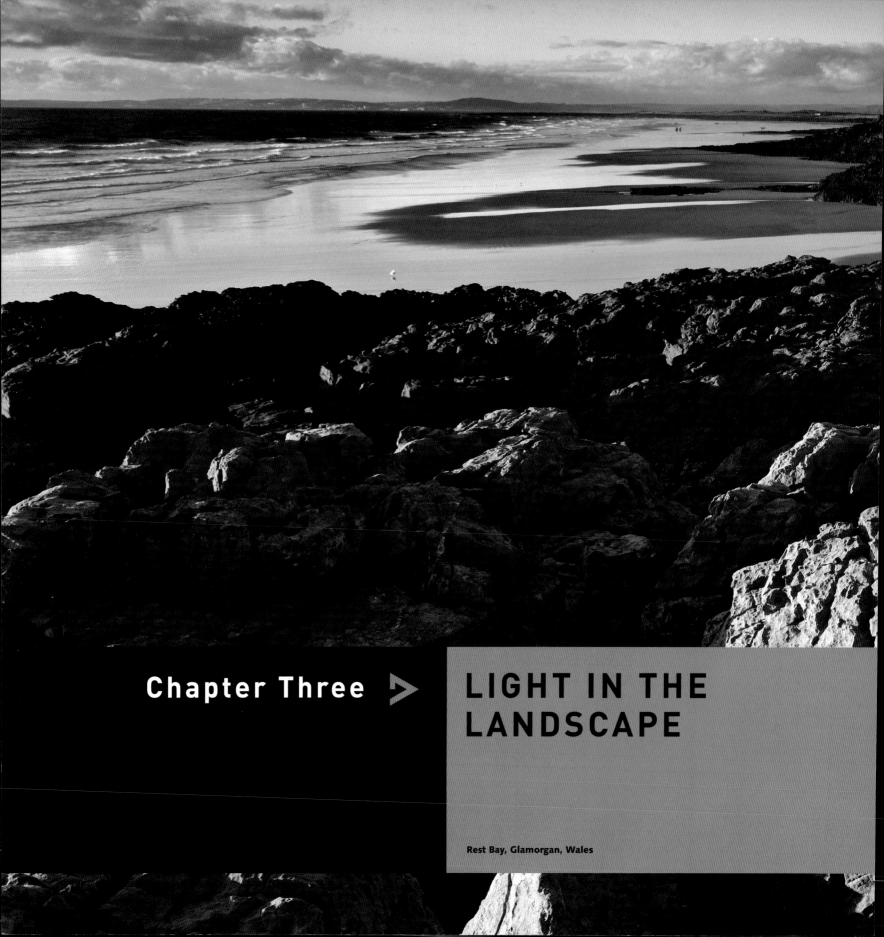

Chapter Three ▶ LIGHT IN THE
LANDSCAPE

Rest Bay, Glamorgan, Wales

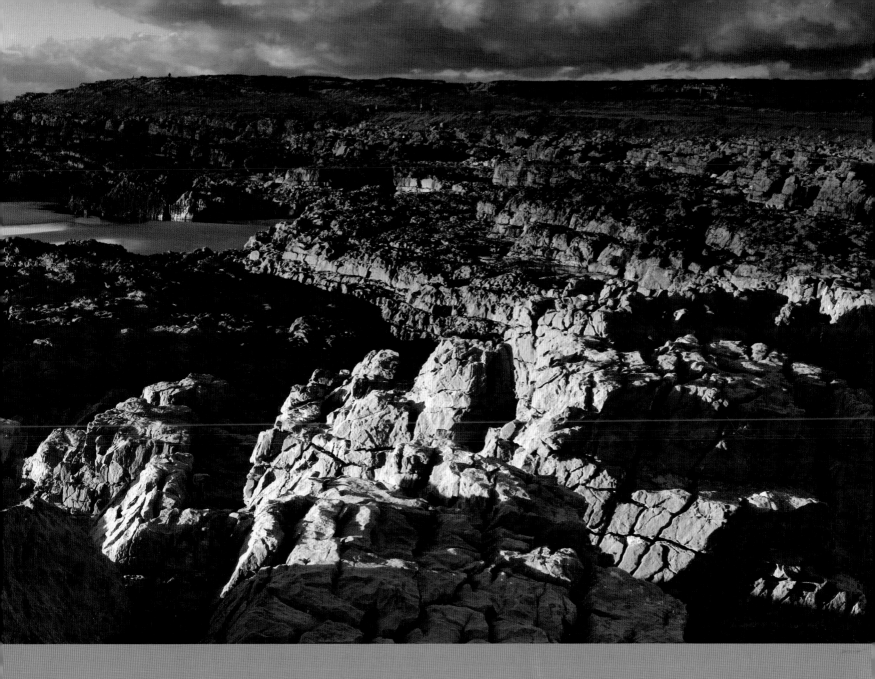

Study the work of distinguished painters and it will become apparent that what often sets them apart from other artists is their depiction of light. Their ability to paint light into a picture and use it as a key element gives their work a distinctive quality that engages the viewer and creates a lasting impression. This is also the case with photography. Learn to use light and portray it as a visible feature and your images will begin to display an engaging and memorable quality.

THE QUALITY OF LIGHT

Backlighting can give a magnificent quality of light; large-scale views can be transformed by its seductive rays. The light is so effective that a dramatically backlit open vista can almost radiate with impact and will grab the viewer's attention. Care has to be taken, though, because this type of light is the most difficult to control.

Of all the potential pitfalls, lens flare is perhaps the most problematic. You may have seen photographs that have been affected by it. It can appear as circular or polygonal bright spots, or can be randomly scattered. When present it will reduce contrast and saturation. It does not look attractive in a landscape image and should always be avoided. Whenever a camera is pointed towards the sun the risk of lens flare

is always high; the only way to eliminate it is by preventing sunlight falling directly onto the lens. With a cloudy sky you can let nature do the work and simply wait for passing cloud to obscure the sun. This is worth doing anyway if the sun is very bright; it will improve the appearance of the sky and help to reduce contrast, which is likely to be high in a backlit image. The other solution is to use an umbrella or a piece of card to cast a shadow onto the lens – just take care to avoid it creeping into your picture; its appearance will do nothing for your sky!

Beware also of flare caused by reflected light, particularly if there is water present. A lake or river can cause very strong reflections that may spoil a photograph. Again, passing cloud can be used to prevent this.

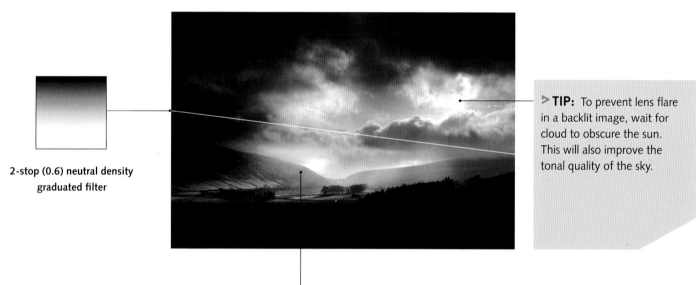

2-stop (0.6) neutral density graduated filter

> **TIP:** To prevent lens flare in a backlit image, wait for cloud to obscure the sun. This will also improve the tonal quality of the sky.

• The low horizon point gives a degree of emphasis to the sky and allows the drama in the cloud structure to become an important feature.

• The light value of the sky was reduced by using a 2-stop neutral density graduated filter. It was still necessary to use the Shadows/Highlights tool when post-processing to further reduce the highlights. A stronger neutral density filter could have been used, but it would have darkened the clouds to an unacceptable degree.

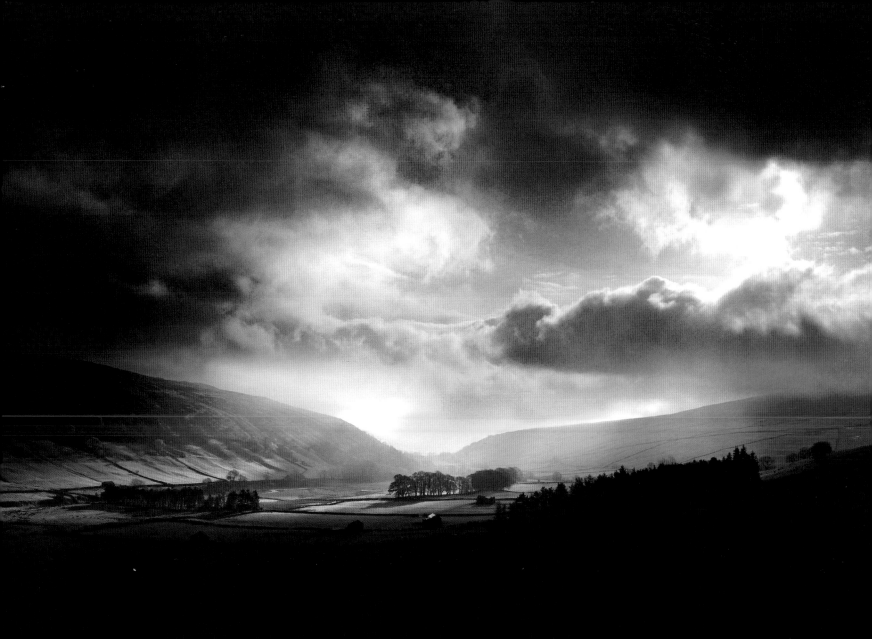

Littondale, North Yorkshire, England

Camera: Mamiya 645AFD with Phase One digital back
Lens: Mamiya 35mm (wideangle)
Filter: 2-stop ND graduated
Exposure: 1/8 sec at f/16, ISO 100
Waiting for the light: 5 days
Post-processing: Suppression of highlights

> THE QUALITY OF LIGHT REDUCING EXCESS BRIGHTNESS

Neutral density graduated filters play an essential role in reducing excess brightness in an image; more often than not this will be the sky, which is always brighter than the landscape. However, there are occasions when the position of the area you wish to darken prevents the use of filtration. This occurs when the highlights are situated somewhere near the centre of the picture, which makes it inaccessible as far as filters are concerned. Fortunately, thanks to digital technology, we now have other options.

There are a number of post-processing tools that can act as a substitute for the ND grad filter. As long as the tonal adjustments made are not too severe, they are capable of producing quite acceptable results. I prefer to control the tonal range at the time of capture as this always gives the best image, but it is useful to have alternatives.

By first selecting the part of the picture to be adjusted by using, for example, one of the Lasso or quick selection tools, highlights and shadows can be adjusted with either the Curves or Levels tools. Another option is to make the adjustment by burning or dodging the required area. In the photograph opposite, I darkened the highlights by burning the brightest parts. They are still too bright for my liking, but there is a limit to what can be achieved in post-processing. The sunlight was simply too strong; the image should have been taken in softer light, but the sky was cloudless and unfortunately the high contrast was there to stay. Nothing could be done to rectify matters at the time of capture, but the adjustment to the highlights has certainly made an improvement.

- In this type of image, choose a viewpoint that contains a dense canopy of foliage. Gaps in the trees where the sky is visible will weaken a photograph.

- The highlights were reduced by burning (darkening) the indicated area in post-processing using the Burn tool.

- The high contrast is partly the result of the back and sidelighting. Had the picture been frontally lit there would have been no strong highlights, but without splashes of sunlight filtering through the trees the image would have looked flat. This type of photograph always benefits from being back- or sidelit.

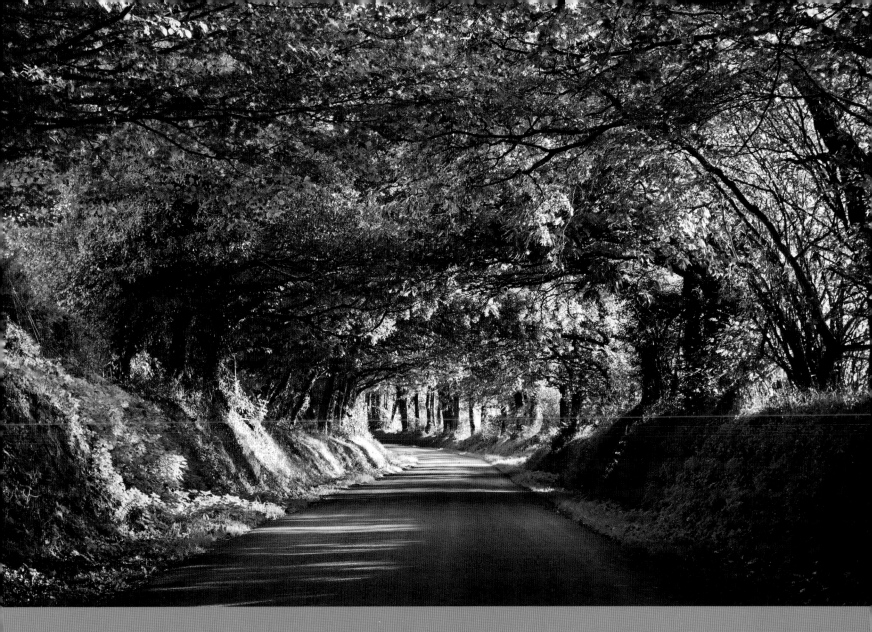

Mellionnec, Brittany, France

Camera: Mamiya 645AFD with Phase One digital back

Lens: Mamiya 35mm (wideangle)

Filter: None

Exposure: 1/2 sec at f/22, ISO 100

Waiting for the light: 1 hour

Post-processing: Reduction of highlights

> THE QUALITY OF LIGHT WAITING FOR THE RIGHT MOMENT

Photographing the landscape takes time because optimum conditions can prove elusive and can also be short-lived. A good deal of sky- and weather-watching is involved if those moments are not to be missed, but where does that leave the photographer who has only a limited amount of time available? Throughout this book I outline the benefits of researching and monitoring locations, making return trips and sometimes spending several days waiting for the right moment. I can adopt this method because I am a full-time photographer. I had reservations about advocating an approach that might be impractical for many readers, but it would be misleading if I understated what is involved in achieving success. Luck plays a part, but in image-making there is an irrevocable connection between time and quality. We operate in an environment that is way beyond our control; all we can do is accept the working conditions and wait for those fleeting, favourable moments to materialize. But don't despair if your time is limited – all is not lost.

If time is at a premium, start by thoroughly researching locations in advance before making any trips. This can be done from home because there is a wealth of information available online. Consider only those locations that have real potential and schedule your trip for the best time of year – this is usually autumn and winter. During your visit, restrict your locations to just a small number to enable you to devote sufficient time to each one. Concentrate on just a few places until you feel you have seen and photographed them at their best. Over time, you should gradually build up a collection of high-quality images. The number of pictures might initially be fairly small, but success is measured by quality, not quantity. One outstanding photograph is worth any number of mediocre images.

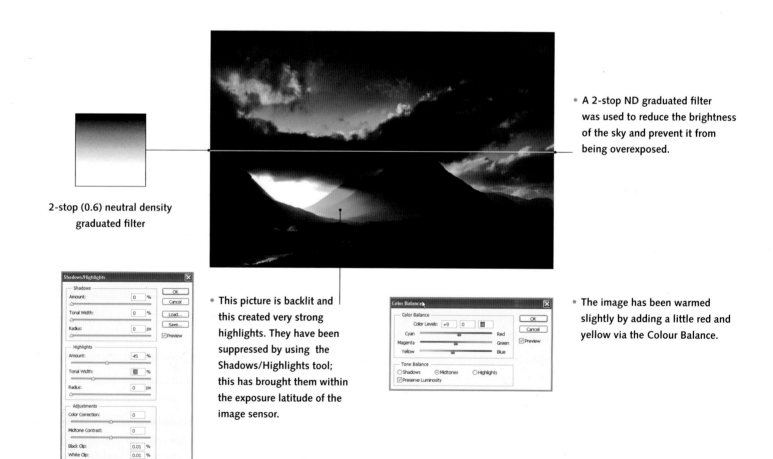

2-stop (0.6) neutral density
graduated filter

• A 2-stop ND graduated filter was used to reduce the brightness of the sky and prevent it from being overexposed.

• This picture is backlit and this created very strong highlights. They have been suppressed by using the Shadows/Highlights tool; this has brought them within the exposure latitude of the image sensor.

• The image has been warmed slightly by adding a little red and yellow via the Colour Balance.

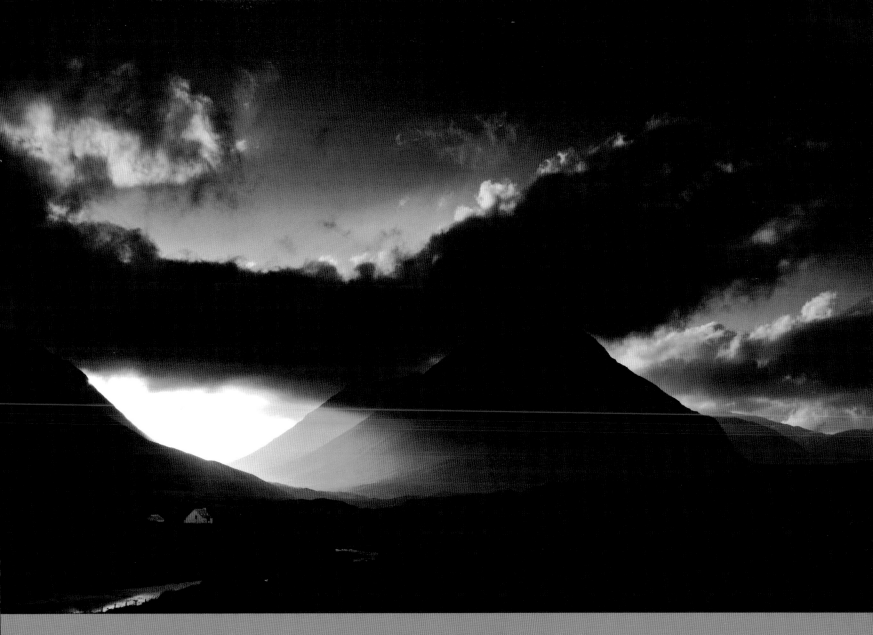

Glen Coe, the Highlands, Scotland

Camera: Mamiya 645AFD with Phase One digital back

Lens: Mamiya 35mm (wideangle)

Filter: 2-stop ND graduated

Exposure: 1/15 sec at f/18, ISO 100

Waiting for the light: 6 days

Post-processing: Reduction of highlights and colour balance adjustment

► HIGHLIGHTS AND SHADOWS

The dynamic range of a sensor refers to the extent of its ability to record detail in both highlights and shadows. High dynamic range enables high-contrast images to be captured with the full spectrum of tonal information retained in both the lightest and darkest parts of a scene. However, there are limits to this. Even though sensor technology is continually improving and a contrast ratio of up to 7 or 8 stops can now be recorded by good-quality cameras, the human eye can accommodate approximately 20 stops. To reproduce a scenic view exactly as you see it, you will often need to reduce contrast levels at the time of capture. This can often be achieved by using a graduated neutral density filter. Normally these filters are used for darkening the sky, but they can also be employed to absorb unwanted light in other parts of an image. They can be very effective, particularly as a typical scene can contain the equivalent of 8 or more stops of contrast.

The picture opposite is backlit, and although this suited the subject perfectly, the light has produced very bright highlights in the background trees. To prevent them from being overexposed, a 1½-stop filter was placed at an angle, as indicated, along the top portion of the image. This has reduced the contrast ratio and has enabled all parts of the image to be correctly exposed.

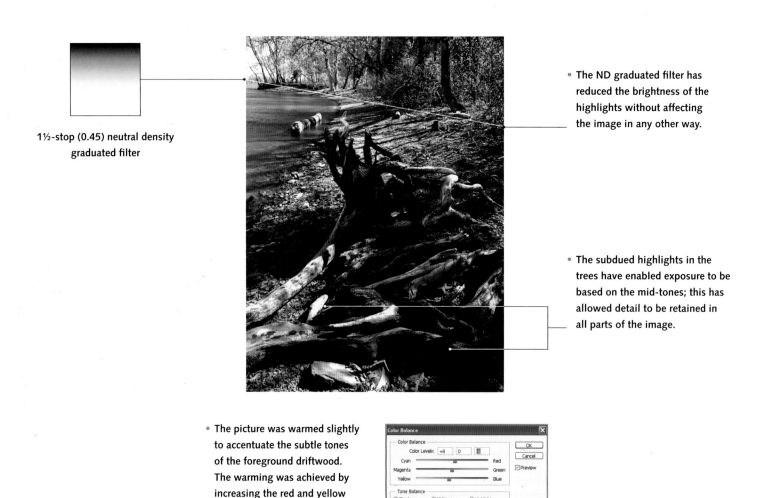

1½-stop (0.45) neutral density
graduated filter

- The ND graduated filter has reduced the brightness of the highlights without affecting the image in any other way.

- The subdued highlights in the trees have enabled exposure to be based on the mid-tones; this has allowed detail to be retained in all parts of the image.

- The picture was warmed slightly to accentuate the subtle tones of the foreground driftwood. The warming was achieved by increasing the red and yellow via the Colour Balance tool. This replicates the effect of an 81B filter.

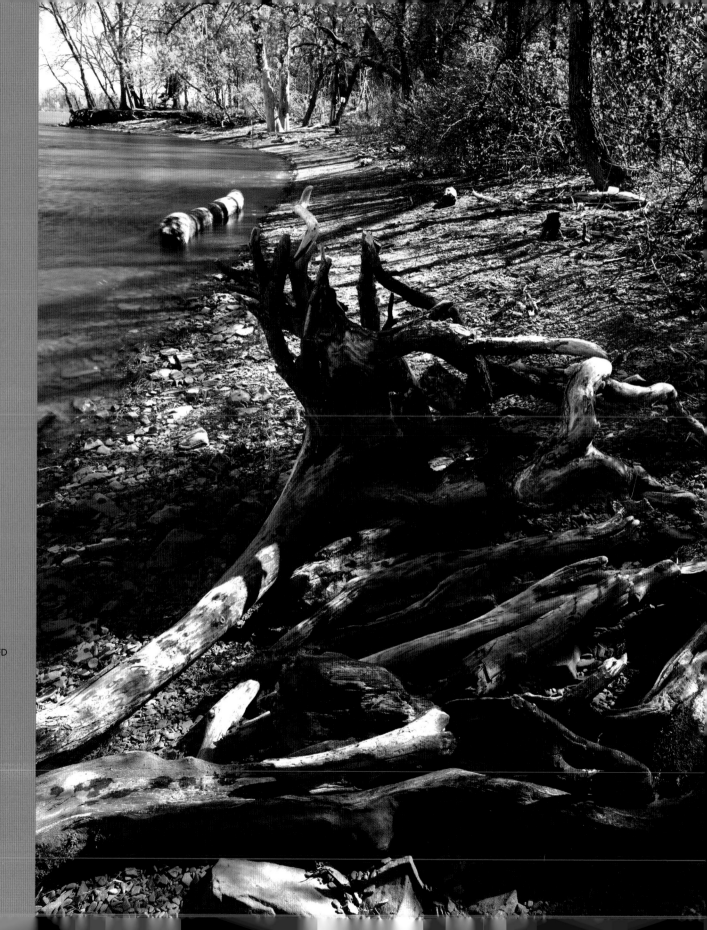

**The Hudson River,
New York State, USA**

Camera: Mamiya 645AFD
with ZD digital back
Lens: Mamiya 35mm
(wideangle)
Filter: 1½-stop
ND graduated
Exposure: 1 sec at f/22,
ISO 100
Waiting for the light:
30 minutes
Post-processing: Colour
balance adjustment

> HIGHLIGHTS AND SHADOWS HIGH LEVELS OF CONTRAST

The photograph opposite is backlit; while this can look captivating in a wooded location, it can also create high levels of contrast. Because of the nature of woodland, highlights and shadows are likely to be widely scattered and the use of an ND grad filter is therefore often impractical. Luckily, there are other options. One solution is to choose a viewpoint that avoids the extremes of contrast. Quite often this will be towards the middle of the woods, where there is a greater density of foliage. The penetrating sunlight will then be softer and the contrast quite likely to be within the dynamic range of your camera's sensor.

Another option is to wait for the light to be softened by passing cloud. In the picture opposite, the sunlight had been weakened by hazy cloud; the resulting lower contrast enabled the image to be taken without loss of detail in both the highlight and shadow areas.

At the time of capturing this photograph the sun was relatively high in the sky; the light source was therefore both above and behind the subject. In a large, open view this would have a flattening effect on the landscape, but this time it has improved the image. The random, scattered nature of the light has created alternating patches of light and shade that give shape and depth to the foreground rocks. The stream, too, has benefited from the overhead light. It has been transformed from a flowing stream into a glowing stream, and the warm reflections in the distance draw the eye into the picture. This also gives an impression of depth by creating a focal point beyond the foreground.

Polarizer (fully polarized)

> **TIP:** Use a polarizer to remove unwanted highlights. Here the filter has suppressed reflections on the wet rocks and has also improved the transparency of the water in the foreground, which helps to depict the colourful leaves.

• The warm glow attracts attention and draws the eye across the foreground towards the centre of the picture.

• No post-processing adjustments were necessary. The neutral colour balance has portrayed the subject accurately and therefore needed no warming; no Curves adjustments to contrast levels were required either.

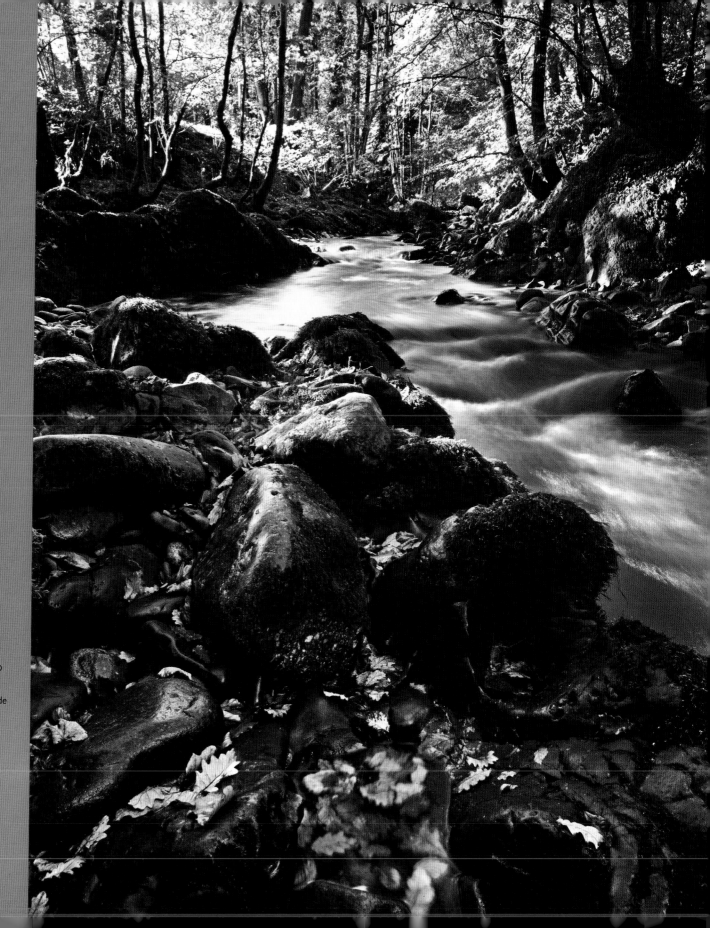

**Afon Sawdde,
the Brecon Beacons,
Wales**

Camera: Mamiya 645AFD
with ZD digital back
Lens: Mamiya 35mm (wide
angle)
Filter: Polarizer
Exposure: 1 sec at f/22,
ISO 100
Waiting for the light:
2 days
Post-processing: None

➤ HIGHLIGHTS AND SHADOWS SEIZING THE MOMENT

I would like to be able to say that this image was pre-planned and captured after much detailed research, many return visits and a great deal of sky-watching. However, the reality is that it fell into my lap.

My arrival at the lake was the culmination of a meandering exploratory excursion. I had no photograph or particular destination in mind that day but, emerging from a sharp bend in the road, I was greeted by this glorious sight. Screeching to a halt, I was out of the car with my camera unpacked in record time. This was one occasion when I was truly thankful for the technological advances that have been made in digital capture. With no time to set up my tripod, image stabilization came to my aid. The photograph was taken in seconds, which was just as well because the ethereal moment was gone in a flash. I managed to make four rapid exposures and also had time to fit an ND graduated filter.

You might assume that the post-processing of this image involved a fair degree of colour enhancement. In fact only a minimal amount was undertaken – similar to the effect of an 81B or C filter – but a combination of the ND grad filter and the Shadows & Highlight tool also helped to bring the colour out in the sky. It was accurate exposure and a reduction in highlights that developed the latent colour present in the early-morning sunlight and clouds. Often these delicate hues remain unseen, being lost through overexposure. By simply darkening the sky and then fine-tuning the highlights, backlit clouds can benefit enormously, without the need for additional colour enhancement.

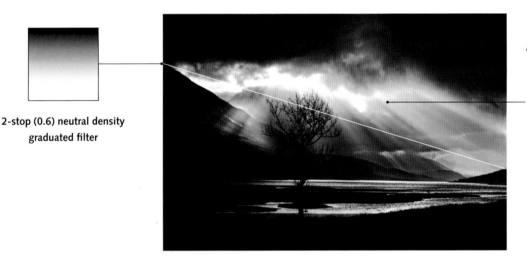

2-stop (0.6) neutral density graduated filter

- The graduated ND filter, together with the Shadows/Highlights tool, brings out the latent colour in the sky.

- Using the Colour Balance tool, red and yellow were increased slightly to replicate the effect of an 81B warm filter

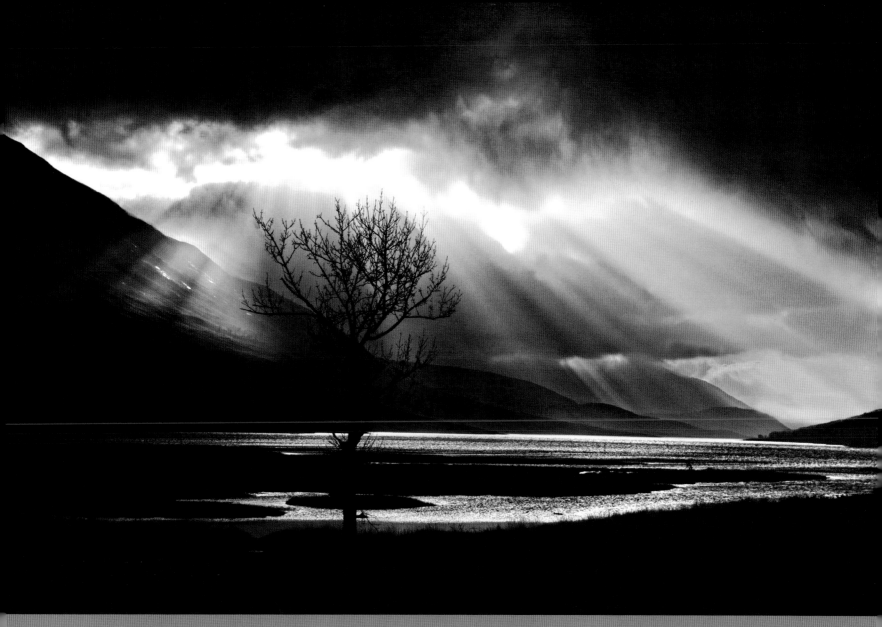

Loch Etive, the Highlands, Scotland

Camera: Canon EOS 7D

Lens: Sigma 17–70mm OS

Filter: 2-stop ND graduated

Exposure: 1/80 sec at f/13, ISO 100

Waiting for the light: Immediate

Post-processing: Colour balance and highlights adjustment

> THE ANGLE OF LIGHT

Finding a landscape that appears to have been designed for the benefit of the photographer can be thrilling. From front to back and from side to side, it might all look marvellous; but, however much it takes your breath away, without the right light and sky it is likely to be disappointing when seen as a photograph. In reality, a landscape is only as good as the light falling on it.

There is no substitute for quality light, so take your time, consider the movement of the sun through its arc and, if necessary, return another time. If you have your camera with you it can be tempting to take the image, but, despite the advances in post-processing, inferior light can rarely be improved beyond a basic level and a picture captured at the wrong time is likely to disappoint.

I first discovered this rocky coastline at Locquemeau eight days before I was finally able to photograph it. Those eight days were spent sky- and weather-watching, waiting for the right conditions. The weather along the north Brittany coast can be as fickle and unpredictable as Britain's and it was fortunate that I was able to wait so long. It took several days because there was only a brief period each day – no more than 30 or 40 minutes – when the sun was in the right position. This greatly reduced the chances of success, particularly as an attractive sky was also on my list of requirements. The risk of failure was high, but there was no alternative because the angle of light was the key ingredient in the making of this image. Thankfully, eight days later, the elements fell perfectly into place. Give the landscape sufficient time and it will, eventually, respond.

2-stop (0.6) neutral density graduated filter

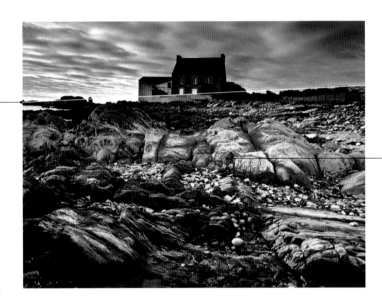

- The low, right-angled sunlight vividly portrays the rugged and colourful nature of the richly varied foreground. This was critical to the success of the picture.

- It was necessary to use an ND grad to reduce the brightness of the sky, but the filter has also affected the building. There was no alternative to using the filter and I felt that a slightly darkened building was an acceptable price to play.

- The picture was warmed slightly by increasing red and yellow via the Colour Balance tool.

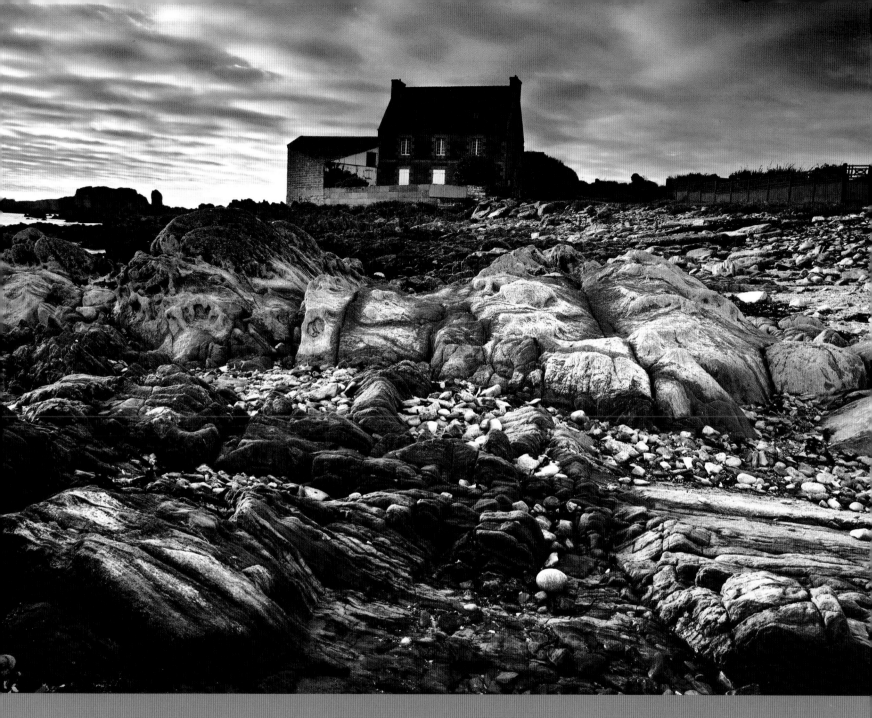

Locquemeau, Brittany, France

Camera: Mamiya 645AFD with Phase One digital back

Lens: Mamiya 35mm (wideangle)

Filter: 2-stop ND graduated

Exposure: 1 sec at f/22, ISO 100

Waiting for the light: 8 days

Post-processing: Colour balance adjustment

> THE ANGLE OF LIGHT ALL IN THE DETAIL

I was leading a small workshop when I captured the image opposite. We were visiting the ruins of Neath Abbey, a Cistercian monastery in South Wales. The remains of the abbey are extensive and offer the photographer many options. The weather was fine on the day we visited – if anything, it was a little too fine, because the sky was almost cloudless. As I am not a fan of clear blue skies, I looked for pictures on a scale that allowed the sky to be omitted.

When photographing ancient monuments I tend to avoid views of the entire structure, preferring to isolate interesting features, or perhaps a specific part of the building. Smaller-scale details offer scope for greater creativity; they are also an effective means of capturing a building's heritage and history.

A small section of the abbey's cloisters caught my eye – to be precise, it was the sun's rays filtering through the windows that attracted my attention. I knew immediately that this was the picture I was seeking.

The photograph virtually composed itself but, of course, it wasn't going to be that simple. The problem was the contrast. My spot meter indicated an exposure range of up to 9 stops, which was too wide for the latitude of the camera's image sensor. As the sky was almost cloudless, there seemed little prospect of the sunlight losing its intensity, particularly as there was only a limited amount of time before the sun would be in the wrong position. It was fortunate, then, that a patch of hazy cloud developed. Although barely noticeable, it was sufficient to soften the light slightly; this, together with post-processing adjustments using the Shadows/Highlights tool, enabled the photograph to be reproduced without loss of detail.

I like this image: of all the many pictures I have taken, this one, perhaps more than any other, captures a unique moment in time. The abbey, and possibly the cloisters too, date back to the twelfth century; other than its method of capture, there is nothing in this photograph that dates it any later.

• **Highlights were suppressed in post-processing using the Shadows/Highlights tool.**

> **TIP:** When photographing buildings, ensure that your camera is both vertically and horizontally parallel with the structure's walls. Avoid pointing the camera at an oblique angle, as even a small deviation will create converging, or diverging, parallels that make the building look distorted.

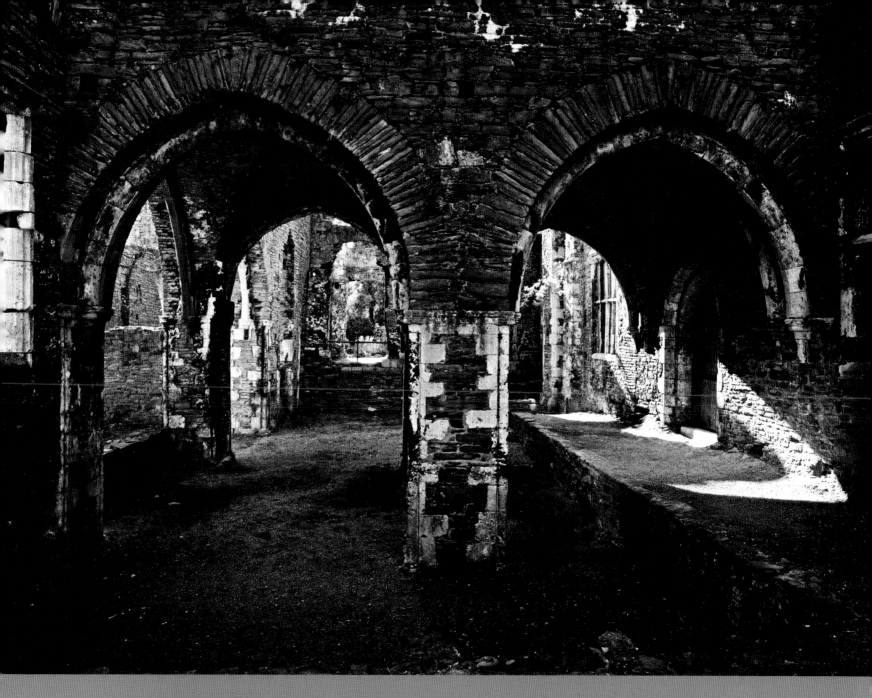

Neath Abbey, West Glamorgan, Wales

Camera: Mamiya 645AFD with Phase One digital back
Lens: Mamiya 35mm (wideangle)
Filter: None
Exposure: 1/2 sec at f/20, ISO 100
Waiting for the light: 20 minutes
Post-processing: Suppression of highlights

THE TIME OF DAY/YEAR

There is a time of day known to photographers as 'the golden hour'; this refers to either the first or the last hour of daylight. These hours are so revered because it is at the point of transition between darkness and light that the sky can truly excel. The heavenly display can be breathtaking and, when faced with such magnificence, the landscape below may struggle to compete. The sky becomes the dominant element; on such occasions it should be given centre stage, although the land beneath still has an important role to play. The landscape acts as the foundation, the solid base upon which the rest of the picture is built. This enables the sky to be seen in the context of a location that the observer can relate to – on its own, no matter how beautiful, a sky rarely makes a lasting impression with a viewer – therefore the composition and choice of viewpoint should be carefully considered.

To make a complete, cohesive image there should be a connection between sky and landscape; an effective way of achieving this is to include a focal point close to where the sky and land meet. Silhouetted trees, for example, are useful for this, particularly if they are leafless. Even a single tree, or a small group, will act as a visual magnet; they attract attention and become the cornerstone on which the entire image rests. In the picture opposite, the sky and land are linked together by a tiny group of trees, which helps the photograph to vividly portray the beauty of dawn in a remote corner of the Yorkshire Dales. Aren't trees wonderful?

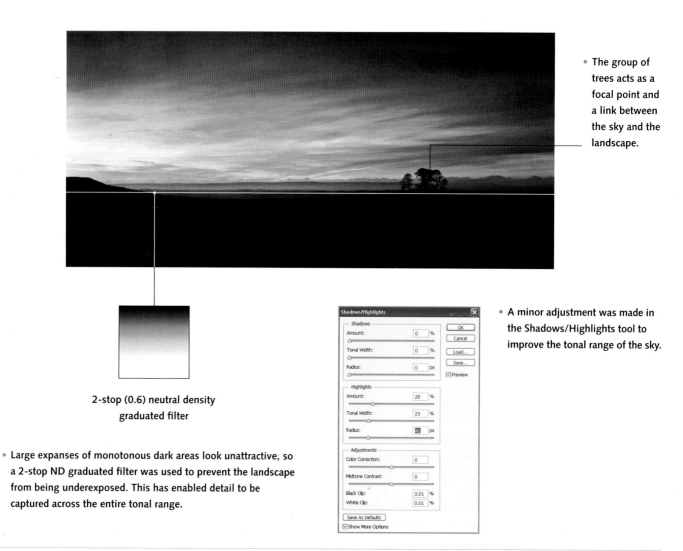

• The group of trees acts as a focal point and a link between the sky and the landscape.

2-stop (0.6) neutral density graduated filter

• Large expanses of monotonous dark areas look unattractive, so a 2-stop ND graduated filter was used to prevent the landscape from being underexposed. This has enabled detail to be captured across the entire tonal range.

• A minor adjustment was made in the Shadows/Highlights tool to improve the tonal range of the sky.

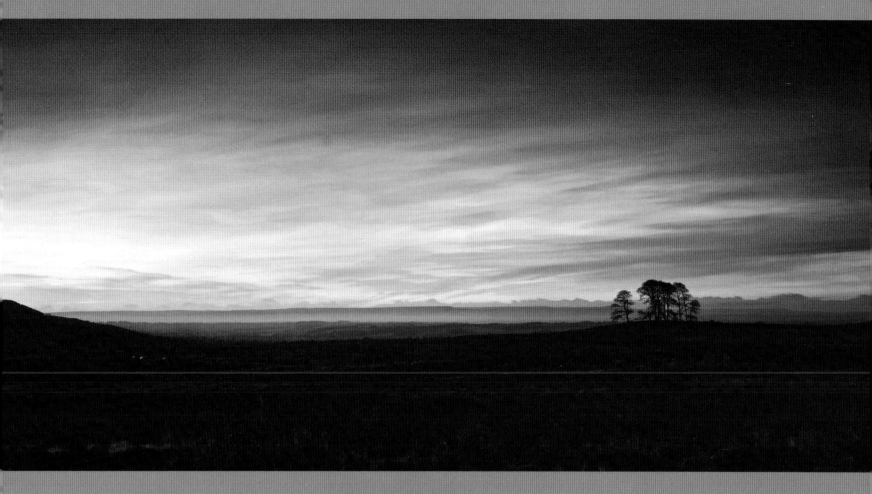

Near Reeth, the Yorkshire Dales, England

Camera: Mamiya 645AFD with Phase One digital back
Lens: Mamiya 80mm (standard)
Filters: polarizer, 2-stop ND graduated
Exposure: 1 sec at f/18, ISO 100
Waiting for the light: 30 minutes
Post-processing: Suppression of highlights

> THE TIME OF DAY/YEAR THE CONSTANTLY CHANGING LIGHT

If you visit a location in the morning, then return several hours later, it may look completely different. Nothing will have changed or moved except, of course, the sun. The constantly changing light has a fundamental effect on the appearance of a landscape, and an image has to be lit correctly to succeed. The time of day matters because there is always a right and a wrong time to make a photograph. Despite this, important as it is, the timing of capture is often not fully considered.

I often see photographers arrive at a location, brimming with enthusiasm, set up their equipment, make several exposures, then immediately depart, no doubt rushing off to grab yet more images to add to their portfolio. I always resist the temptation to call them back and explain to them that it is not yet the right time; I want to

suggest that they return later, when the angle of light will be much better. But it's not my place to intervene, so I remain silent. Hopefully they will learn from experience.

Low sidelighting was the only light that suited the lunar-like surface of the quite remarkable Mewslade Bay. Those intricate, weathered rock formations simply had to be lit in a specific way. To have photographed them in the wrong light would have been a dreadful waste. There was one light and one light only that did them justice. This gave a window of not much more than 30 minutes in which to capture them. As is often the case, timing was of paramount importance in the making of this image.

1-stop (0.3) neutral density
graduated filter

Polarizer (fully polarized)

- A combination of a 1-stop ND grad filter and a polarizer has balanced the light values of the sky and landscape. This has enabled both to be captured without loss of detail.

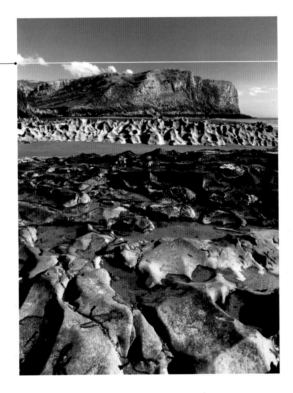

> **TIP:** When photographing at the coast, check the times of high and low tide before setting out. This can save many wasted journeys. This image was taken at low tide – the only time when the rocks are completely exposed.

- To strengthen the colour of the rocks, the photograph was warmed by adding a small amount of red and yellow via the Colour Balance tool.

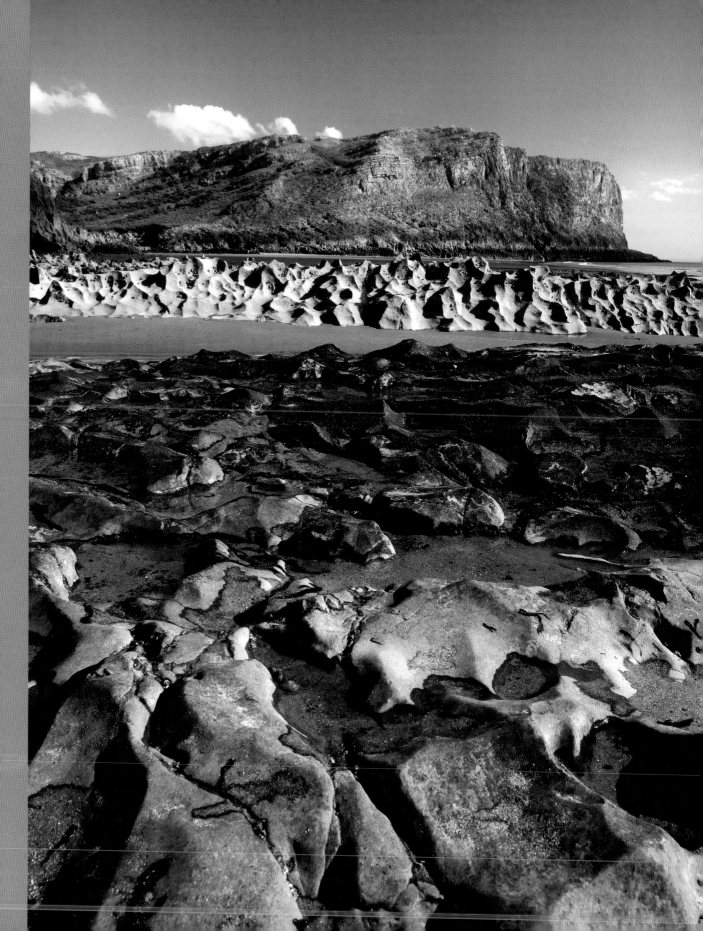

**Mewslade Bay,
the Gower Peninsula,
Wales**

Camera: Mamiya 645AFD
with ZD digital back
Lens: Mamiya 35mm
(wideangle)
Filters: Polarizer, 1-stop
ND graduated
Exposure: 1/4 sec at f/22,
ISO 100
Waiting for the light:
3 days
Post-processing: Colour
balance adjustment

> THE TIME OF DAY/YEAR SEASONAL CHANGES

It is not only the time of day that matters: the time of year is also important. Apart from seasonal changes in the appearance of the landscape, variation in the height and width of the sun's arc means that the light is also continually changing. There are many scenic views that can only be photographed during the summer months; at other times of year, when the arc is smaller, there may never be light shining where you want it. This happens frequently in mountainous areas, where surrounding peaks can cast long shadows over the landscape, so it pays to research such locations in advance to avoid wasted journeys.

When I captured this view of the remote church at Llanfaglan, I was there at the right time of day – sunset – but I was about two months too early, in February; April or May would have been preferable. The scene is almost frontally lit, as a result of the sun's arc being too small at the time the image was made. The picture would have benefited from being lit from the side, and this would only occur on longer days. It was frustrating, but I'm still rather fond of the image despite there being room for improvement. I have it in mind to return one day; it would, if nothing else, be interesting to see the location in a different light.

2-stop (0.6) neutral density
graduated filter

- The image would have been improved by being lit by more obliquely angled sunlight. This would have given more shape and depth to the upper portion of the landscape.

- A 2-stop ND graduated filter was positioned across the sky to darken it and prevent it from being overexposed.

> **TIP:** To be in the right place at the right time, research locations in advance and determine the lighting conditions at different times of year.

- The image has been warmed by adding a small amount of red and yellow via the Colour Balance tool.

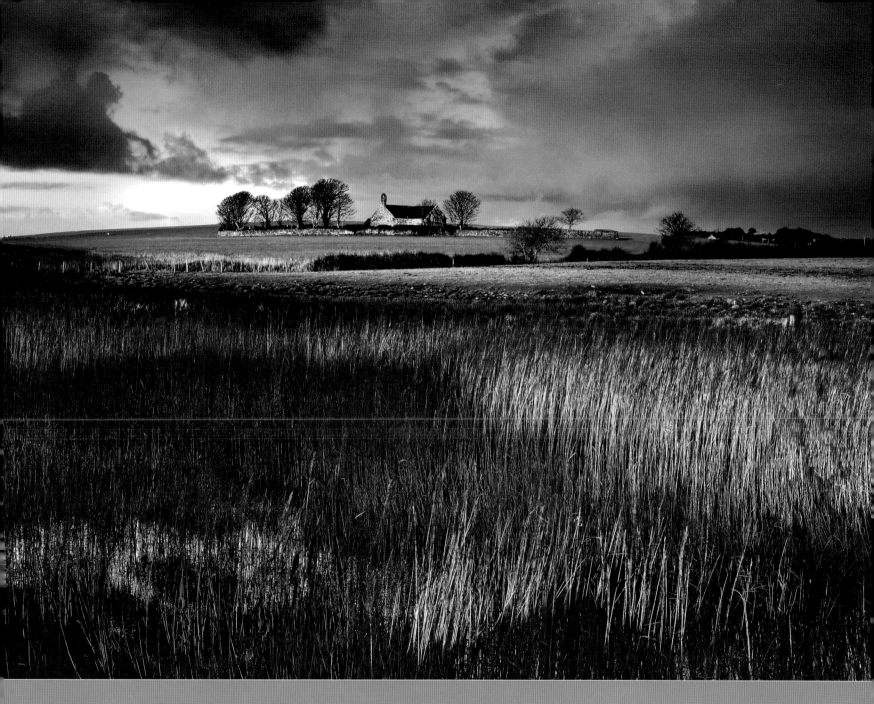

Llanfaglan, Caernarvonshire, Wales

Camera: Mamiya 645AFD with ZD digital back

Lens: Mamiya 35mm (wideangle)

Filter: 2-stop ND graduated

Exposure: 1 sec at f/22, ISO 100

Waiting for the light: 50 minutes

Post-processing: Colour balance adjustment

> THE TIME OF DAY/YEAR TIMING IS EVERYTHING

Abbey Cwm Hir is a remote village hidden in the Cambrian Mountains in the heart of rural Wales. This elevated view of the valley surrounding the village was captured when the deciduous landscape was a spectacle of glorious colour. It was, of course, autumn at the time; looking at this picture, it is difficult to imagine it being photographed at any other time of year. As a subject, this expansive valley is undoubtedly at its peak in autumn. I have visited it several times in different seasons and, attractive as it always is, there is only a two- or three-week period when it looks its absolute best. Here, the time of year makes a big difference and, in this respect, this landscape is by no means unique.

Often the time of year or time of day matters more than the actual location. Timing is absolutely everything, the 'when' being so much more important than the 'what'. Every landscape has its moment, and successful image-making depends on capturing the fleeting display at its peak. It might be just a split second or a particular time of year; or, to the exasperation of many photographers, it could be a challenging combination of both. However brief the opportunity, it shouldn't be missed, and with careful research and planning the chances of success will be greatly increased. The importance of precision timing doesn't make it any easier, but that makes it all the more satisfying when the elusive moment suddenly eludes you no longer, and the photograph you have been doggedly pursuing is finally captured.

- The protruding tree branches are an irritation. They make no contribution to the picture and should have been excluded, but there was only one possible viewpoint and regrettably they had to remain.

2-stop (0.6) neutral density graduated filter

Polarizer (fully polarized)

- The polarizer has reduced reflections on the wet foliage, which strengthens its colour.

> **TIP:** Use large-scale maps to look for elevated viewpoints. This photograph was taken along a remote footpath that was off the beaten track and hidden from the road. I found it only by carefully studying my Landranger map, with a scale of 1:50,000.

- No post-processing adjustments were undertaken.

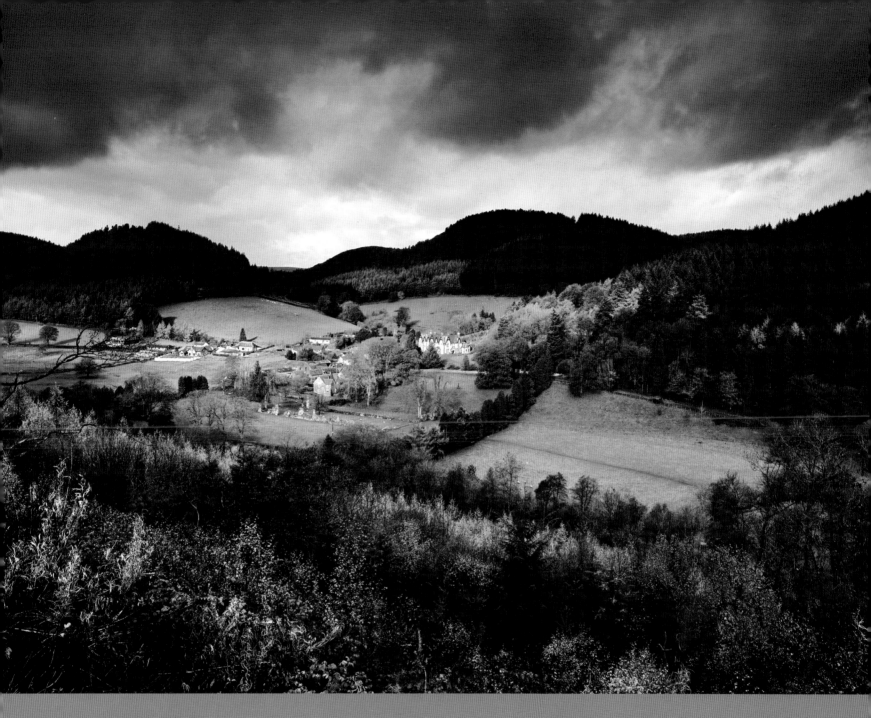

Abbey Cwm Hir, Powys, Wales

Camera: Mamiya 645AFD with Phase One digital back

Lens: Mamiya 35mm (wideangle)

Filters: Polarizer, 2-stop ND graduated

Exposure: 1/4 sec at f/20, ISO 100

Waiting for the light: 3 days

Post-processing: None

▷ THE TIME OF DAY/YEAR HEAD FOR THE HILLS

I have always thought that the region of England known as the Lake District is misleadingly named – there is much more to it than its watery expanses. This is a landscape to savour and an inspirational photographer's paradise. To my mind, the jewel in the crown of this paradise is the majestic Langdale Valley – and winter is the season when it excels itself. This is the time of year when its sweeping fells and rugged mountains are brought into dramatic perspective as soft sunlight casts long shadows over a richly contoured terrain.

To gain a comprehensive view of the extensive valley, an elevated position is needed, so a steep and strenuous, but thankfully fairly short, ascent is required. There is no shortage of viewpoints. Each offers a slightly different, but equally spectacular, perspective of the mountainous terrain; here it is undoubtedly 'when' rather than 'where' that matters. If you are there at the right time, in the right conditions, you could place your tripod virtually anywhere and you would still capture the magnificence of this heavenly landscape. Choose the right time of year – quality time when the light is favourable – and that quality will transfer to your images.

- Due to the position of the sun there was deep shadow on the face of the mountain that looked unsightly and lacked detail. It was therefore lightened in post-processing using the Shadows/Highlights tool. To ensure that only the mountain face was adjusted, it was first selected by using the Lasso tool.

- Lasso (feathered edge 100 pixels)

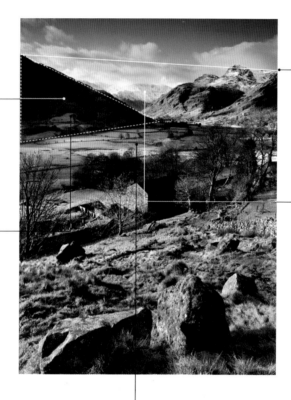

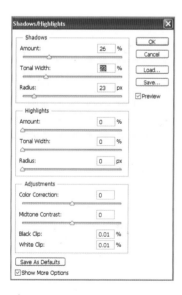

2-stop (0.6) neutral density graduated filter

- The sky is less than perfect because a layer of cloud has obscured the mountain peaks. Ideally, a snow-capped mountain should be photographed against a deep blue background. Any cloud present should be above the peaks, not enveloping them.

- The elevated position provides an uninterrupted view of the entire valley.

> **TIP:** Climb high to improve a view. A location can look completely different from an elevated position, so if possible assess a view from a high vantage point before dismissing it.

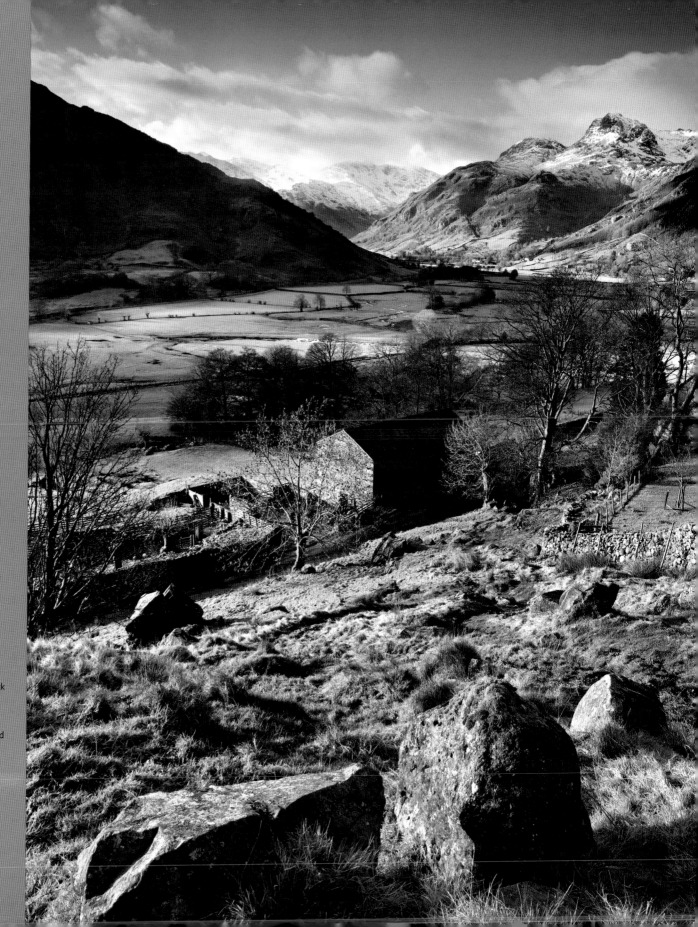

**Langdale Valley,
the Lake District,
England**

Camera: Mamiya 645AFD
with Phase One digital back
Lens: Mamiya 35mm
(wideangle)
Filter: 2-stop ND graduated
Exposure: 1/6 sec at f/22,
ISO 100
Waiting for the light:
4 days
Post-processing: Selective
shadows adjustment

> THE TIME OF DAY/YEAR RIGHT TIME, RIGHT PLACE

I once heard a story of a photographer who had travelled several thousand miles to Britain to capture the spectacle of England's renowned autumn colours. England does have its fair share of deciduous trees, and I hope our visitor wasn't disappointed with what he saw. I fear, however, that it didn't live up to his expectations. To anyone not familiar with the English language, the importance of small, apparently superfluous, words can sometimes be lost in translation. The word 'New', for example, when placed before 'England' carries a hidden significance way beyond that suggested by its diminutive size and everyday meaning. When another word – autumn, or fall – is also added, then that significance reaches another level, particularly if you're a landscape photographer. I think the geographical implications of 'New' before 'England' quickly became apparent to our unfortunate overseas visitor – he had, of course, been intending to experience the colourful delights in the area close to Boston, Massachusetts, not Boston, Lincolnshire. Britain's Boston is, of course, a delightful town, if not the internationally acclaimed centre of autumnal magnificence.

I was reminded of this story on a glorious autumn day when I was ensconced in the heart of a similar paradise. Nantahala National Forest in late October is a sight to behold. I could have been standing in the middle of a giant kaleidoscope; colour was everywhere and there was no escape from it. It was going to dominate my photographs, of that there was no doubt. Image-making opportunities were abundant, but a shortage of cloud reduced the number of options. Clear blue skies hold little appeal for me, and it was fortunate that I was able to compose a picture that had some cloud present. There wasn't a great deal, but it was sufficient to maintain interest in the upper portion of the photograph and fill the gap created by the sloping mountain.

This image, although taken in North Carolina, reminds me of the colourful beauty and character of New England. The other, much older, England has different but equally impressive qualities. I do hope our misplaced photographer found them.

- **The cloud fills a void space and helps to minimize the unbalancing effect of the sloping mountain.**

2-stop (0.6) neutral density graduated filter

- **The small group of buildings acts as a focal point and helps to give the picture scale.**

- **The picture was warmed by adding a small amount of red and yellow via the Colour Balance tool.**

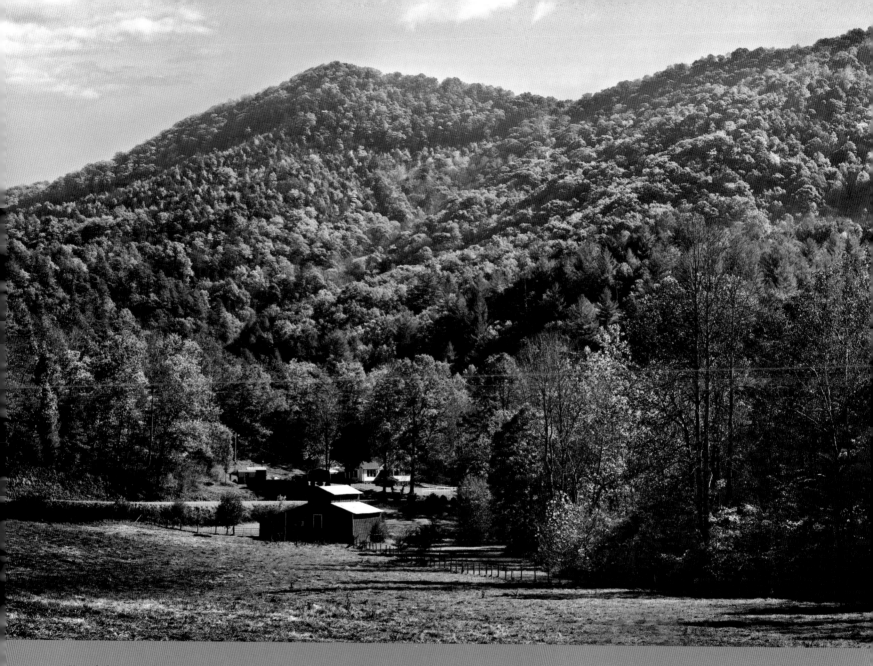

Nantahala National Forest, North Carolina, USA

Camera: Mamiya 645AFD with ZD digital back
Lens: Mamiya 80mm (standard)
Filter: 2-stop ND graduated filter
Exposure: 1/10 sec at f/16, ISO 100
Waiting for the light: 2 hours
Post-processing: Colour balance adjustment

THE USE OF COLOUR

There is a time in spring when, briefly, a hint of autumn can be seen in a wooded landscape. This happens as certain deciduous trees begin to leaf out. It is in the early stages and lasts only a few days, but it provides a distinctive splash of colour to an awakening forest. I was tempted to warm this image slightly, but decided against it. It is the delicate, subtle hues that are the theme of the background and nothing would be gained from tinkering with the colour. As it is, the tree-filled backdrop is the ideal foil for the bright blue shed that is the main focal point.

It was the tiny building – its diminutive size emphasized by the towering trees and forest behind it – that initially caught my attention. The disparity in scale has been further accentuated by the position of the shed. Placing it low in the picture enables the building to be viewed in the context of its environment, and this strengthens the composition. A closer viewpoint would have diminished the photograph because size and scale would not have been adequately portrayed.

Despite its modest proportions, the shed still draws the eye and this is largely the effect of colour. Even a tiny object, if brightly coloured, will attract attention. Beware, therefore, because a vivid splash of a distinctive hue in the wrong place will upset the balance of an image. Colour is powerful; it acts as a strong visual magnet and should always be used with care.

Polarizer (fully polarized)

- The polarizing filter has improved saturation and contrast. I prefer to use a polarizer rather than attempt to recreate the effect in post-processing, as this is rarely successful.

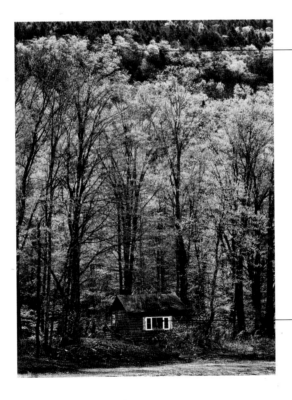

- Omitting the sky tends to strengthen this type of picture. Including it would bring no benefit and would merely be a distraction.

- Placing the shed in a low position depicts its modest size in relation to its environment.

- No post-processing adjustments were undertaken.

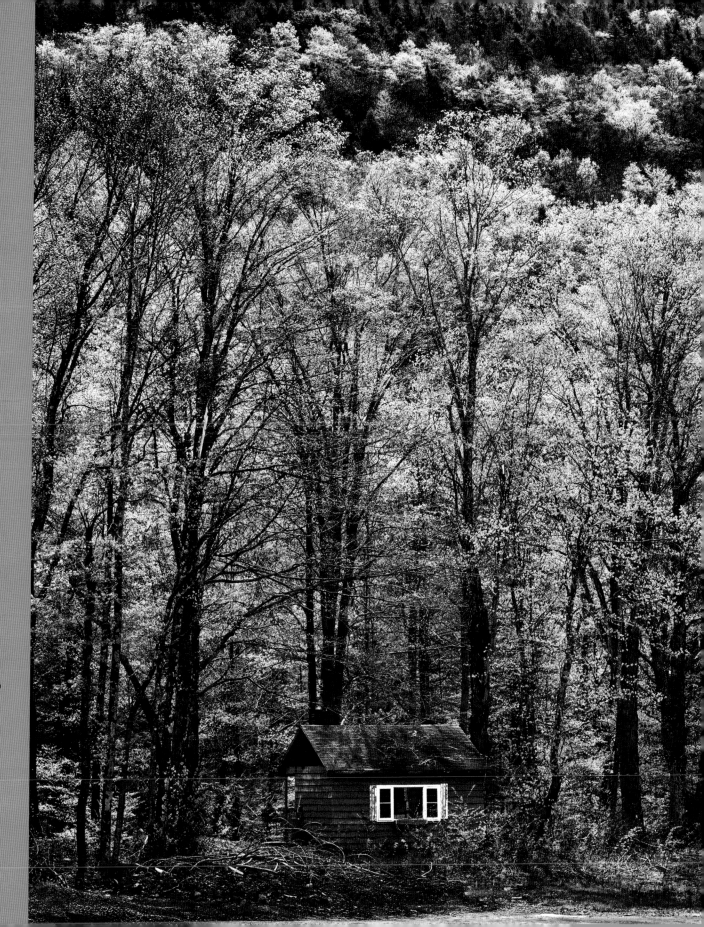

**Lanesville,
New York State, USA**

Camera: Mamiya 645AFD
with ZD digital back
Lens: Mamiya 150mm
(short telephoto)
Filter: Polarizer
Exposure: 1/4 sec at f/16,
ISO 100
Waiting for the light:
Immediate
Post-processing: None

> THE USE OF COLOUR LIGHT AND TEXTURE

As a landscape photographer you can expect to spend much of your day sky-watching, looking for breaks in the cloud that will throw sunlight on your subject to highlight focal points. Often it is the interplay of light and shadow that determines the success of your picture, but there can also be other requirements. Light is endlessly variable, and the right type must be used to make distinctive images. Highlights and shadows are not always desirable; sometimes soft, shadowless light is more appropriate.

A colourful, texture-rich scene is likely to benefit from low contrast, as a strongly variegated subject will already have a wide tonal range that will not be improved by the presence of other bright, or dark, areas.

Adding splashes of sunlight to it would be unnecessary and could interfere with the subtle tones you are trying to capture. A cloudy, overcast sky is therefore sometimes to be welcomed.

When colour and texture is the theme of an image, the sky can often be excluded, but when it is present it should, if possible, share the qualities of the landscape beneath it. A textured or mottled cloud structure, rather than a bland, featureless expanse, is therefore preferable. The key to success is to combine the appropriate light and sky with the right type of subject. Make this a habit and it will show in your photography.

1½-stop (0.45) neutral density graduated filter

Polarizer (fully polarized)

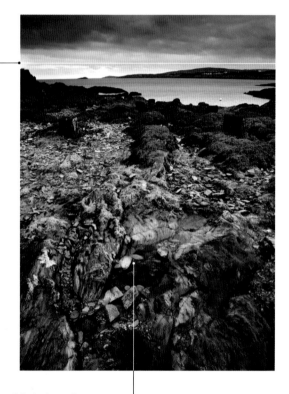

- **The tonal quality of the sky has been improved by the use of an ND graduated filter. A lighter sky would have been undesirable because it would have looked pale and insipid.**

- **The soft light from the overcast sky has enabled the richly coloured surface of the rock-covered coast to be depicted.**

> **TIP:** If coastal subjects are wet, their appearance can often be improved by using a polarizer. This reduces highlights on shiny, reflective surfaces.

- **No post-processing adjustments were undertaken.**

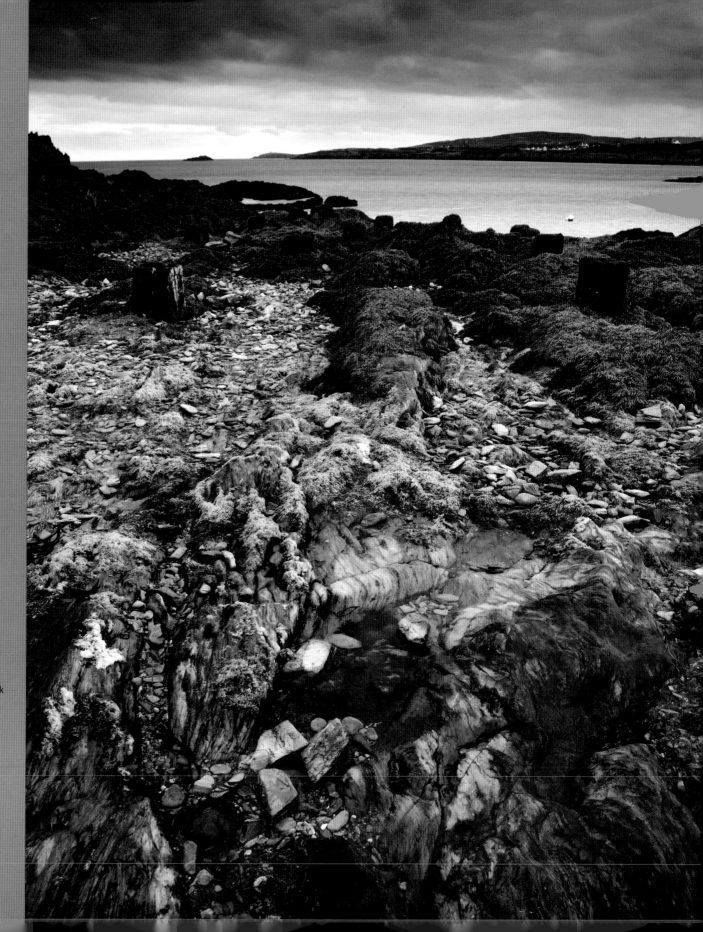

**Bull Bay,
Anglesey, Wales**

Camera: Mamiya 645AFD
with Phase One digital back
Lens: Mamiya 35mm
(wide angle)
Filters: Polarizer, 1½-stop
ND graduated
Exposure: 1 sec at f/22,
ISO 100
Waiting for the light:
Immediate
Post-processing: None

No, that isn't a real flower on the opposite page; it is just a photograph, a flat reproduction of a three-dimensional object. It has so much depth, though, that it almost leaps off the page to tempt you to pick it up and breathe in its delicate fragrance. This illusion is the result of two factors: the limited depth of field and the colour combination.

If we first look at the depth of field, you can see that it is very small. There is so little of it that only the single poppy in the foreground is in sharp focus. This is due to using a combination of a relatively large aperture and a long focal-length lens. This has restricted the depth of field to between 1 and 2ft (0.3–0.6m); by focusing on the foreground, the resulting loss of sharpness in the background flowers creates a stark contrast between the two zones and this emphasizes depth.

The second factor is the presence of both warm and cool colours. Warm tones – those at the red/orange end of the spectrum – appear to advance and be close to the camera, while the cooler colours – the blues and greens – appear to recede into the distance. An isolated red flower, if photographed against an out-of-focus blue or green background, will appear to have depth and look real and tangible.

You can also see the effect of colour by the appearance of the background flowers. The red poppies seem to be closer than the blue cornflowers, even though they are more distant. The distance involved, incidentally, was much greater than is apparent in the photograph. This is due to the long focal length of the lens. Telephoto lenses compress distance and have a noticeable flattening effect on any scene that has depth.

- Although there is three-dimensional depth in the image, paradoxically, it also looks flat. This is due to the long focal length of the lens, which greatly compresses distance.

> **TIP:** Warm colours, particularly red, give the impression of being close to the observer, while cooler tones appear to be more distant. These characteristics of colour can be used to create depth in an image.

- The light was a little harsh at the time of taking the photograph; contrast was therefore reduced slightly by making an inverted S in the Curves tool.

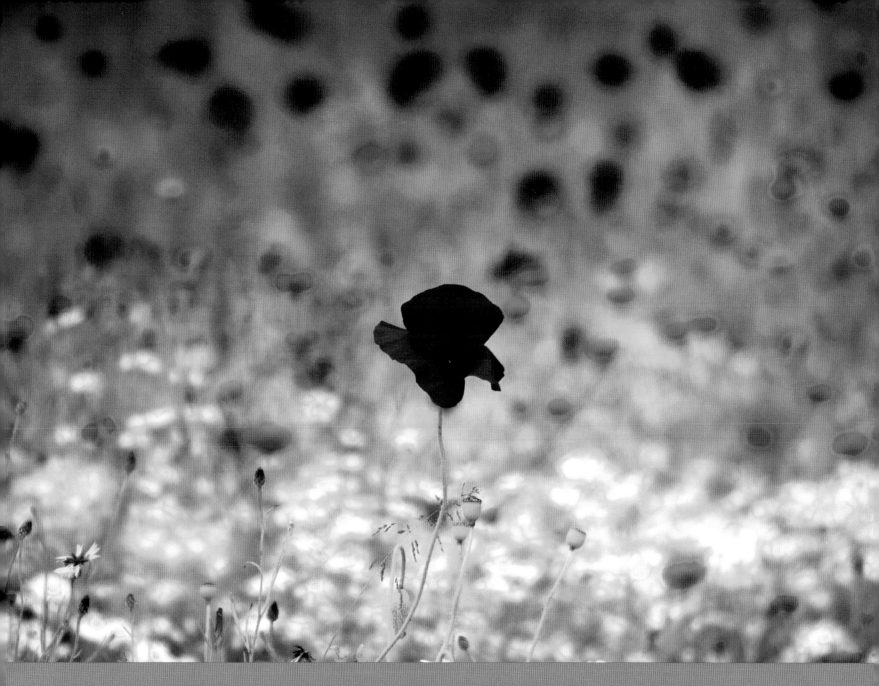

Near Souillac, the Dordogne, France

Camera: Mamiya 645AFD with ZD digital back

Lens: Mamiya 300mm (telephoto)

Filter: None

Exposure: 1/250 sec at f/5.6, ISO 100

Waiting for the light: Immediate

Post-processing: Curves adjustment

THE PRESENCE OF MIST

Mist and fog bring a new dimension to a photograph. For mood and atmosphere, and perhaps a little drama, there is nothing better than sunlight filtering through a mist-enshrouded landscape. Catch it at the right time and the chances are you will have a very fine image – but what, precisely, is the right time?

For this type of picture to succeed, a fine balance between landscape and mist is required. Too much landscape will diminish the moody atmosphere; too little will leave you wondering what you're looking at, as you search for signs of life beneath a thick cloud of monotonous grey fog. Success is, of course, all about timing.

As the sunlight penetrates the murky atmosphere the temperature will rise and gradually the mist will dissipate. It can be fascinating watching this process as, almost imperceptibly, the landscape emerges from its grey blanket. Small details and features slowly begin to appear and give the eye something to latch onto. This is the time when the photograph can be composed and, when there seems to be the right combination of land and mist, the exposure made.

There is no foolproof recipe for success; it depends on intuition as much as anything. If it looks and feels right then it probably is. The most important thing is to arrive early so you don't miss the best moment. If anything, I was a little late taking this image of Pitlochry; slightly more mist would have been preferable. Timing is everything…

2-stop (0.6) neutral density graduated filter

- The image would have benefited from a greater density of mist. Here it is almost nonexistent, which is to the picture's detriment.

- The presence of the small, sunlit tree is a small but important detail. It acts as a focal point and introduces a sense of scale and distance to the picture.

- The presence of mist and fog will reduce contrast. Sometimes this can improve a picture, but on this occasion I boosted the contrast slightly by making a minor adjustment via the Curves tool.

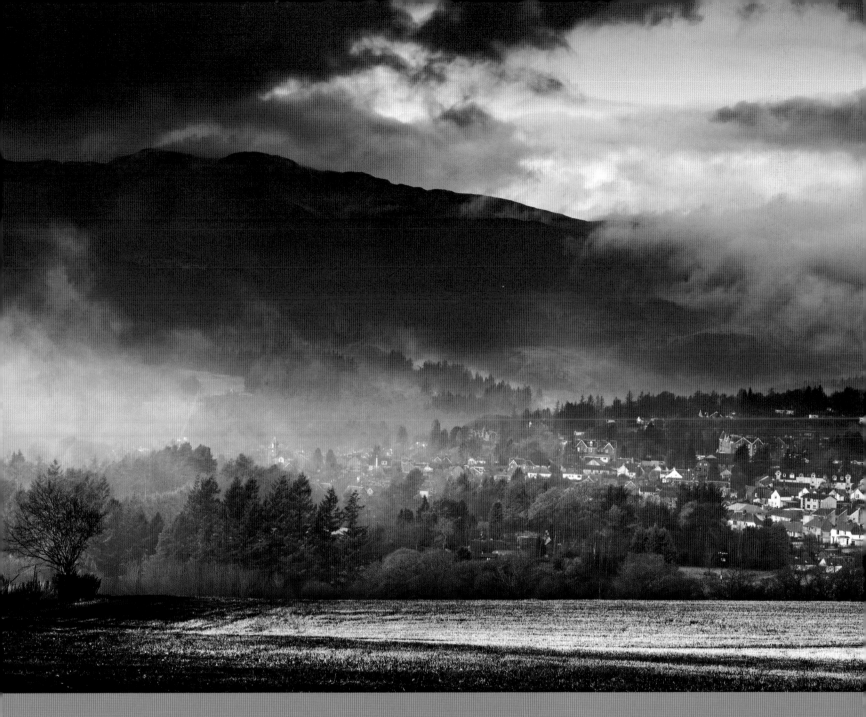

Pitlochry, Perthshire, Scotland

Camera: Mamiya 645AFD with ZD digital back

Lens: Mamiya 150mm (telephoto)

Filter: 2-stop ND graduated

Exposure: 1/5 sec at f/22, ISO 100

Waiting for the light: Immediate

Post-processing: Curves adjustment

THE PRESENCE OF MIST THE BALANCE OF ELEMENTS

Water and mist can be a potent combination, particularly if you add in a little early-morning sunlight, a strong foreground, a pleasant sky and – one of landscape's most prized commodities – reflections on an absolutely still lake. When all these elements coincide, the presence of mist might be restricted to a supporting role. It need no longer be the main theme and could be just an added bonus to an already fine image.

With so many factors to consider, the photographer's judgement becomes crucially important; it is the balance of the elements, and how they are knitted together, that determines the outcome of the image. Ideally a slow, considered approach should be taken, but that isn't always possible. Perfect conditions are often short-lived, particularly where mist and reflections are concerned, and minutes – or even seconds – can sometimes make all the difference. As you contemplate the scene in front of you it can suddenly evaporate, so lightning-quick reactions might be called for.

When composition and viewpoint have to be chosen in an instant it has to be an intuitive decision. With experience your instincts will tell you what is right. Make the most of the individual elements and allow them all to make a contribution in a balanced way, with no specific feature being too dominant. Sadly, the picture opposite doesn't illustrate this. I was transfixed by the foreground; I allowed it to dominate the photograph and this was a mistake. The sunlit shoreline, its reflection and the mist hovering above have only a minimal presence. With hindsight I should have used a longer focal-length lens to bring the distant hillside closer, but at the time the foreground looked compelling and I succumbed to its charm. It was an error of judgement; a strong, eye-catching foreground is often the cornerstone of a distinctive image, but sometimes you can have too much of a good thing. This was one of those occasions.

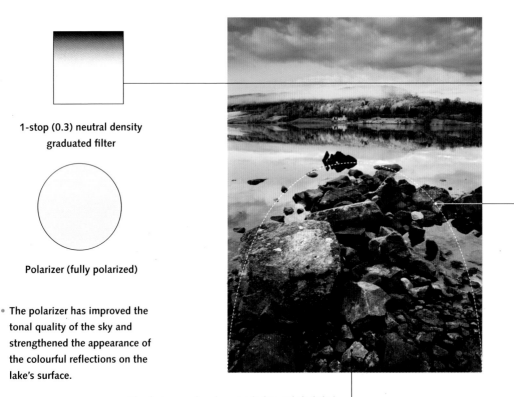

1-stop (0.3) neutral density graduated filter

Polarizer (fully polarized)

- **The polarizer has improved the tonal quality of the sky and strengthened the appearance of the colourful reflections on the lake's surface.**

- **Lasso (feathered edge 100 pixels).**

- **The foreground rocks were lightened slightly by adjusting the tonal curve in the Curves tool. To prevent other parts of the picture being affected they were selected by using the Lasso tool.**

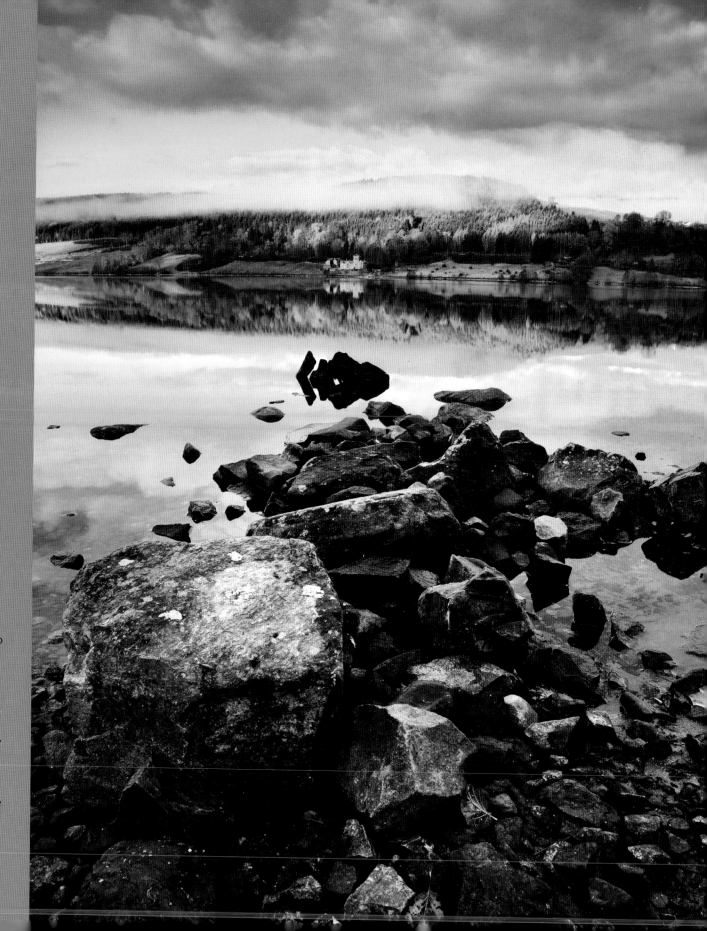

**Loch Tummel,
Perthshire, Scotland**

Camera: Mamiya 645AFD
with ZD digital back
Lens: Mamiya 35mm
(wideangle)
Filters: Polarizer, 1-stop
ND graduated
Exposure: 1/2 sec at f/22,
ISO 100
Waiting for the light:
Immediate
Post-processing: Selective
curves adjustment

Chapter Four ▶ COMPOSITION AND DESIGN

Kettlewell, the Yorkshire Dales, England

The landscape was not designed with the photographer in mind. Despite its intrinsic beauty, it is often chaotic. If it is to become a piece of art, the landscape has to be arranged and packaged. This is the creative aspect of image-making, and with the right composition even the most mundane subject can be transformed into a visual masterpiece. Composing a photograph is largely instinctive; successful composition comes with practice and experience. Although rules can't be rigidly imposed, the guidelines that do exist are discussed here.

CREATING DEPTH

Open views are one of the most difficult subjects to photograph successfully. Sadly, there is often a world of difference between what we see at the time of capture and what we ultimately look at on the computer screen. The most common reaction is: this isn't what I was expecting. The picture looks flat, what happened to the depth? Why is there no impact? Everything looks so small. What did I do wrong?

To successfully transfer an expansive, sweeping view onto a flat piece of paper or screen isn't as simple as it might appear. As you stand, camera mounted on tripod, gazing across a sprawling vista, it can all look magnificent. It is a memorable sensory experience – but it's a multi-sensory experience. The wind in your hair, the sunshine, the fresh, invigorating air and the feeling of satisfaction of being in a wonderful place all contribute to the occasion, but unfortunately these impressions cannot be captured. The visual elements are all that can be taken away, so to avoid disappointment they have to be utilized with utmost care.

The starting point is to choose a viewpoint that contains an attractive foreground, ideally one that steps gradually towards the horizon and provides a gentle transition from near to far distance. A wideangle lens will emphasize the depth and distance, particularly if the camera is positioned very close (3–4ft/1–1.2m) to the nearest foreground. The near distance objects should be big and bold – sometimes the foreground can occupy as much as 50% of a photograph, and this alone will give a picture impact. To maintain interest beyond the foreground, the viewpoint should also include a distant focal point – small buildings are useful for this – as this will add to the impression of depth.

Light, of course, has to be considered. Low sidelighting is often ideal, but broken cloud can also be helpful. Watch as sunlight and shadows play across the landscape to illuminate specific features, then choose the moment when patches of light fall on important focal points. If all these elements combine favourably, you are likely to capture an image that recreates the experience you felt at the time of making it.

2-stop (0.6) neutral density graduated filter

- A 2-stop ND grad was placed at an angle to darken the sky and prevent it from being overexposed.

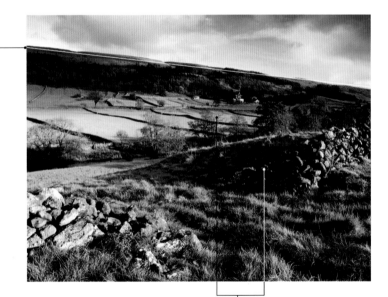

- No post-processing adjustments were undertaken.

> **TIP:** Use patches of sunlight and shadow to emphasize contours. This will help to create the impression of scale and distance.

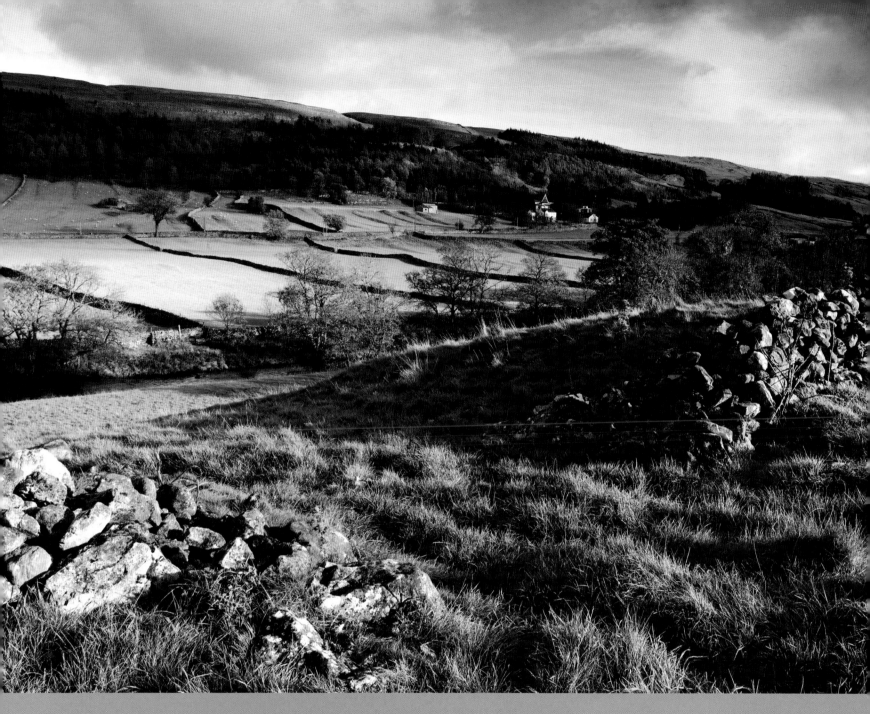

Near Conistone, the Yorkshire Dales, England

Camera: Mamiya 645AFD with ZD digital back

Lens: Mamiya 35mm (wideangle)

Filter: 2-stop ND graduated

Exposure: 1/4 sec at f/22, ISO 100

Waiting for the light: 1 hour

Post-processing: None

⟩ CREATING DEPTH ANOTHER DIMENSION

The depiction of depth in a landscape image is an objective that most photographers strive to achieve. It can be challenging because three dimensions can never be transferred onto a two-dimensional medium without something being lost. The loss of depth cannot be completely eliminated but, by careful composition, it can be minimized. It can, in other words, be recreated. It is an illusion, but that is what is so impressive when you see three-dimensional depth in flat visual art.

In the absence of perfectly parallel converging lines – which are relatively rare in the rural landscape – depth has to be created by including other elements. If objects of an easily perceived scale are

shown in a picture to be receding, from close to the camera all the way to the distant horizon, they will act as an effective means of giving an image depth. This effect can be accentuated by using a wideangle lens and positioning the camera as close to the foreground as your depth of field will allow. There should, however, be an unrestricted view from foreground to background, clearly showing the diminishing size of the objects as they taper away into the distance. With this type of arrangement it should be possible to recreate the missing third dimension and convey the illusion of depth. So, why be satisfied with an image of just two dimensions when, with a little careful composition, you can have three?

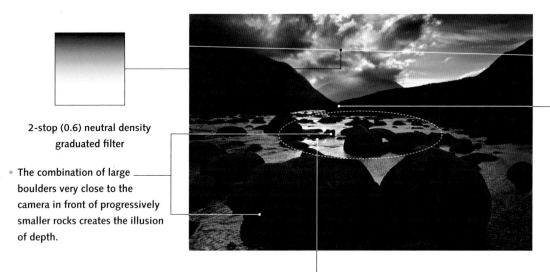

2-stop (0.6) neutral density
graduated filter

• The combination of large boulders very close to the camera in front of progressively smaller rocks creates the illusion of depth.

• Depth has been further emphasized by the receding lines of the river banks as they converge to meet in the far distance.

• Lasso (feathered edge 100 pixels).

• The highlights reflecting on the water's surface have been reduced by using the Shadows/Highlights tool. To avoid suppressing highlights elsewhere in the picture the river was isolated from the rest of the image by the use of the Lasso tool.

• The picture has been warmed by the addition of a small amount of red and yellow via the Colour Balance tool.

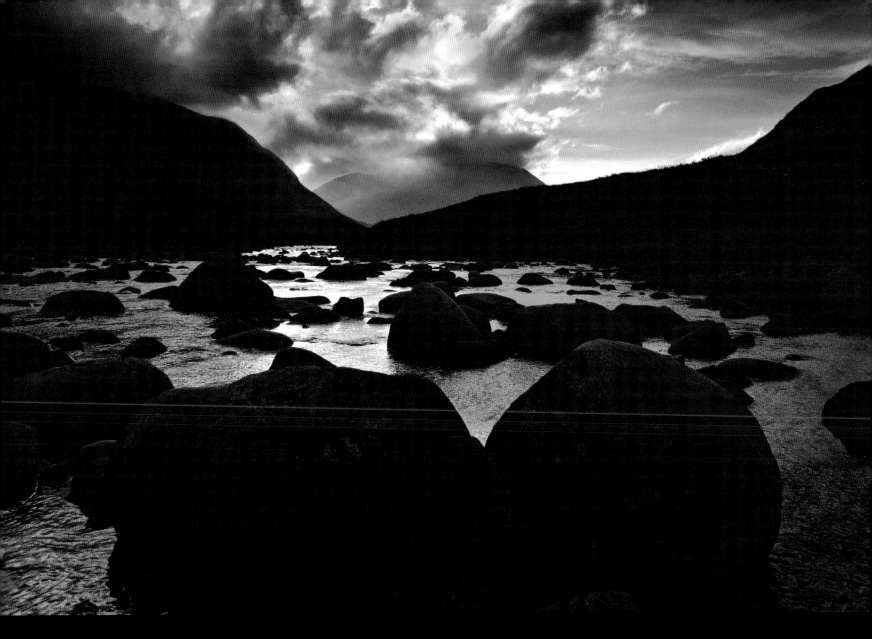

Loch Etive, the Highlands, Scotland

Camera: Mamiya 645AFD with ZD digital back
Lens: Mamiya 35mm (wideangle)
Filter: 2-stop ND graduated
Exposure: 6 sec at f/22, ISO 100
Waiting for the light: 2 days
Post-processing: Selective suppression of highlights, colour balance adjustment

> CREATING DEPTH SHAPES AND LIGHT

As soon as I arrived at the rugged coast at Locquemeau in northern Brittany it was obvious that it was bursting with image-making opportunities. The exposed shoreline is a craggy expanse of sea-weathered rocks of intriguing colours and shapes that invite close scrutiny. As well as the more obvious open views, there are pictures hidden deep in the cracks and crevices that reveal themselves only to a keen, investigating eye. Over a two-week period I spent many hours here, mainly waiting and weather-watching, but also discovering and capturing a number of interesting images. Altogether, I made six quite different photographs, which is a high return from just one location (two more can be seen on pages 85 and 177).

The image seen opposite was captured an hour before the picture on page 177. Here the sun is in a higher position and slightly in front of the camera. This has created a combination of side- and backlighting, which has given shape and modelling to the foreground rocks. This type of light can be quite superb, particularly for photographs that are structured around a dominant, ruggedly varied foreground. The intricate highlights and shadows it creates can really bring a foreground alive and give it tangible depth. Experiment with different angles of light and you will see how the appearance of your subject changes as varying combinations of light and shadow fall across it.

2-stop (0.6) neutral density graduated filter

- The side/backlighting has created a combination of highlights and shadows that emphasize the craggy nature of the rocky foreground. The light has also created a strong impression of depth. The sun's position was crucial to the success of this picture; here, it is low in the sky and slightly in front of the camera.

- The slightly backlit sky was considerably brighter than the landscape; in addition to using a 2-stop ND grad filter, it was also necessary to reduce highlights in the sky with the Shadows/Highlights tool.

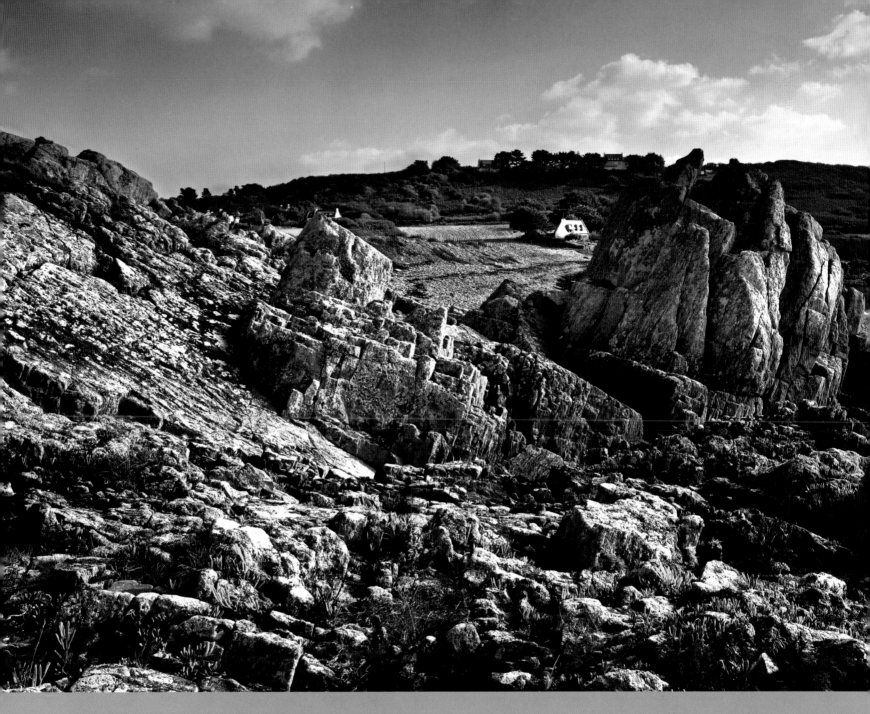

Locquemeau, Brittany, France

Camera: Mamiya 645AFD with Phase One digital back
Lens: Mamiya 35mm (wideangle)
Filter: 2-stop ND graduated
Exposure: 1/2 sec at f/22, ISO 100
Waiting for the light: 8 days
Post-processing: Reduction of highlights

▷ THE FOCAL POINT

This is one of a number of exposures I made of this sparse but attractive stretch of woodland in the backwaters of North Carolina. Of all the pictures I captured that day, I think this one is the most successful. The composition, sunlight, sky and trees all combine to produce an image that transcends the appeal of its individual elements. The tiny wooden barn is also an important feature. It is virtually essential because it provides a focal point and anchors down the rest of the picture. It also gives the image scale and accentuates the height of the surrounding trees. Without it, the picture would have been greatly diminished and I probably would have rejected it. As a group, though, all the ingredients knit together exceptionally well to produce an alluring display of autumn colour.

Although colour plays a significant role in the impact of the photograph, it is the composition, particularly the positioning of the barn, that makes the major contribution. By placing the small building close to the bottom of the picture its dominance is reduced, the height and presence of the trees is emphasized, and the eye is drawn upwards along the length of the trees towards the sky. This arrangement marries the elements together and gives the group a balanced coordination. The picture's portrait format also helps in this respect.

Polarizer (fully polarized)

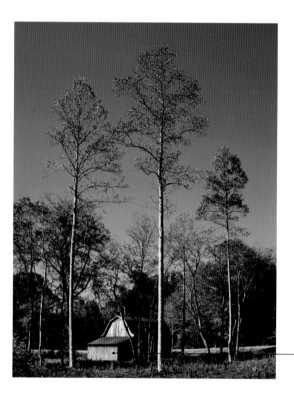

- The polarizing filter has enriched the colour of both the sky and the foliage. The clear sky suits the image because bright, bold colours are appropriate to its theme. A pale sky would have weakened the photograph, while the presence of cloud would have upset the balanced simplicity of the picture.

▷ **TIP:** Polarizing a clear blue sky has to be done with caution. Uneven darkening can occur, particularly when using a wideangle lens. Using a portrait format reduces the risk, as does a longer focal-length lens.

- The low position of the barn helps to accentuate the height and presence of the trees.

- To compensate for a cool blue cast in the daylight, the image was warmed by adding a small amount of red and yellow via the Colour Balance tool. This has also strengthened the colour of the foliage.

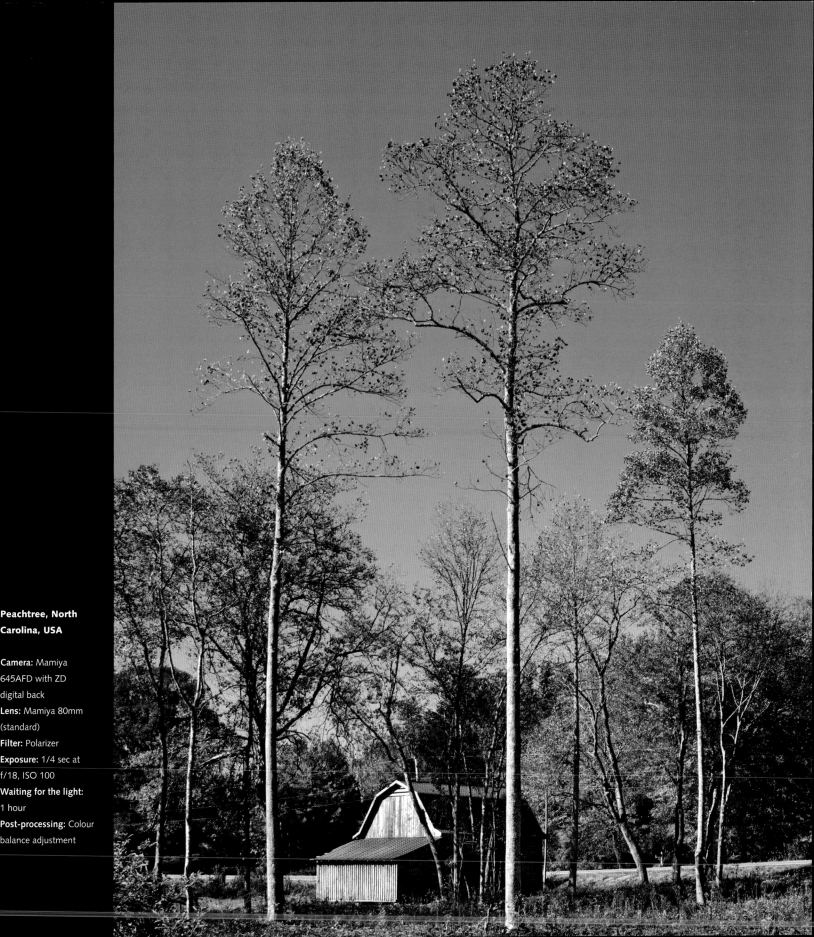

Peachtree, North Carolina, USA

Camera: Mamiya 645AFD with ZD digital back
Lens: Mamiya 80mm (standard)
Filter: Polarizer
Exposure: 1/4 sec at f/18, ISO 100
Waiting for the light: 1 hour
Post-processing: Colour balance adjustment

Colour and buildings are, as we have seen on the previous pages, very strong focal points. They have a magnetic quality and invariably attract a viewer's attention; you can therefore imagine the effect when a brightly coloured building is included in a landscape picture. It will stand out like a beacon and immediately engage the eye. That was certainly the case as I drove along a twisting road through the sparsely inhabited Glen Orchy and caught a glimpse of a distant, vividly painted barn. I was following the course of the River Orchy searching for waterfalls, but then this striking splash of pink grabbed my attention. My anticipation grew as I approached: all the elements seemed to be there, and I could see that there was a photograph waiting to be captured. Waterfalls were forgotten for the time being as I assessed the view and considered my options.

A panoramic format was the obvious choice to accommodate the long stretch of woodland behind the barn and enable a deep drainage ditch to be excluded from the foreground. Having decided on this format,

the picture was fairly simple to compose; however, two long hours later I still had not taken the photograph. As you might have guessed, the delay was caused by the light.

Although not particularly prominent in the picture, light plays an essential role: there had to be a very specific combination of light and shadow distributed across the landscape for the image to succeed. The sun was to the left and I wanted light falling along the length of the background trees and also onto the small barn. For these two elements to be emphasized, all other areas had to be in shade, so broken cloud would have to create a narrow strip of sunlight across both of these features. Unfortunately, the cloud cover was weak; it was two and half hours before the right pattern of light and shadow materialized. This was gone in a matter of seconds, but it was long enough for the image to be captured. Picture taken, I went back to the river to search for waterfalls, but by then it was warm and sunny so I took a walk through the woods instead. Waterfalls are definitely poor-weather subjects.

The sky is less than perfect. There is dead space in this corner and ideally the clouds should be positioned to the right, not the left. This would have created a more balanced picture.

2-stop (0.6) neutral density graduated filter

> **TIP:** Buildings act as very strong focal points. Their presence will give an image depth and scale.

No post-processing adjustments were undertaken.

Inverlochy, Argyll & Bute, Scotland

Camera: Mamiya 645AFD with Phase One digital back
Lens: Mamiya 35mm (wideangle)
Filter: 2-stop ND graduated
Exposure: 1/2 sec at f/20, ISO 100
Waiting for the light: 2½ hours
Post-processing: None

> THE FOCAL POINT DISTANT HORIZONS

For a distant view to make an impression as a photograph the eye must travel across the landscape. The viewer must be encouraged to study the picture and embark on a journey from front to back, starting with the foreground, continuing through the middle distance, and then on to the distant horizon. For the eye to take such a path the image must contain visual stepping stones that act as focal points. They will attract attention and link together elements in the receding landscape. Buildings can be used for this, as can trees. Buildings can be very effective as they always draw the eye and, being of an easily perceived size, will give a picture scale and depth. Include a strategically placed

barn or cottage in your photograph and you will be able to build your composition around it, as it automatically becomes a strong focal point. Imagine the picture opposite without the barn. It would be incomplete. It would lack a focal point and there would be no visual cornerstone around which the rest of the image could be constructed.

The other elements present do make a contribution, as does the right-angled sidelighting (so essential in depicting the rugged nature of the background mountain), but it is the building that is crucial to the success of the photograph.

1-stop (0.3) neutral density graduated filter

Polarizer (fully polarized)

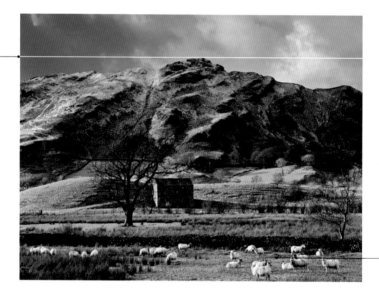

- The sheep in the foreground fill a void and help to provide a sense of scale; the splashes of bright pink and blue on them are a little distracting, but this was an interference I was stuck with. I tried to minimize the distraction by waiting for shadow to fall across this part of the picture.

- Contrast has been increased by introducing an S-curve. The heightened contrast strengthens the presence of the barn and emphasizes the craggy face of the mountain.

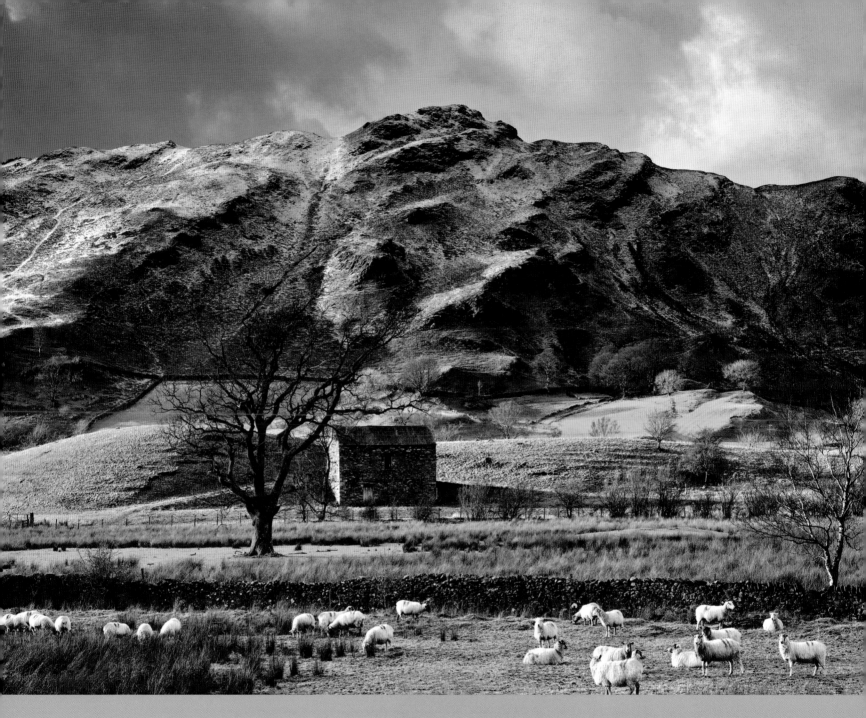

St John's in the Vale, Cumbria, England

Camera: Mamiya 645AFD with Phase One digital back

Lens: Mamiya 80mm (standard)

Filters: Polarizer, 1-stop ND graduated

Exposure: 1/5 sec at f/18, ISO 100

Waiting for the light: 3 days

Post-processing: Curves adjustment

BALANCE AND SYMMETRY

Balance in a landscape image can take many forms. Often symmetry, or repetition, can be used as the theme; it can be subtle, perhaps having only a subliminal presence, or it could be bold and assertive with a stark, unambiguous display of balanced shapes or elements. In the photograph opposite, captured along the rugged northern Brittany coastline, the arrangement is loosely defined, being a combination of repeated, somewhat regimental vertical lines, supported by a random conglomeration of softly shaped, colourful pebbles.

In my opinion, the two very different forms work well together. One complements the other and the visual impact of them together exceeds the appeal they would hold if photographed as individual subjects. Combining two (or more) complementary elements in an image can be the basis of many distinctive photographs; all that is required

to create these pictures is the observation and imagination of the photographer. Unfortunately, because of the nature of the landscape, design is not something that comes readily to mind. Often it doesn't seem to be appropriate or relevant. There are occasions where, with the right design, images can be created out of virtually nothing, but the opportunities have to be seen first. This can be a challenge, but the photographer's creative eye can be developed through a combination of experimentation, trial and error, and experience. My advice is to look at the landscape in a different way. View it as a collection of shapes, colours and textures and consider how these individual elements can be combined together in a balanced way. Over time, your photography should reflect your heightened awareness of the opportunities that even an apparently unspectacular subject can provide – and success should then follow.

- The light was fairly bright and the resulting contrast was a little too high. It interfered with the subtle tones of the subject, and has therefore been reduced slightly by making an inverted S in the Curves tool.

- The image was warmed by adjusting the Colour Balance to add a small amount of red and yellow. This was to compensate for a blue cast, which can sometimes be present in coastal locations.

- Without the pebbles, the rock formation would have looked too repetitive. The combination of two quite different elements makes a more complete picture.

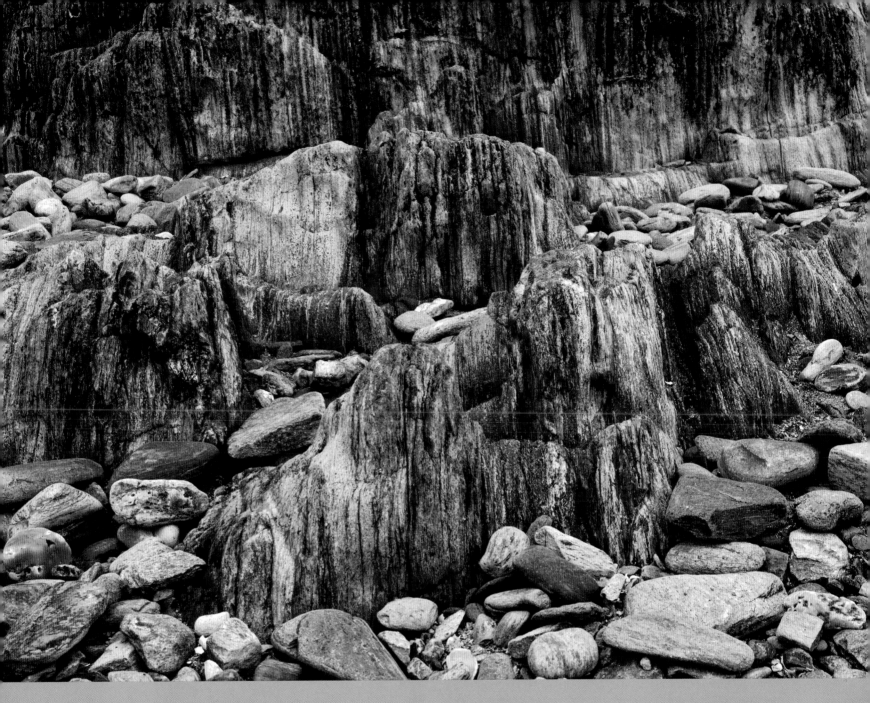

Locquemeau, Brittany, France

Camera: Mamiya 645AFD with Phase One digital back

Lens: Mamiya 35mm (wideangle)

Filter: None

Exposure: 1/2 sec at f/22, ISO 100

Waiting for the light: Immediate

Post-processing: Curves and colour balance adjustments

> BALANCE AND SYMMETRY ASPECT RATIOS

The majority of DSLRs have an aspect ratio of 3:2. Identical to that of 35mm, it is the most common format of all, and the majority of landscape images are taken with it. In most cases, this isn't a choice the photographer has consciously made; the reason it is so widely used is because the format's ubiquity means that it tends to be the default option. Medium-format, and also Olympus, cameras have an aspect ratio of 4:3, which I prefer. It is, of course, an individual choice because there is no right or wrong ratio. Sometimes a more rectangular shape is desirable, and a number of photographers favour a wide, panoramic format, with a ratio of either 2:1 or 3:1. They often use a specially designed camera, but different formats, including panoramic, are available to all photographers, irrespective of what camera they use.

This change in format is achieved by the simple process of cropping. This quick and painless task can often greatly improve an existing photograph and can provide many new image-making opportunities. It can be undertaken as an afterthought, if you are not satisfied with an existing composition, but ideally it should be considered at the time of capture as an integral part of creating the picture. This is particularly the case with panoramic images. Often a subject or view will be dismissed because it doesn't suit the default format of the camera, but it might be perfect as a panoramic. The potential for the change in format has to be seen, however, and this depends on the vision and imagination of the photographer. I use a separate handheld viewfinder to frame the subject before deciding on a specific format, and I find this very helpful. A simple cardboard frame could also be used. All you need is something that helps you look at a subject and consider the various options.

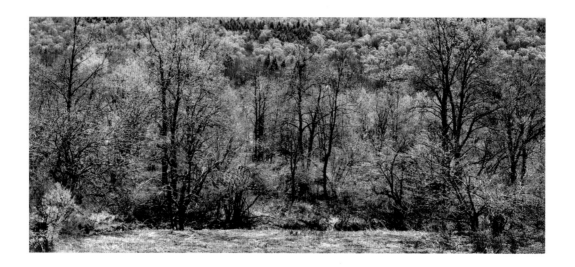

• Neither the foreground nor the sky has any role to play in this image. The arrangement of the important elements – the delightfully variegated trees and bushes – dictates the format. The picture would have been greatly diminished had a squarer aspect ratio been used.

• A small adjustment has been made to the tonal curve in order to increase contrast.

> **TIP:** Don't use your camera's default format by default. Think in terms of different aspect ratios – you can choose virtually anything you like – and it will definitely improve your photography!

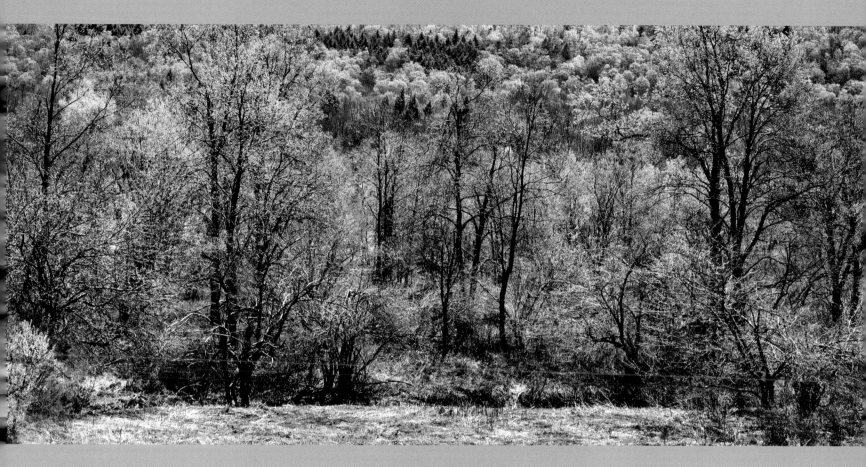

Near Hunter, New York State, USA

Camera: Mamiya 645AFD with ZD digital back
Lens: Mamiya 150mm (short telephoto)
Filter: None
Exposure: 1/5 sec at f/19, ISO 100
Waiting for the light: Immediate
Post-processing: Curves adjustment, cropping

▷ BALANCE AND SYMMETRY SENSE OF ORDER

Symmetry is a quality I frequently attempt to create when composing an image. If there is an opportunity to impose a sense of order on the landscape, I take it. I sometimes wonder, though, if my enthusiasm for a finely balanced arrangement hinders my observation. I hope it doesn't dominate my thinking to the extent that I fail to see other possibilities. In any case, symmetry is a rather rare commodity in the natural world.

On a very small, micro scale, nature often has a pronounced symmetrical appearance, but as we step back and look at the bigger picture a randomness takes over, and it is this random quality that presents the challenge to the photographer. Taming and reorganizing this disorder often lies at the heart of a successful image. In order to depict these symmetrical qualities some subjects require close scrutiny

and careful thought, because there are many options to consider. What focal length lens do I use? Is there a focal point? What will be the best angle of light? Should the photograph be portrait or landscape format? Are there any weak areas in the sky? Are there any telegraph poles or other unwanted elements that might interfere with the symmetry? Such were the thoughts running through my mind as I contemplated photographing the stretch of well-organized farmland in the picture opposite. There were a number of compositions to consider, and after pacing the length and breadth of the field several times, images finally started to take shape. The actual capturing of the photographs took no more than ten minutes. The thinking process and preparation occupied me for almost two hours – and that is not unusual.

Polarizer (fully polarized)

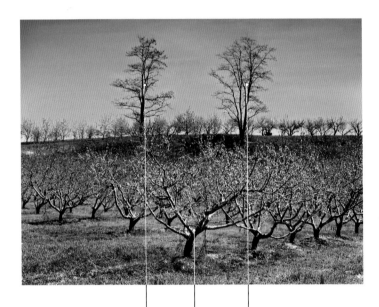

- The hazy sky is a disappointment. It spoils the picture to some extent, but there was no alternative. Maintaining the structure of the image was the priority and, frustrating as it was, a compromise was necessary. The less than perfect sky was an acceptable price to pay, as it enabled the symmetry to remain intact.

- The symmetry is based around the central position of the small tree in the foreground, which has been placed exactly in the middle of the two distant trees.

- No post-processing adjustments were undertaken.

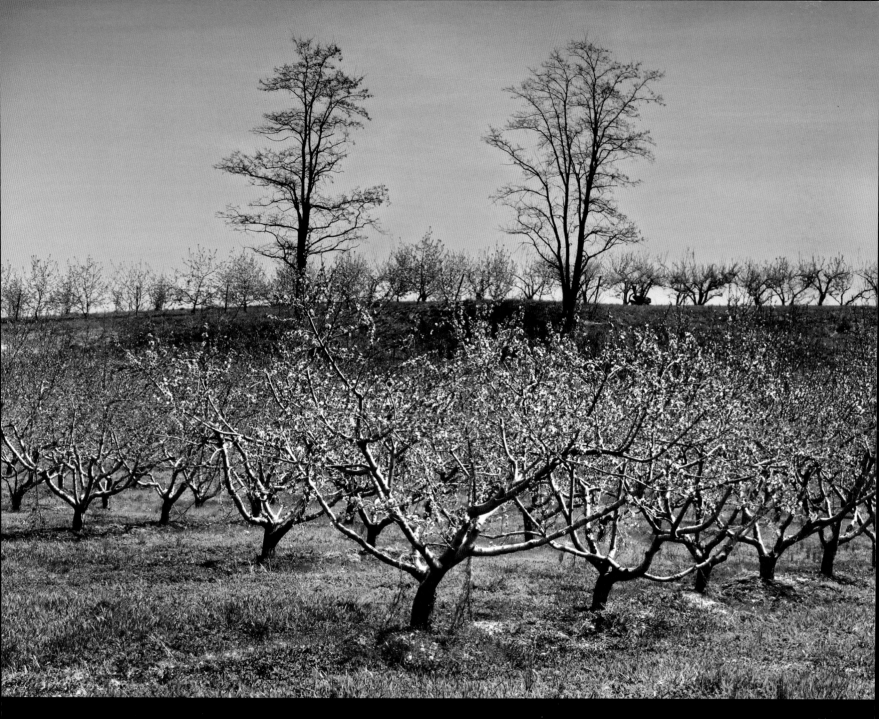

Near Barrytown, New York State, USA

Camera: Mamiya 645AFD with ZD digital back
Lens: Mamiya 35mm (wideangle)
Filter: Polarizer
Exposure: 1/8 sec at f/16, ISO 100
Waiting for the light: 10 minutes
Post-processing: None

> BALANCE AND SYMMETRY TRANSFORMATION

It is very satisfying when an apparently featureless piece of land can be transformed into a piece of visual art by the power of photography. Without doubt, beauty is in the eye of the beholder; no individual artwork has ever attracted universal acclaim, and art can only be viewed subjectively. I fully accept that what appeals to me will not always be appreciated by others.

The picture opposite is therefore intended to serve two purposes: it will, hopefully, be considered as an aesthetically pleasing landscape image but, failing that, it is an illustration of photography's ability to transform the way the landscape is viewed.

From a distance, the rural landscape is exactly what it is perceived to be – fields, trees, mountains, hills and rivers – but a closer look reveals a lot more. Look beneath the surface and the building blocks of photographic art become apparent. These are the patterns, contours, textures and symmetrical shapes that can be arranged into original, eye-catching landscape pictures. The making of this type of image requires observation, imagination and creative thinking but, once seen and organized, these subjects are not particularly difficult to capture. What is important, though, is the interpretation of the landscape and the careful arrangement of the elements into a symmetrical and balanced pattern. Look at the landscape through your photographer's eye and the opportunities for creativity will soon become apparent. An exciting new dimension to your photography will then unfold.

- This image is built around five horizontal bands of colour and texture. From top to bottom they form a symmetrical pattern of stripes that span the width of the picture to form a semi-abstract interpretation of a small stretch of fertile landscape.

- In addition to the horizontal symmetry, there are two repeated curves in the row of trees and the dry-stone wall. Positioning the curved dips in these two features so that they coincide forms the cornerstone around which the rest of the photograph is arranged.

- The image was captured under an overcast sky. The flat lighting suited the subject; shadows would have interfered with the picture's simple symmetrical structure. However, contrast was increased slightly by making an S in the Curves tool.

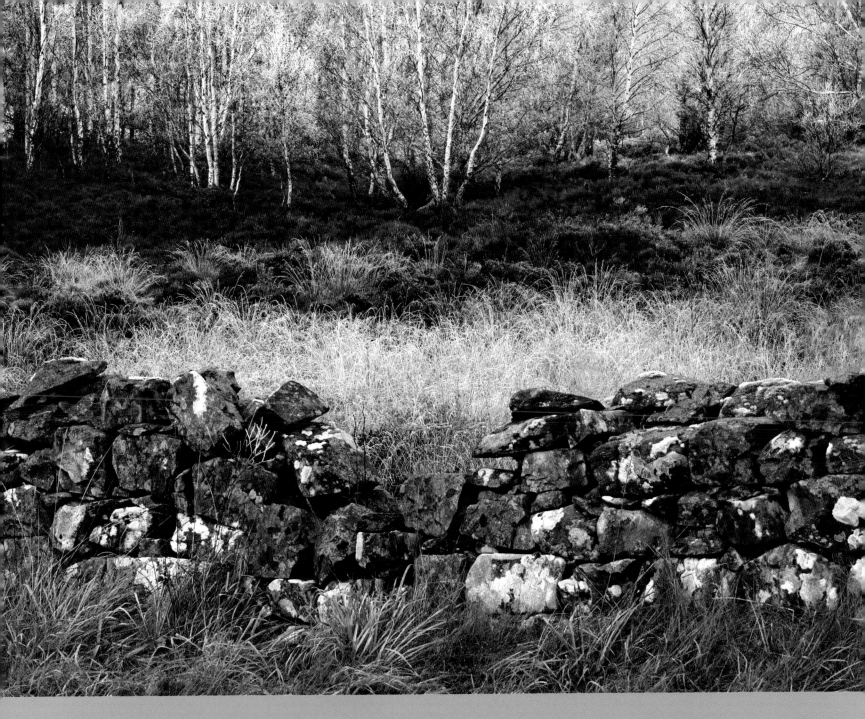

Near Tummel Bridge, Perthshire, Scotland

Camera: Mamiya 645AFD with ZD digital back
Lens: Mamiya 80mm (standard)
Filter: None
Exposure: 1/2 sec at f/32, ISO 100
Waiting for the light: Immediate
Post-processing: Curves adjustment

> BALANCE AND SYMMETRY VIEWFINDERS

For most of my career, I have used a large-format view camera. These cameras have no viewfinder; instead there is a ground-glass screen at the rear (similar, but inferior to, an LCD screen). An image of the subject is projected onto the screen by the camera lens. It isn't very bright, has to be manually focused by a bellows mechanism, is a mirror image of the subject (i.e. left and right are transposed) and is also upside down. This might all sound a little impractical, and I have known photographers run a mile when they have seen these cameras, claiming they are impossible to use in the landscape environment. They do take some getting used to, but their rather cumbersome operation has its advantages. They slow down the image-making process and impose on the photographer a regime of pursuing quality rather than quantity. Also, the lack of a viewfinder, by necessity, separates the viewing and composing of the picture and the actual taking of it – and this has significant benefits.

To overcome the absence of a convenient built-in viewing system I use a separate handheld viewfinder. Therefore, before even removing the camera from its case, I have chosen the location, assessed the subject from every angle, found the viewpoint, composed the image, and decided what focal length lens to use. As a result, the concept and the arrangement of the picture have, at that point, been carefully considered and, in my mind at least, the photograph has been taken. The creative aspects of producing the image have therefore been completed – and my camera has yet to make an appearance.

This procedure is now firmly established as my standard method of working, and I still follow it today. Whether you are using digital or film, I recommend that you adopt this practice and separate the viewing and the taking of the picture. It can only improve your standards of photography.

● The image looked a little weak, so the colour was strengthened using the Colour Saturation tool.

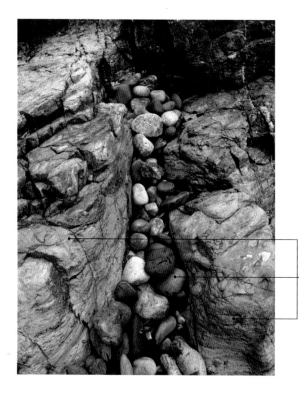

● I was initially attracted by the contrasting colour of the pebbles and the surrounding rock. After slow and careful evaluation through my handheld viewfinder, I decided on a composition built around a central channel of pebbles. This split the picture into three vertical sections, which gave the image a degree of balance and symmetry.

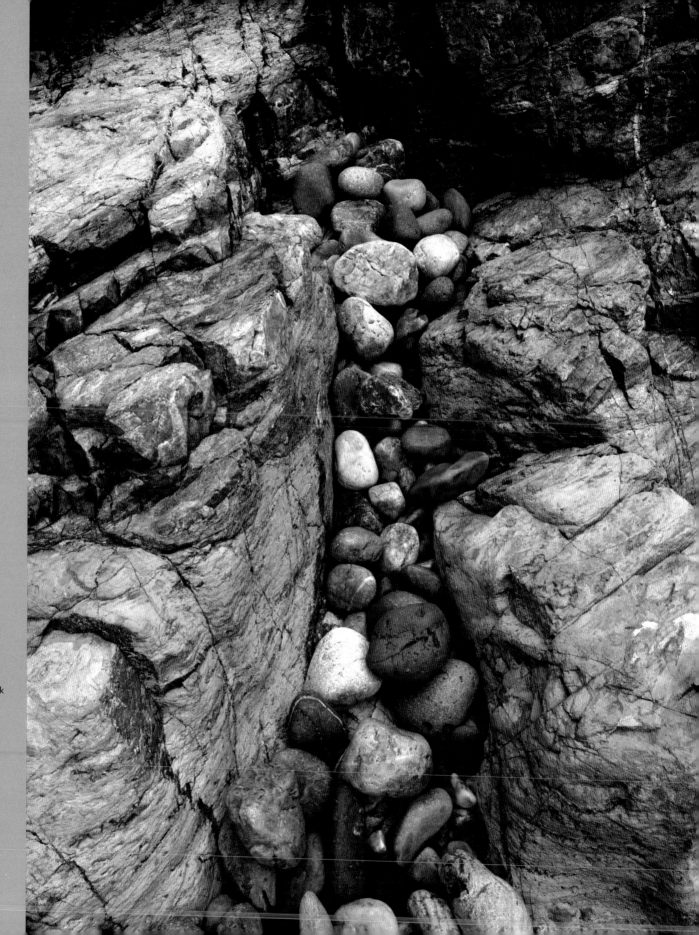

**Church Bay,
Anglesey, Wales**

Camera: Mamiya 645AFD
with Phase One digital back
Lens: Mamiya 35mm
(wideangle)
Filter: None
Exposure: 1/4 sec at f/22,
ISO 100
Waiting for the light:
1½ hours
Post-processing: Colour
saturation adjustment

> SIMPLICITY

Striking the right balance in a photograph can sometimes simply mean including an appropriate amount of information. There is a fine line between too little and too much information or detail in a picture. If it is insufficient, the image will lack interest and seem pointless, but if too much is included it will confuse the eye and fail to hold the viewer's attention. It is important that a photograph makes sense and is intelligible at a glance. To achieve this, it should include only those elements that are relevant to the theme. Depending what that theme is, this can sometimes mean that the composition has to be very simple.

Colour is a potent force in a photograph and there doesn't need to be a complete spectrum for it to make an impact. If colour is the theme, the range of hues should be restricted to a small number of clearly defined solid blocks, rather than a kaleidoscope of multi-coloured specks. A tightly framed composition will also help to keep the arrangement simple. Close-up images, either abstract or realistic, are a particularly effective means of depicting colour and texture.

This approach was the solution I arrived at after a period of study and contemplation of a jumble of fishing nets along the north Brittany coast. The nets were close to a busy marina and I attracted a number of bemused glances as I scrutinized the colourful pile through a handheld viewfinder, while pacing forwards, backwards and sideways in a variety of body-twisting contortions. The curiosity of the passers-by then intensified as I set up my tripod and camera. Despite their interest, I was left alone to capture the image and, picture taken, quickly packed everything up and melted away into the crowd.

• The image has been limited to four different colours and textures. I felt that including more than this would have been confusing.

> **TIP:** Soft, shadowless light is preferable when bold colour is to be depicted.

• The original picture looked a little insipid, so the colour saturation was increased slightly.

Paimpol, Brittany, France

Camera: Mamiya 645AFD with Phase One digital back

Lens: Mamiya 35mm (wideangle)

Filter: None

Exposure: 1/4 sec at f/22, ISO 100

Waiting for the light: Immediate

Post-processing: Colour saturation adjustment

> SIMPLICITY LET IT FLOW

Rivers and streams are an endless source of opportunity; a variety of intriguing images can lie hidden in their flowing waters. Often close-up shots are the most successful; good results can be achieved by moving or zooming in and concentrating on small, specific features.

Water flowing over attractive rock formations – particularly colourful rocks – makes an interesting subject, and a combination of white, splashing water and weathered, patterned stone can be very rewarding. It is important that the right balance of rock and water is found. Too much of either one can look uninteresting, so considerable thought has to be given to the composition of this type of picture. Avoid large areas of monotonous white water, as they don't photograph well and will

look unsightly (plain, darkly coloured rocks should also be excluded). Interesting shapes and patterns can be formed by the flowing curves that appear as water splashes over protruding boulders, and they can make strong images when isolated from their surroundings. Zoom lenses are helpful for this because it can sometimes be difficult to set up a tripod in the required position. A degree of flexibility in the choice of viewpoint can therefore be an enormous help.

These images won't leap out in front of you, so patience and perseverance will be required when searching for them. They are worth the effort, though, and can be quite stunning.

Polarizer (fully polarized)

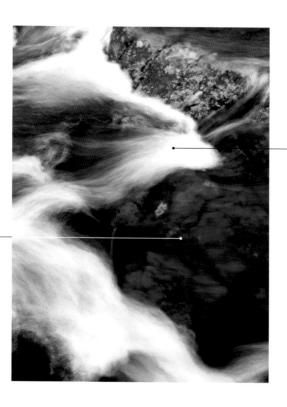

● A polarizer was used to absorb reflections; this also strengthened the appearance of the colourful rocks. A side effect of using this filter is the absorption of light. This would normally require an increase in exposure, but I wanted to avoid this. I therefore increased the speed of the image sensor to ISO 200.

● A shutter speed of 1/2 sec was used to blur the water. A longer exposure would have led to a reduction in its subtle tonal variation and also a loss of definition.

● No post-processing adjustments were undertaken.

> **TIP:** Rising and falling water levels can transform the appearance of a river. Visit a location at different times to ensure the best moments aren't missed.

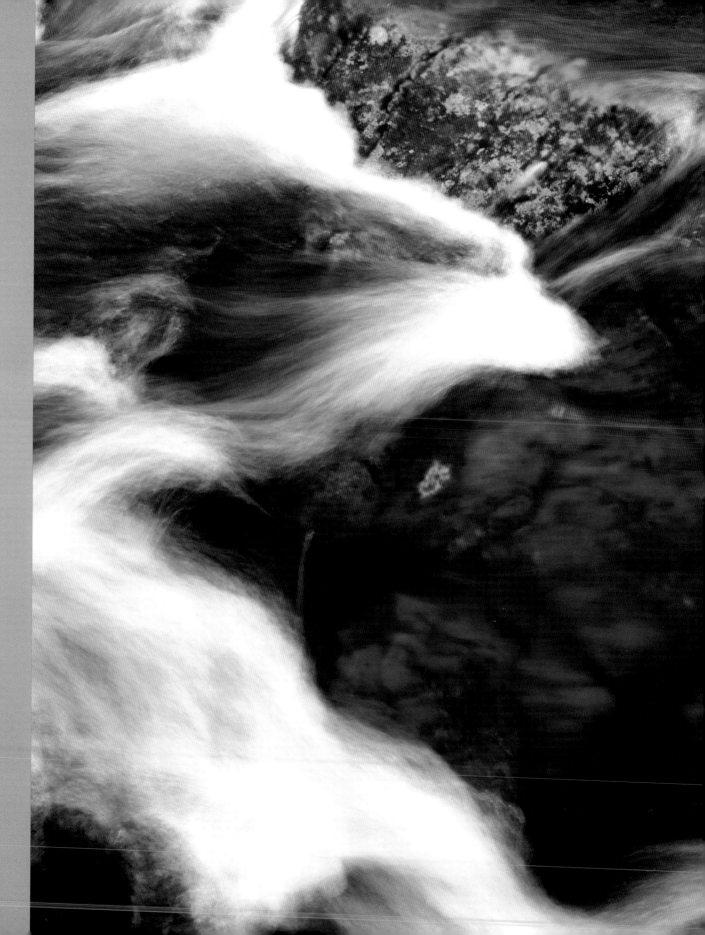

The River Ba, the Highlands, Scotland

Camera: Mamiya 645AFD with ZD digital back
Lens: Mamiya 150mm (telephoto)
Filter: Polarizer
Exposure: 1/2 sec at f/22, ISO 200
Waiting for the light: Immediate
Post-processing: None

> THE SKY AS AN ELEMENT

When viewed as part of a two-dimensional photograph, the sky appears to be as solid and tangible as the land beneath it. It is a powerful element in an image and makes an important, and in many ways unique, contribution. In terms of area, it is often a substantial part of a picture. The quality of sky must therefore be carefully considered during the thinking and planning stages of making a photograph.

The image opposite is approximately 60% sky and 40% landscape, and it is a little disappointing that the quality of the sky is rather weak. Marrying together a single, strategically placed cloud with a specific

feature of the landscape can be a very effective arrangement, but the sky here isn't exactly what I had in mind. Scattered clouds were drifting by and, ever the optimist, I assumed it would just be a matter of time before the perfect formation materialized. Despite waiting and waiting, however, the longed-for cloud structure proved elusive. Wispy cloud and haze were the problem and they have, to an extent, spoiled the image. Had the landscape not appealed to me as strongly as it did I wouldn't have taken it. As it is, the photograph does serve a purpose: it illustrates the creative opportunities that can result from combining together distinctive features in both sky and landscape.

Polarizer (fully polarized)

• **The polarizer has darkened the blue sky and strengthened the appearance of the single cloud. Unfortunately, it has also accentuated the presence of wispy cloud that spoils the sky.**

• **No post-processing adjustments were undertaken.**

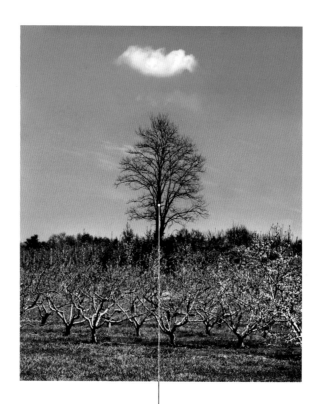

• **Placing the tree centrally accentuates the symmetry in the image.**

• **A clean sky, free of hazy cloud, with a crisply defined contrast between the single cloud and blue background would have greatly improved the picture.**

> **TIP:** One advantage of the hazy sky was the softly muted sunlight it produced. Delicately coloured subjects benefit from being photographed under soft light. For best results, strong highlights and shadows should generally be avoided.

**Near Barrytown,
New York State, USA**

Camera: Mamiya 645AFD with ZD
digital back
Lens: Mamiya 35mm (wideangle)
Filter: Polarizer
Exposure: 1/2 sec at f/22, ISO 100
Waiting for the light: 2 hours
Post-processing: None

> THE SKY AS AN ELEMENT SOLID SKY

In a landscape image, the sky and the land beneath it are equal partners. When viewed as a photograph, the sky will be perceived as a solid object, with colour, shape and sometimes even depth. The transient nature of the sky, with its ever-changing moods and whims, makes it a perfect subject for the camera. It is more than capable of standing on its own in a picture, but it is often the partnership of sky and landscape that brings out the best in both. Potentially one of the most successful, and certainly the most alluring, combinations is an attractive sky with a mirror image of itself reflected in the calm waters of a tranquil lake. This can look spectacular when seen as a photograph,

particularly at sunrise and sunset. The optimum conditions are likely to occur infrequently, so perseverance is likely to be necessary to capture the spectacle. However, you might be lucky – as I was when I took the picture opposite – and simply stumble upon a heaven-sent opportunity.

It could be just a fleeting moment, so always be prepared. It might be some time before fortune smiles on you again, and image-making opportunities should never be missed. Expect the unexpected and you will reap the rewards.

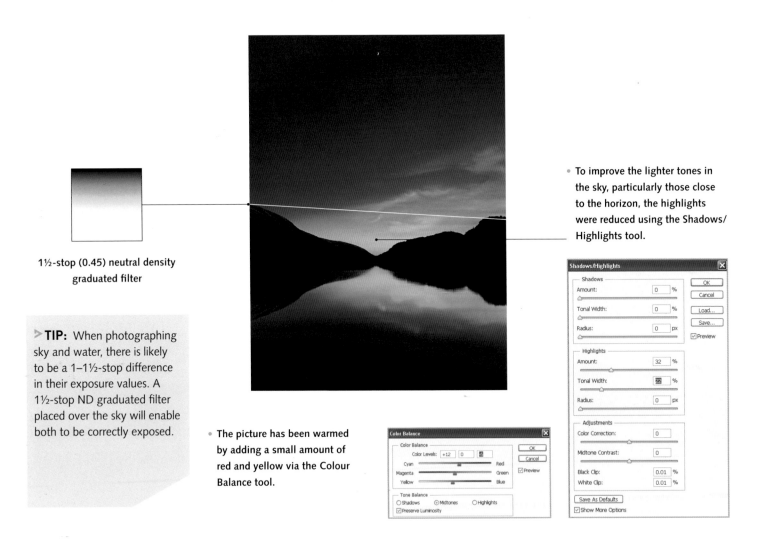

1½-stop (0.45) neutral density graduated filter

> **TIP:** When photographing sky and water, there is likely to be a 1–1½-stop difference in their exposure values. A 1½-stop ND graduated filter placed over the sky will enable both to be correctly exposed.

• To improve the lighter tones in the sky, particularly those close to the horizon, the highlights were reduced using the Shadows/ Highlights tool.

• The picture has been warmed by adding a small amount of red and yellow via the Colour Balance tool.

**Thirlmere,
Cumbria, England**

Camera: Mamiya 645AFD
with Phase One digital back
Lens: Mamiya 80mm
(standard)
Filter: 1½-stop
ND graduated
Exposure: 1 sec at f/20,
ISO 100
Waiting for the light:
Immediate
Post-processing: Suppression
of highlights, colour balance
adjustment

Heavily clouded skies are not usually a welcome sight. The light that manages to escape from them usually provides little opportunity for creative image-making, but there can be exceptions. With the right type of cloud structure, the sky itself can become the subject.

Backlit skies, in particular, hold promise, and an hour or two spent watching the celestial display, as beams of light break through the gloomy darkness, can be highly rewarding. Shimmering rays can create vivid focal points that form the basis of many fine skyscape pictures. Because of the uninterrupted view, this type of image is most likely to

be seen in coastal locations. As well as having a large expanse of sky, there is also the possible bonus of rays reflecting on the water's surface. For the detail in a cloud formation to be revealed it has to be accurately exposed; however, using a graduated ND filter is not always necessary. If the other elements in the picture are to be left subdued – and it is often preferable that they are – then a filter isn't required. Exposure can simply be based on the sky, which will enable the tonal range in the clouds to be faithfully recorded. By keeping all the elements subdued, the sunbeams and reflections will stand out. They will be the only highlights, which will strengthen the visual impact of the photograph.

• I would normally use a 1- or 1½-stop graduated ND filter when capturing both sky and water, but chose not to on this occasion. I decided to allow the sea to remain subdued in order to create a stronger contrast with the rays of sunlight filtering through the clouds.

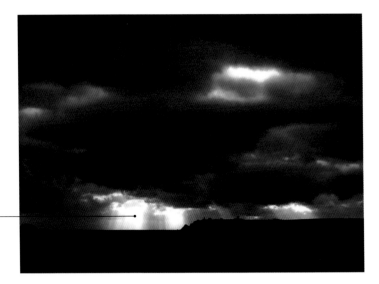

> **TIP:** Interesting skies can appear at any time of day, but particularly during early morning and late evening when the sun is low but not too close to the horizon. At those times light beams can have a vivid intensity and will contrast well against a brooding, threatening sky.

• The picture was partially warmed by making a small adjustment to the Selective Colour tool to increase red and yellow. This enabled the warmth of the sunlight to be accentuated without affecting the cool tones of the cloud.

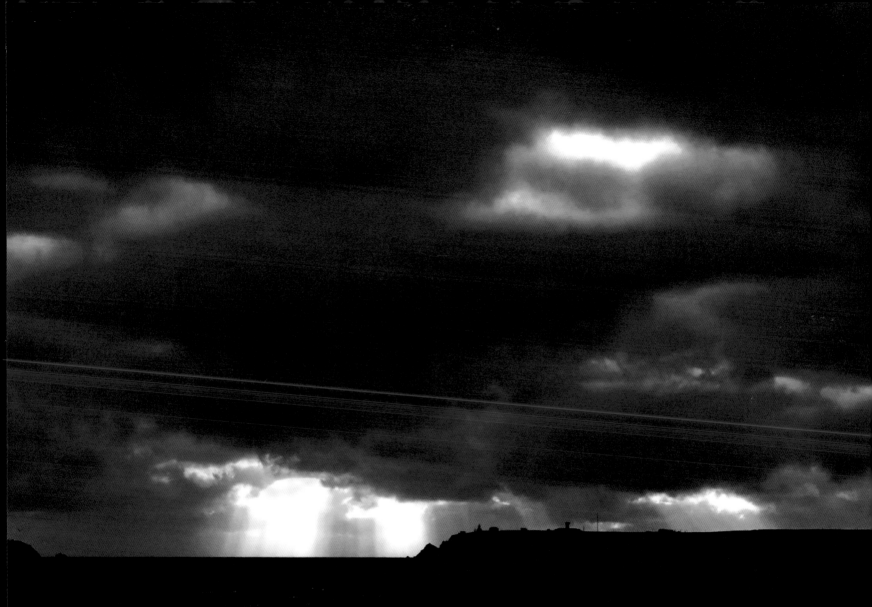

West Angle Bay, Pembrokeshire, Wales

Camera: Mamiya 645AFD with ZD digital back
Lens: Mamiya 35mm (wideangle)
Filter: None
Exposure: 1 sec at f/18, ISO 100
Waiting for the light: 1 hour
Post-processing: Selective colour balance adjustment

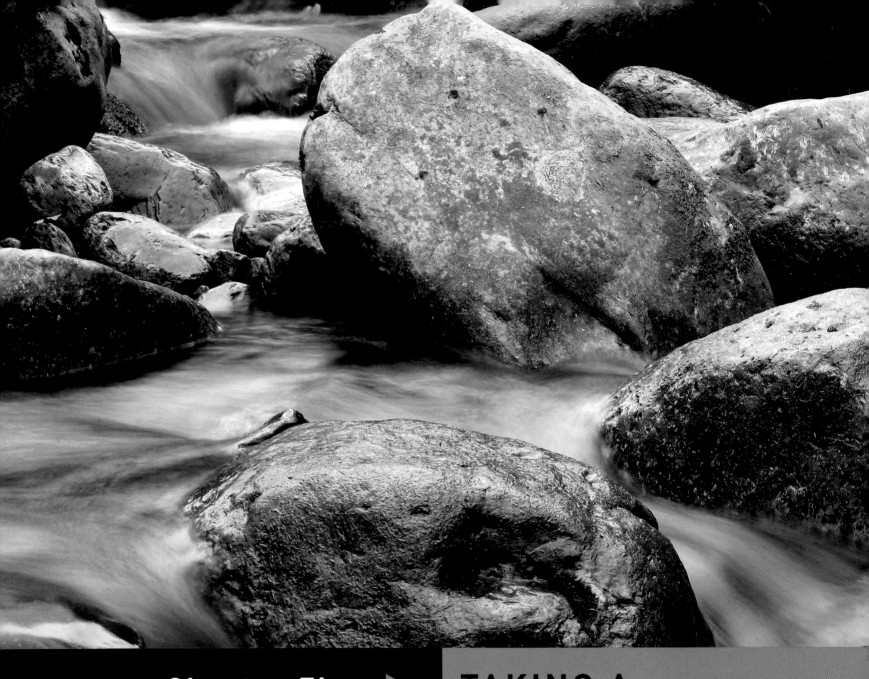

Chapter Five ▷

TAKING A
CLOSER LOOK

Newlands Beck, the Lake District, England

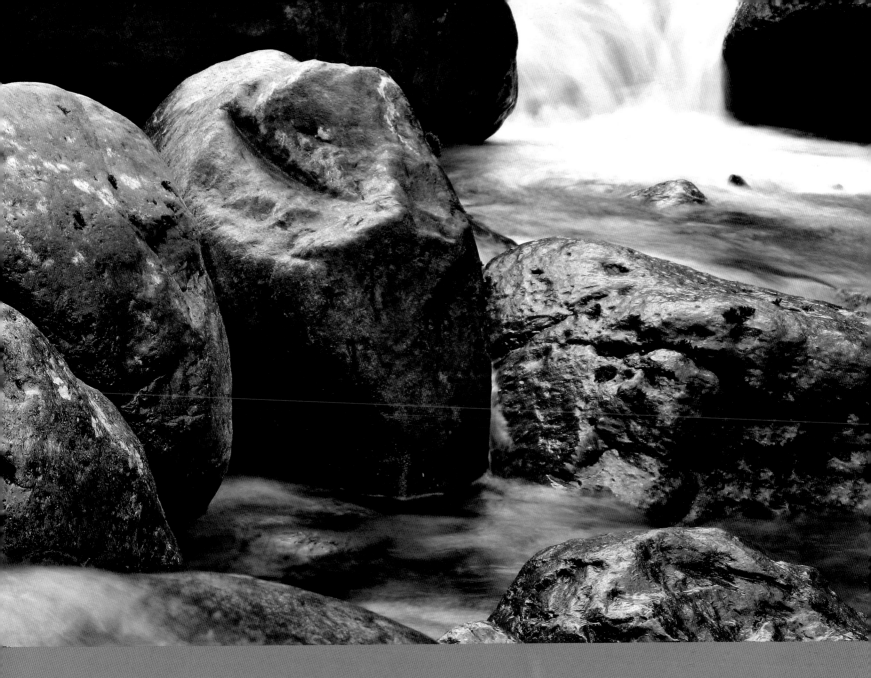

There is a fine line between an abstract image and a meaningless one. Where that line is drawn is a matter of interpretation and there will never be universal agreement concerning the merit of a particular piece. As a photographer, I think that viewing the world in an abstract way improves observation. Rather than simply looking, we start to think imaginatively about what we see. We begin to perceive shapes and patterns; this not only helps creativity, but also leads to a better understanding of composition.

> ISOLATING THE SUBJECT

There is a pronounced depth to this image, both in the shape of the rocks and in their textured surfaces. The depth is largely due to the shadows cast by fairly strong sunlight. When photographing a colourful subject I would normally avoid bright light, as highlights can interfere with subtle tonal variations. However, in this instance I was able to view the subject in both flat and directional light, and on this occasion the stronger light was clearly the better option. This is because the coarse texture of the rocks has a porous quality; there is no surface moisture and, as a result, no reflections from the sunlight. The lack of strong highlights has enabled the picture to be captured with a relatively high degree of contrast, which has undoubtedly improved its appearance.

Although this is an abstract image, there has been no departure from reality in the making of the photograph. The abstract appearance is due to the nature of the subject itself; the effect has been created by simply moving in close and isolating the rocks from their surroundings. Viewed from a distance, a rock-covered coastline will display no abstract qualities, but close up its appearance can change dramatically. By a process of selection and isolation a new dimension of reality can emerge, when only colour, shape and form are seen. It is at that point that original and creative images can be made.

Polarizer (fully polarized)

- The polarizer has helped saturate colour and has increased contrast slightly. This has accentuated the rock's textured surfaces.

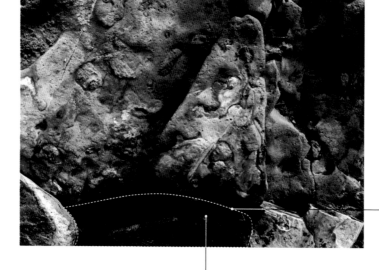

- Lasso (feathered edge 100 pixels).

- There was deep shadow in the crevice beneath the central rock. This was lightened via the Shadows/Highlights tool. To prevent other parts of the photograph being affected the area was selected and isolated using the Lasso tool.

> **TIP:** Colour plays an important role in abstract pictures. Avoid over-complicated patterns and keep the distribution of colour simple. It should support, not conflict with, the shapes and forms you are depicting.

Port Eynon, Gower Peninsula, Wales

Camera: Mamiya 645AFD with ZD digital back
Lens: Mamiya 35mm (wideangle)
Filter: Polarizer
Exposure: 1/2 sec at f/22, ISO 100
Waiting for the light: 40 minutes
Post-processing: Selective shadows adjustment

It can be fascinating to stroll through woodland searching for pictures. Potential subjects are everywhere, but they often disappoint because what initially looks promising may fail to stand up to close scrutiny. This can be frustrating, but it pays to persevere. Forests and woodland are, by nature, chaotic places and the challenge facing the photographer is to find or create order out of overwhelming disorder. There is no shortcut to this; only meticulous and methodical searching will reveal the gems hidden in the dense undergrowth.

Close-up subjects are a rich source of opportunity and, once discovered, they are relatively easy to photograph. One problem that may be encountered is the normally straightforward task of setting up your tripod in the right position. That might sound surprising, but there is a law in photography that says the best vantage points are always the most inaccessible – believe me, this law comes into its own in the middle of a dense forest! Branches and tree roots can make formidable obstacles, and there is very little leeway when photographing at close

distances. The camera position has to be precise and this can be difficult in confined spaces, particularly if the ground is uneven, as it often is in woodland. A zoom lens can be invaluable in these situations and will greatly help with composition. A small, adaptable tripod can also be useful when movement is restricted.

The tree bark in the picture opposite might seem like an easy subject to capture. However, what is not apparent from the photograph is the steep drop of several feet immediately in front of the tree, which left virtually no room to set up my equipment. Image stabilization was not an option because the low level of light required too long a shutter speed. The only solution was to perform a precarious balancing act with camera, tripod and photographer locked in an immovable embrace for the duration of the exposure. It lasted a mere three seconds, but, perched as I was on the edge of a steep drop, they were the longest three seconds of my life!

- Despite the low level of subdued light and the resulting low contrast, it was necessary to use the Shadows/Highlights tool to darken the lighter tones. This is because exposure was based on the darker parts to ensure detail was captured in these areas. This technique is known as ETTR (expose to the right).

**Chaos de Toul Goulic,
Brittany, France**

Camera: Canon EOS 7D
Lens: Tokina 12–24mm
Filter: None
Exposure: 3 sec at f/13,
ISO 100
Waiting for the light:
Immediate
Post-processing:
Highlights adjustment

> CREATING ABSTRACT IMAGES

I have said many times that in the landscape anything and everything is a potential subject. Given the right conditions and perfect light (yes, it does happen!), even the most mundane objects can have their moments of glory. The power of light is immense and the effect it can have on a scene, or a particular feature, is often remarkable.

However, powerful as it is, light is not the only source of transformation. Another factor that is just as effective is, quite simply, time. Over time, everything, be it man-made or natural, eventually changes. Decay will set in and, as with light, a transformation will take place – perhaps not with the same speed or immediacy, but eventually time will make its presence felt.

As a photographer, I have discovered that there is intrinsic beauty in decay. I will happily spend hours scouring the landscape, searching for the glorious colours and textures that are a marvellous result of the ageing process. You can therefore imagine my delight as I chanced

upon a discarded mound of cabbages at the rear of a farm shop. I knew that somewhere in the mountain of rotting vegetables there was a photograph waiting to be teased out. I must have caught them at the peak time, because every cabbage, indeed every leaf, looked magnificent, and it didn't take long to find and compose an image. But it wasn't quite that simple, because the light was poor; weak sunlight was directly overhead and this had a flattening effect on the leaves. It didn't look promising, but by shielding most of the light with an umbrella I was able to create strong sidelighting, which gave the cabbage shape and depth. Without the low-angled light, those seductive curves and subtle variations in colour and texture would have been lost and the picture would have failed.

This image is the result of two of nature's most powerful forces – light and time – combined together to create a display that surely had only one purpose. That was, of course, to be captured by a grateful photographer.

• Strong sidelighting has introduced contrast; the resulting tonal variations have created depth and shape and accentuated curves, textures and colour.

> **TIP:** When capturing close-up subjects, control the light by using either a shade (e.g. an umbrella) or a reflector (a large white card will suffice). These devices will enable contrast and light and shadow to be adjusted and will help to depict texture, shape and depth.

• No post-processing adjustments were undertaken.

Near Selkirk, the Borders, Scotland

Camera: Mamiya 645AFD with Phase One digital back
Lens: Mamiya 35mm (wideangle)
Filter: None
Exposure: 4 sec at f/22, ISO 100
Waiting for the light: Immediate
Post-processing: None

> CREATING ABSTRACT IMAGES SOMETHING DIFFERENT

The mountains of Snowdonia have for centuries been a mecca for painters and, more recently, photographers. Countless images exist, but the majority are sweeping views of the hills, valleys and lakes. This is a heavily photographed landscape, and in such places it can be a challenge to find new and original subjects. With this in mind I am always looking for something different, and close-up pictures are never far from my thoughts.

Cregennan Lake and its surrounding mountains encapsulate the beauty and character of Snowdonia and its inspiring locations. I have photographed the area many times, but on a recent visit I ignored the more obvious viewpoints and looked for inspiration on a smaller scale. Within an hour of exploratory searching, a small section of craggy, colourful rock caught my eye. Its diamond-shaped formation, together

with the strikingly vivid textured surface, appealed to my aesthetic senses. To my eye, this tiny morsel of towering mountain was an almost flawless pattern of nature and, as thunder rumbled ominously in the distance, I wasted no time in making the exposure.

Sometimes the appeal of an abstract subject, although strong at the time it is photographed, can diminish when it is reproduced as a small, two-dimensional image. This is often the result of perspective and scale because the impact of a picture also diminishes as its size reduces. To overcome this, it helps if the abstract arrangement isn't too complicated. Its patterns, shapes and colour must be easy to perceive and should strike a chord when viewed. The inclusion of repetitive shapes will also be beneficial because they can form the basis of an easily discernible theme.

> **TIP:** I have known small abstract images to be transformed when seen as large prints, so don't be too hasty in consigning them to the recycle bin; you might inadvertently throw out a masterpiece.

• This picture is flawed because the diamond shape is incomplete. Sadly, it was not possible to include the lower tip because it was hidden behind a round boulder. Rather than introduce another shape, I chose to maintain the simplicity and therefore cut the lower point off the diamond.

• There was a relatively high level of contrast in the picture; this was reduced by making an inverted S in the Curves tool.

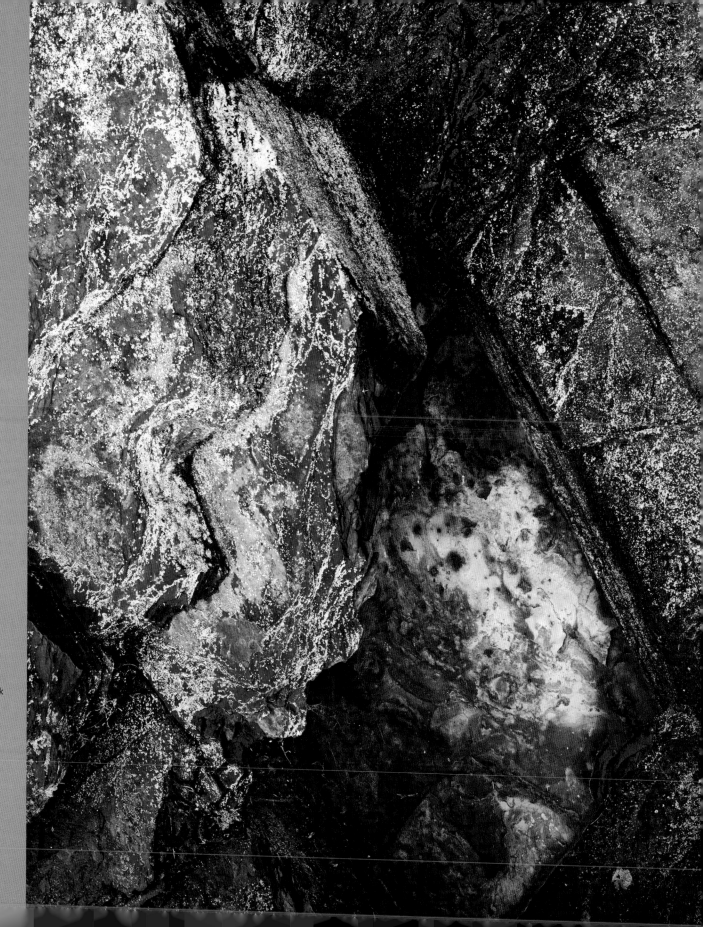

**Llyn Cregennan,
Snowdonia, Wales**

Camera: Mamiya 645AFD
with Phase One digital back
Lens: Mamiya 35mm
(wideangle)
Filter: None
Exposure: 1/2 sec at f/20,
ISO 200
Waiting for the light:
Immediate
Post-processing: Curves
adjustment

> CREATING ABSTRACT IMAGES IRRESISTIBLE BEAUTY

Water is a perennially popular subject and can, in its various forms, act as a key element in many distinctive images. It might be surprising, then, that a lack of water can also provide the opportunity for creative and original photography. But that's the beauty of nature. However hostile the conditions might appear there will always be something, somewhere, worth capturing. Despite there being other attractions, it was the bone-dry mudflats of the Dee Estuary that caught my eye. A giant jigsaw puzzle of natural beauty, they were quite irresistible.

I spent an absorbing hour scrutinizing every cracked and colourful piece of parched marshland. There were a vast number of options – so many that the choice was bewildering. I stopped searching and decided to capture just one image. It was tempting to take more, but they would have all been very similar; there is nothing to be gained from making additional exposures simply because it is easy to do so. I would rather take my time, capture just one photograph, and make every effort to ensure that it portrays the subject's characteristics and qualities as effectively as possible.

Polarizer (fully polarized)

- The polarizer has boosted colour saturation and increased contrast slightly.

- The sky was overcast and the resulting flat lighting suited the subject perfectly. Strong sunlight would have been unsuitable for capturing its delicate tonal range and textured surface.

- To compensate for a cool blue cast in the daylight the image was warmed by adding a little red and yellow using the Colour Balance tool.

> **TIP:** Beware when searching for images on a dried mudflat. The surface is likely to be fragile and can be easily fractured. Take care where you walk, as you may inadvertently ruin a picture.

The Dee Estuary, Deeside, Wales

Camera: Mamiya 645AFD with Phase One digital back

Lens: Mamiya 80mm (standard)

Filter: Polarizer

Exposure: 1/2 sec at f/18, ISO 100

Waiting for the light: Immediate

Post-processing: Colour balance adjustment

> CREATING ABSTRACT IMAGES HIDDEN IMAGES

The coastline is alive with close-up subjects. When the weather is poor and the lighting subdued, enjoyable days can be spent scouring coves and beaches for small-scale, intriguing and original images. Patience is required because, plentiful as the opportunities are, photographs are often hidden and have to be teased out from their surroundings.

Once again, it was fishing nets that caught my attention as I strolled along the coast at Onslow Bay searching for inspiration. The multi-coloured mound stood out from a distance and drew me towards it. Subjects like this have great potential, and their discovery is always a heart-lifting moment. However, I try to take a detached view, because what initially appears to be a treasure trove of images often fails to live up to expectations.

Some types of subject – an assortment of nets being an excellent example – offer an endless variety of compositional options. The number of possible shape and colour combinations is so great that it is limited only by the imagination of the photographer. There is no right or wrong arrangement and no magic formula that can guarantee success. The advice I would offer is to seek to create or reveal subtle shapes and patterns in your subject, and perhaps use colour to delineate those qualities. Flowing lines and curves photograph well and can make distinctive pictures when seen in their natural environment. Experiment with different permutations of shape and tone, and aesthetically pleasing results should begin to emerge.

• I attempted to produce an image that portrays the visual appeal and tangible quality of the fishing nets by using a combination of tonal variations and curves in the woven fabric. The curves have been accentuated by flowing lines that are raised above the background to form a centrally positioned focal point.

• Depth is depicted by the soft shadows in the folds of the nets.

• In order to enhance the depth of the folds in the nets, contrast was increased slightly by introducing an S in the Curves tool.

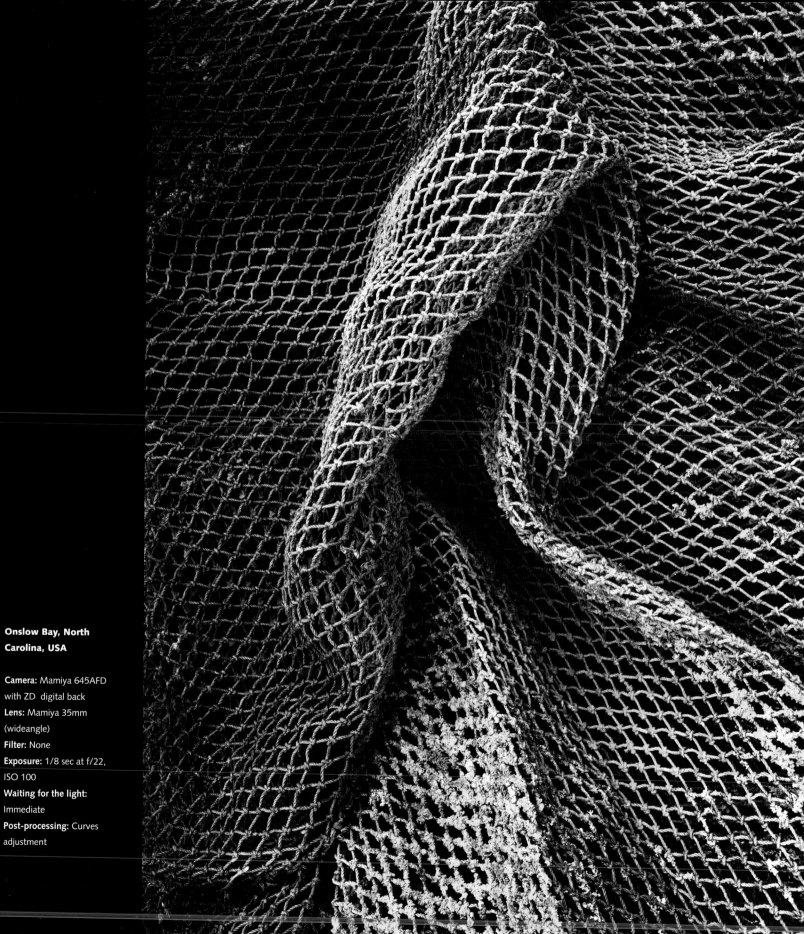

**Onslow Bay, North
Carolina, USA**

Camera: Mamiya 645AFD
with ZD digital back
Lens: Mamiya 35mm
(wideangle)
Filter: None
Exposure: 1/8 sec at f/22,
ISO 100
Waiting for the light:
Immediate
Post-processing: Curves
adjustment

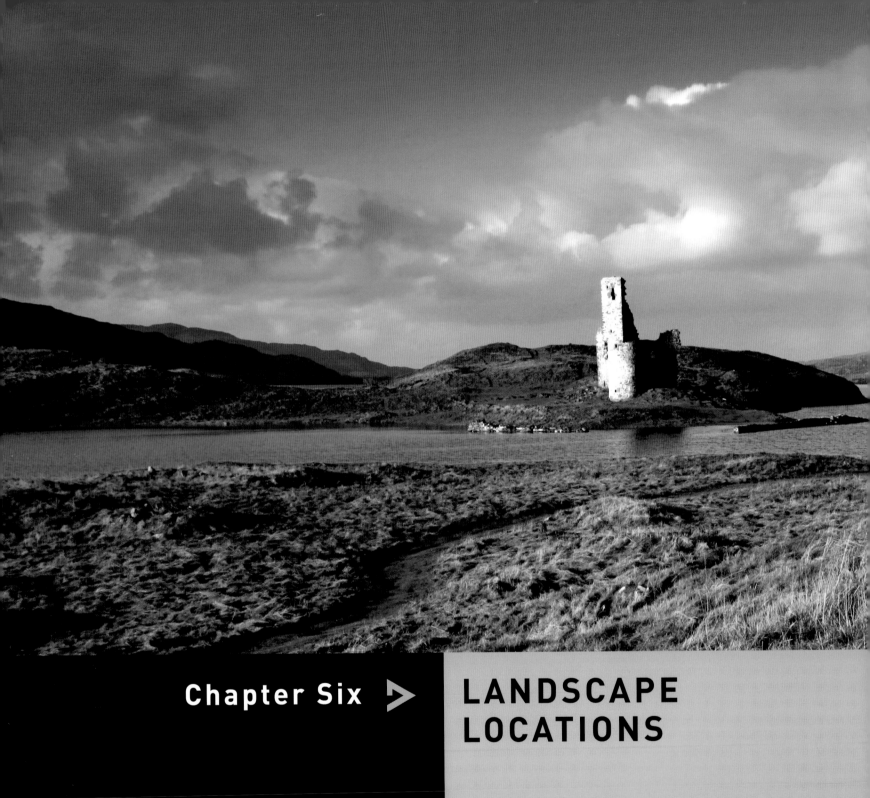

Chapter Six ▷ LANDSCAPE LOCATIONS

Ardvreck Castle, Sutherland, Scotland

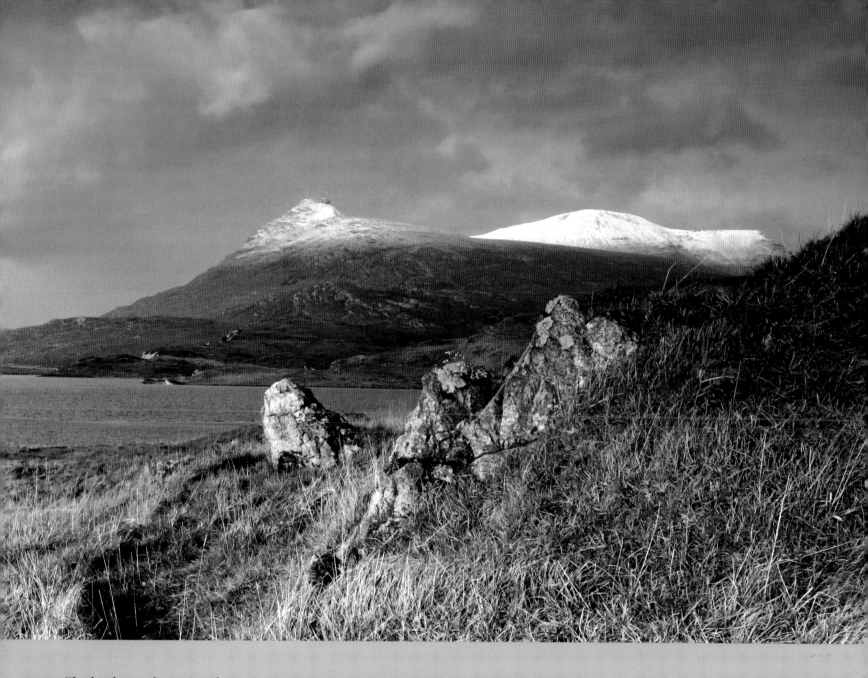

The landscape has many faces. It is vast, endlessly varied and continually changing. As a subject it is both fascinating and challenging; the wealth of material is so enormous it can be overwhelming. But it is not what you photograph, it is when; every landscape has its shining moment of glory. Unlike other forms of visual art, photography captures time. It preserves the moment and it also captures light. The two elements of light and time are a photographer's canvas and paint; how they are combined determines the success of an image.

> RURAL AND URBAN

At first glance, this scenic view might appear to be simple to capture – at least, as simple as any landscape image could be. In many ways it was, although there were some pitfalls to be avoided, one of which, to my lasting regret, I failed to overcome.

I will begin with a positive aspect and discuss the quality of light. This is a distant view and was taken with a telephoto lens; the effect of the long focal length, together with a lack of foreground, means there is very little depth.

In this type of image that can be acceptable, but to prevent the picture looking completely flat, sidelighting has been used to depict the landscape's contours and to give shape and form to the trees. Fortunately, the aspect of the viewpoint, together with the time of day

and year, has enabled the valley to be lit from precisely the right angle. As well as being sidelit, it is also slightly backlit. This is a captivating type of light and in this photograph it suits the subject perfectly.

Now, a negative point; the sloping hillside causes the picture to look unbalanced and, while there is no remedy for this, the sky could have been used to minimize the visual effect. Sadly I have failed to achieve this. To balance the upper portion of the image, there should be a group of clouds in the left corner. They should be clear and distinct and, had that been the case, the hillside and sky would have been in harmony. But the concentration of the clouds is to the right, which exacerbates the imbalance. I waited as long as possible, but eventually I had to accept the sky as it was to avoid losing the precious light. So, perfect light but disappointing sky. Perhaps I will return one day to try again.

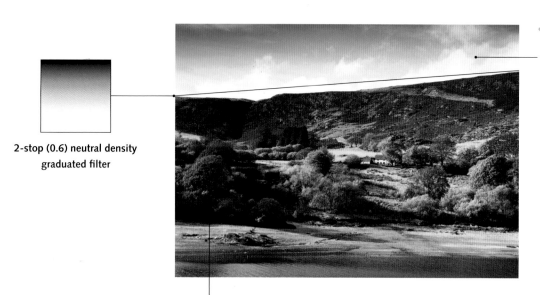

2-stop (0.6) neutral density graduated filter

Had these clouds been in the left corner they would have helped to redress the imbalance caused by the sloping hillside.

> TIP: A pitfall to be avoided when including trees in an image is allowing the edge of the frame to cut into them. If possible, compose your photograph in such a way that all trees are left intact with a little space separating them from the picture's border.

The image was warmed by adding a small amount of red and yellow using the Colour Balance tool.

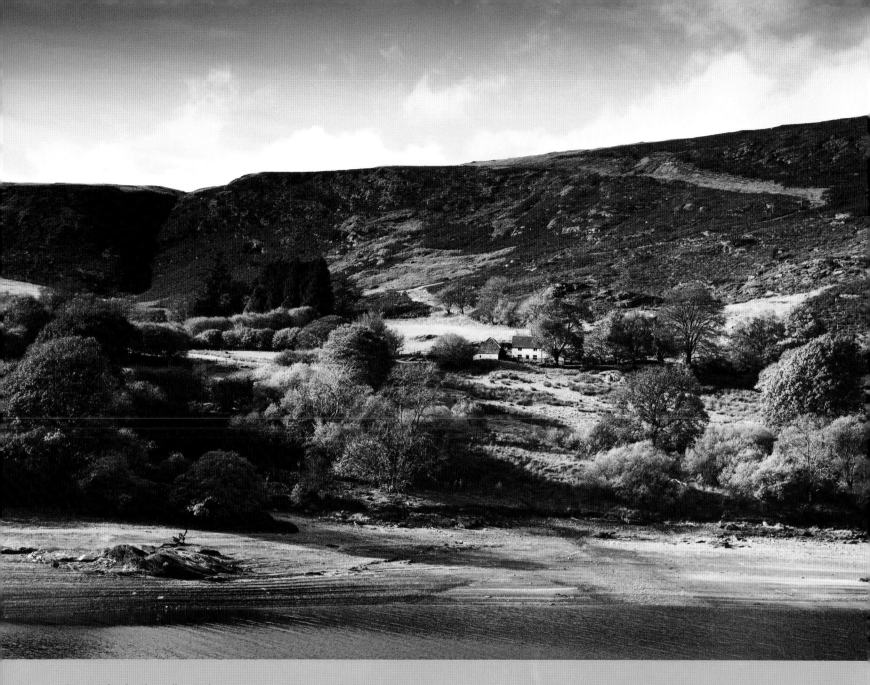

Carreg Ddu, the Elan Valley, Wales

Camera: Canon EOS 7D

Lens: Sigma 17–70mm

Filter: 2-stop ND graduated

Exposure: 1/40 sec at f/9, ISO 100

Waiting for the light: Immediate

Post-processing: Colour balance adjustment

> RURAL AND URBAN CATCHING THE COLOURS

Catching autumn at its peak is not as easy as it once was (not that it ever was easy). In recent years, it has been occurring later, but precisely when is difficult to predict. To further complicate matters, it also seems to be showing more pronounced regional variations. From one end of Britain to the other, autumn colour can now be seen somewhere from late September through to the end of November, but precisely where and when is virtually anyone's guess. The only solution is to monitor locations on a regular basis from late summer onwards. If they are some distance away, then remote monitoring is sometimes possible.

I often check with regional tourist offices or other local resources before making a journey. Their information can be helpful to a certain extent, but there are no guarantees. Colour can suddenly erupt in a blaze of glory and then disappear just as quickly. Luck, as usual, plays a part. What can be guaranteed, though, is that those who make the greatest effort will reap the greatest rewards. My advice is to get out in the field as often as possible. At some point you will be in the right place at the right time and then that sought-after image will be just a click of the shutter away.

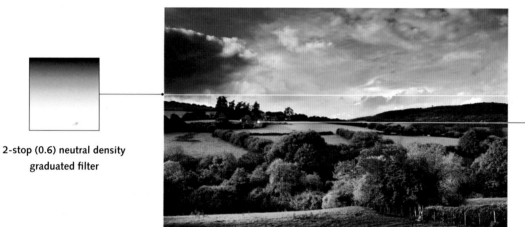

2-stop (0.6) neutral density graduated filter

• Notice how the brightly coloured farm, although small, attracts the eye. This draws attention towards the horizon and helps to give the picture depth and scale.

• An autumn landscape will often benefit from a little warming. In this picture it has been achieved by adding a small amount of red and yellow using the Colour Balance tool.

> **TIP:** The quality of light used to photograph a scene should be appropriate to the nature of the landscape. Here it is lit by soft sunlight from one side. The angle and intensity of the light has enabled the shape and colour of the trees to be portrayed, and has also given a textured appearance to the field in the foreground. The quality of the light is very important in this image and there was little margin for error. Stronger sunlight would have interfered with the landscape's delicate tonal range, while softer illumination would have caused the photograph to look flat and uninteresting.

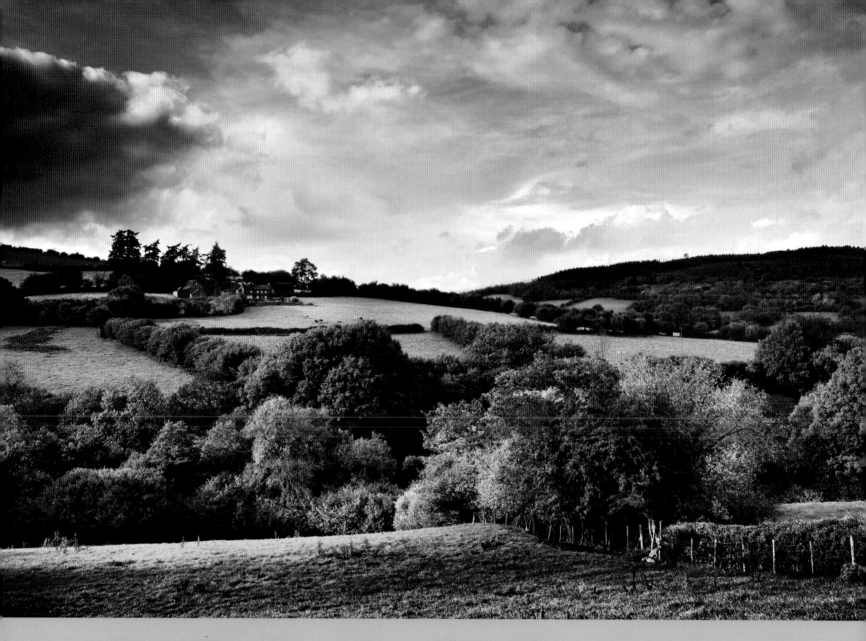

Near Cwm Crawnon, the Brecon Beacons, Wales

Camera: Mamiya 645AFD with Phase One digital back

Lens: Mamiya 35mm (wideangle)

Filter: 2-stop ND graduated

Exposure: 1/8 sec at f/15, ISO 100

Waiting for the light: 2 hours

Post-processing: Colour balance adjustment

> RURAL AND URBAN GO WITH THE CURVE

To my eye, there is something very beautiful about curves. Lacking harsh angles and abrupt intersections, their flowing lines are visually soothing and relaxing; when present in a landscape they bring those qualities to a photograph. If pastoral charm and serenity is to be your picture's theme, the inclusion of curves and gently flowing lines will help to convey that feeling.

Undulating landscapes appeal to me both because the natural curves of their contour lines are a joy to photograph, and because they make attractive focal points around which an image can be composed. It was therefore with mounting anticipation that I climbed to the summit of a steep incline to gain a better view of the rolling hills of Wensleydale in the North Yorkshire Dales. The ascent was the culmination of a

gruelling two-mile trek across valleys and fells, but the viewpoint was worth every step. Everything was perfectly placed and, miraculously, at the centre of it all was a marvellous, tree-lined curved hillside. If I were to design a landscape then this would undoubtedly be it. The weather was dreadful at the time, but I knew that, however long it took, I would capture this flawless view.

As you can see, I did succeed – eventually. From beginning to end it took a total of ten days for the right conditions to materialize. It was worth the wait, but it was no great hardship anyway. The Yorkshire Dales is a world-class landscape and there are few places I would rather be. Ten days waiting? I have known a single day to last longer.

2-stop (0.6) neutral density graduated filter

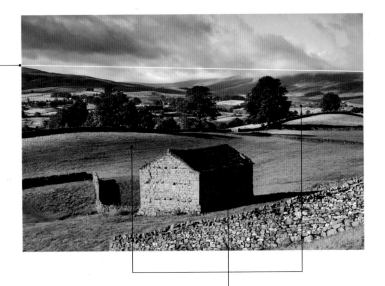

- The ND graduated filter has reduced the brightness of the sky and prevented it from being overexposed. This enables the sky's tonal range to be accurately recorded.

- The right quality of light was critical to the success of this picture. Low-angled morning light has given shape and depth to all the individual elements. The stone wall, barn, hillside, trees and distant hills have all benefited from the patterns of sunlight and shadow that have been created as a result of sidelighting.

- No post-processing adjustments were undertaken.

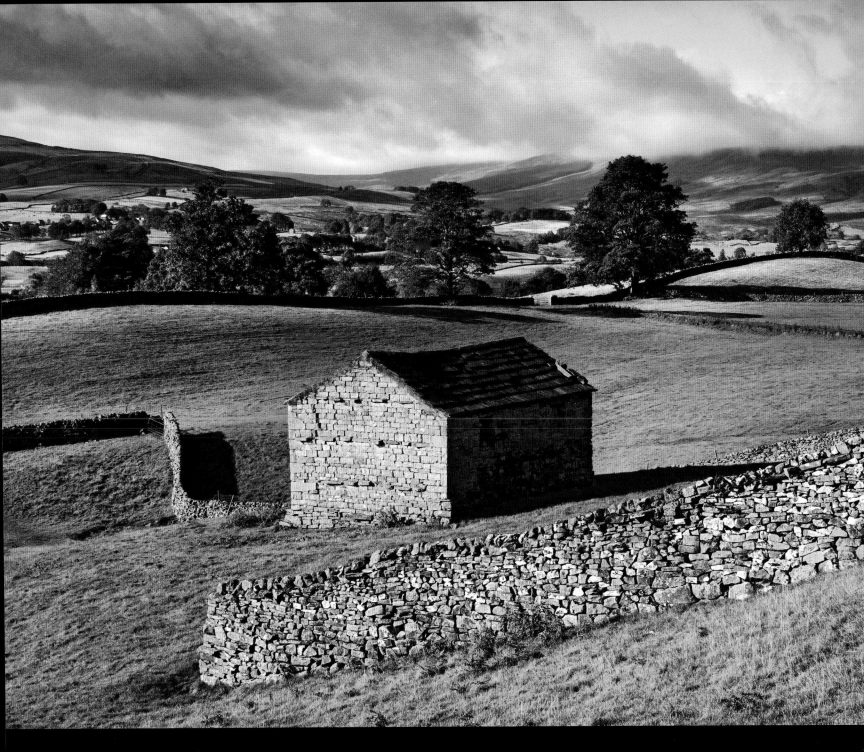

Near Hawes, the Yorkshire Dales, England

Camera: Mamiya 645AFD with Phase One digital back

Lens: Mamiya 80mm (standard)

Filter: 2-stop ND graduated

Exposure: 1/15 sec at f/16, ISO 100

Waiting for the light: 10 days

Post-processing: None

> RURAL AND URBAN LAST OF THE LIGHT

Although not apparent when looking at this picture, this was captured in virtually the last light of the day. The somewhat premature end to the daylight was the result of the height of the surrounding hills, which, during the winter months, plunge this deep valley into shadow at an unreasonably early hour. The image was taken in mid-November and, at that time of year, the already short days of winter become a great deal shorter in this particular location. This often happens in hilly or mountainous areas; as a rather crude rule of thumb, it can generally be assumed that the more undulating the location, the shorter the opportunity to photograph it.

Although the sunlight is still strong, you can see the shadows starting to creep ominously across the floor of the valley. Within minutes of the shutter being released, everything was engulfed and 18 hours would pass before the shadow lifted. Even though the days are short, it isn't necessarily an obstacle to quality image-making. At this time of year what we lose in quantity of light is more than compensated for by quality, and it is invariably quality that counts.

2-stop (0.6) neutral density graduated filter

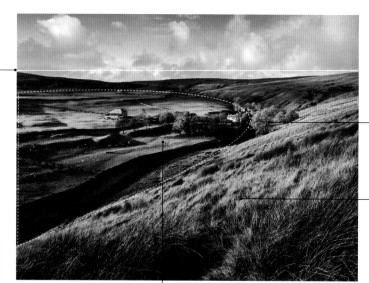

- The shadows cast by the low winter sunlight have delineated the shape and contours of the hills. The angle of the sun was also important because it enables the farm, which is the main focal point, to be brightly lit.

- Lasso (inverse selection) – feathered edge 100 pixels.

- Contrast was increased by making an S in the Curves.

- I wanted to warm the image, but the bright green grass of the hillside was an important feature and I wanted to leave that part of the subject untouched. This was achieved by selecting the green hillside with the Lasso tool and then making an inverse selection. This enabled everything except the hillside to be warmed, which was done by adding a small amount of red and yellow via the Colour Balance tool.

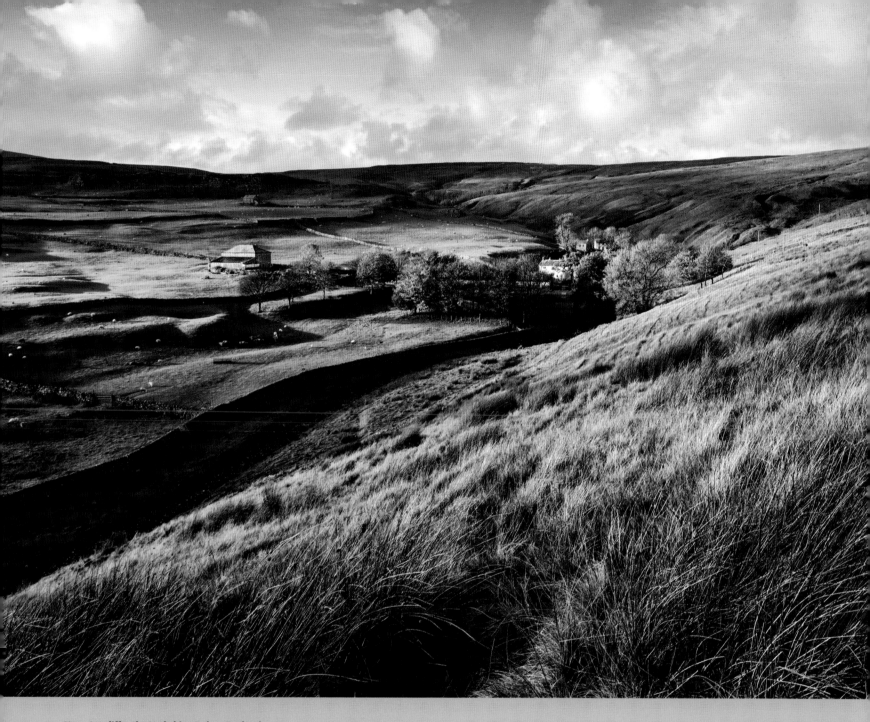

Near Arncliffe, the Yorkshire Dales, England

Camera: Mamiya 645AFD with ZD digital back

Lens: Mamiya 35mm (wideangle)

Filter: 2-stop ND graduated

Exposure: 1/8 sec at f/22, ISO 100

Waiting for the light: 2 days

Post-processing: Curves and selective colour balance adjustment

> RURAL AND URBAN RESISTING IMPULSES

I can happily spend hours strolling through ancient towns, as there is so much to see. Although you don't need to be a photographer to enjoy the experience, the possibility of making new and original images enhances the occasion. Some places ooze with character and it can be totally absorbing to explore their alleyways and courtyards, searching for subjects. There can be a lot to see and it is sometimes difficult to decide exactly what to photograph. That was certainly my experience as I wandered through the historic town of Treguier in northern Brittany; there were pictures everywhere, and I was becoming overloaded with ideas. I took a break and gathered my thoughts.

In the past I have had a tendency to be trigger-happy in these situations. I have then been burdened with several photographs that were all similar or virtually identical, and many were subsequently discarded. Rather than undertaking the editing process after capturing the images I now do it beforehand, while my camera is locked away in its case and out of reach. There is no longer any impulsive shutter-clicking and photographs are made only after carefully considering the various options and objectively assessing all potential subjects. I restrict myself to a maximum of three images of any one location. Often I set myself a challenge and attempt to capture just one photograph that encapsulates the character of a town. This concentrates the mind and acts as a catalyst for creativity. Restricting your output to just one picture can be a useful exercise and, if towns and buildings interest you, I recommend that you try this approach. You might discover what the power of creative thinking and perceptive observation can do for your photography.

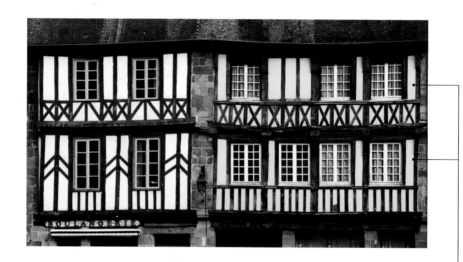

• The sky was overcast and the light soft. As a result the image lacked contrast, so this was adjusted by making an S in the Curves tool.

> **TIP:** If space permits, converging parallel lines in a building can be avoided by photographing from a distance with a telephoto lens. This enables the building to be captured without having to point the camera upwards, and vertical lines will therefore remain parallel. A spirit level also helps to ensure that the camera, and therefore the building, is perfectly straight.

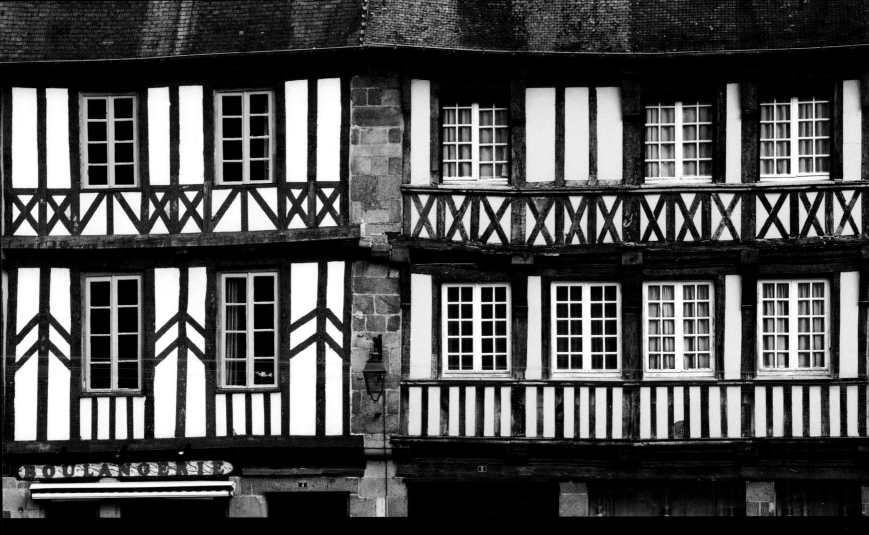

Treguier, Brittany, France

Camera: Canon EOS 7D

Lens: Sigma 17–70mm OS

Filter: None

Exposure: 1/80 sec at f/11, ISO 100

Waiting for the light: Immediate

Post-processing: Curves adjustment

> LAKES, RIVERS AND WATERFALLS

Overcast days should not be written off; they can be put to good use photographing certain types of subject. For example, close-up images and waterfalls and rivers are particularly suited to flat, shadowless light, as are subjects that have an intricately varied tonal range.

I was nearing the end of two weeks in Scotland, and the fine weather that had prevailed for much of that time was coming to an end. The sky was overcast, so I headed for Blair Atholl, in the heart of the Highlands. Not to the famous whisky distillery, although that was tempting, but to the Falls of Bruar, a series of waterfalls found along the meandering Bruar Water. The water flows through a heavily wooded gorge and, having researched the area, I knew that it was a promising location.

The falls occurred at regular intervals but, in the absence of abseiling equipment (which has yet to find its way into my kit bag!), much of the river was inaccessible. This is often the case with steep gorges and, in any case, I could see from my map that there were a number of more easily reached parts that also looked interesting. Drought is rare in the Highlands, so its rivers and waterfalls are usually flowing vigorously – and where there is gushing water there are always photographs.

I took several that day, but the one opposite is perhaps the most distinctive. I particularly like it because it shows the waterfall in its wider environment; the craggy, variegated gorge walls that enclose it are a very important feature. The water and surrounding rock both make an equal contribution. One without the other would fail to make a complete picture; therefore both were essential to the success of the image. To emphasize the connection between water and rock, I used a telephoto lens to compress distance and bring both elements together. Depth is reduced, but the overall visual impact is perhaps strengthened.

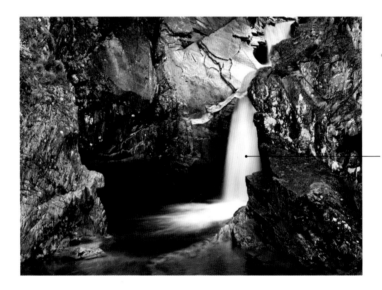

- The telephoto lens has reduced the depth between the foreground rocks and the waterfall. This has magnified the size of the cascading water and prevented it from being lost in its surroundings.

- No post-processing adjustments were undertaken.

> **TIP:** Waterfalls benefit from being photographed in flat, shadowless light, as do strongly variegated subjects. In this image, the presence of strong sunlight would have ruined the delicate tonal range that exists across all parts of the picture because of the resulting increase in contrast.

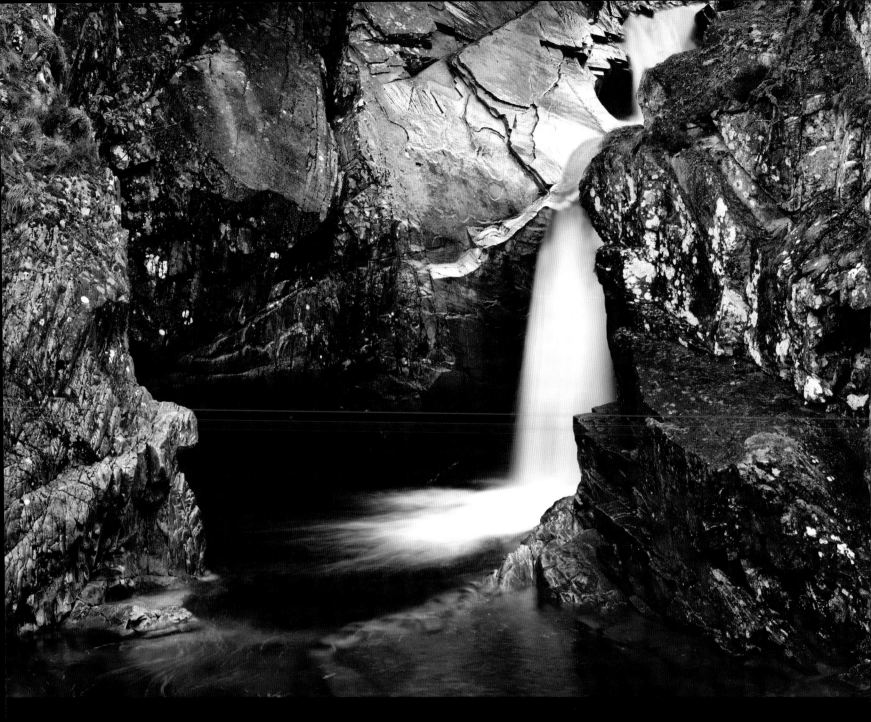

Falls of Bruar, Perthshire, Scotland

Camera: Mamiya 645AFD with ZD digital back
Lens: Mamiya 150mm (telephoto)
Filter: None
Exposure: 2 sec at f/25, ISO 100
Waiting for the light: Immediate
Post-processing: None

> LAKES, RIVERS AND WATERFALLS POTENTIAL PITFALLS

Waterfalls are a popular subject for artists of many disciplines, but it is perhaps to the photographer that they offer most potential. Photography's unique ability to capture and fuse together moments in time really comes into its own with moving objects, and what finer example can there be than a vigorously flowing, cascading waterfall?

Like many photographers, I relish the challenge of transforming a raging torrent into something beautiful. A photograph can perform this miracle, but every element in the picture has to be carefully considered if this creative feat is to be achieved. In theory, waterfalls are simple to capture; in practice, there are a number of potential pitfalls that must be avoided. One of the most common defects in water-themed photographs is a lack of tonal variation in the subject; this occurs when large expanses of unbroken white wash and spray are present. They

should either be totally excluded or minimized as much as possible. The most effective way to do this is to choose and compose your subject carefully. Look for waterfalls that are flowing over a rugged surface where protruding rocks are clearly visible. The presence of a rocky base will add shape and definition to the water and enhance the overall appearance of the picture. Foreground rocks will also help because they add colour and depth and provide a platform on which the image can be built.

Waterfalls are an excellent subject for the camera and fine images can be made with the right combination of flowing water and solid rock. Spend time experimenting with different compositions and viewpoints and you should be rewarded with some fine photographs.

Polarizer (fully polarized)

> **TIP:** When photographing a waterfall, use foreground rocks to give the image depth and additional visual interest.

• The presence of a clearly visible rugged rockface beneath the water has prevented any loss of definition in the highlights. Detail has been retained across the entire tonal range and this greatly enhances the appearance of the waterfall.

• The image was warmed slightly by adding a small amount of red and yellow using the Colour Balance tool. This was to compensate for a cool cast that was caused by a cloudy, overcast sky.

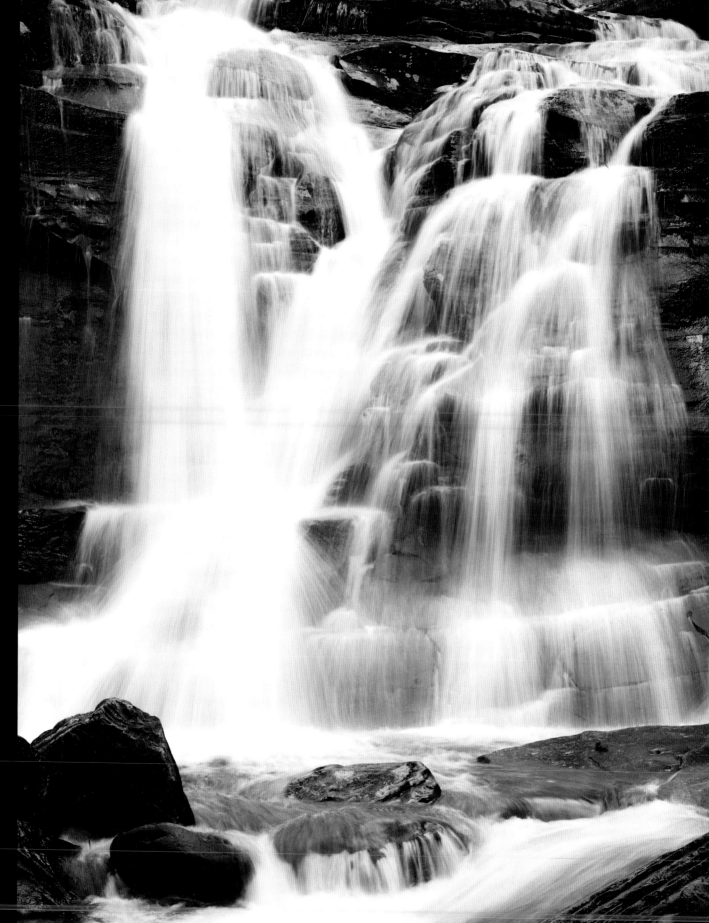

**Kaaterskill Creek,
New York State, USA**

Camera: Mamiya
645AFD with ZD
digital back
Lens: Mamiya 80mm
(standard)
Filter: Polarizer
Exposure: 1/2 sec at
f/16, ISO 100
Waiting for the light:
1 hour
Post-processing: Colour
balance adjustment

> LAKES, RIVERS AND WATERFALLS DIFFERENT VIEWPOINTS

If you compare this picture with the image on the previous page you will see that it was taken from the same place. Actually it is not exactly the same place; this photograph was taken at Kaaterskill Creek, but from a different viewpoint. In this case the camera position, as you can see, is more distant. It is a wider, more open view and there is greater emphasis on the stream and the foreground rocks. Although they portray the same subject, the two pictures are quite different and both, in my opinion, have their merits. I couldn't decide which was the stronger of the two at the time of taking them and I am still not sure.

Indecision can often arise when photographing streams and waterfalls because they offer so many different options. Narrowing the choices down to just one picture can be difficult. In these situations, capture however many images (within reason) you feel inspired to take. If you make just a single exposure you may be left feeling that a stronger composition was lurking somewhere in the river. Leave no stone unturned; look, examine and think creatively and a variety of images should begin to emerge from the flowing waters. Do ensure, though, that your pictures are all different. There is nothing to be gained by capturing an unimaginative, repetitive theme. Discard similar photographs before, not after, you take them.

Polarizer (fully polarized)

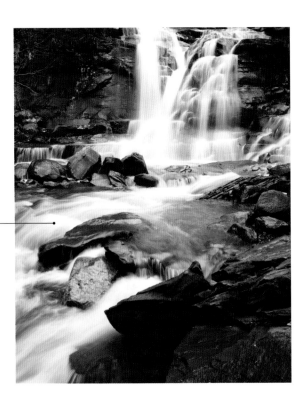

> **TIP:** Use flat, shadowless light when photographing this type of subject. Avoid bright sunlight because it will create too much contrast and the highlights on the water will lose definition.

• The polarizing filter absorbed 2 stops of light, which enabled a shutter speed of 1/2 sec to be used. The relatively long exposure has improved the image by blurring and softening the water. To create this effect, an exposure of between 1/4 and 2 sec will usually be required.

• Unlike the earlier picture on page 133, this one has not been warmed. Compare both images and the difference in their colour balance will be apparent.

• No post-processing adjustments were undertaken.

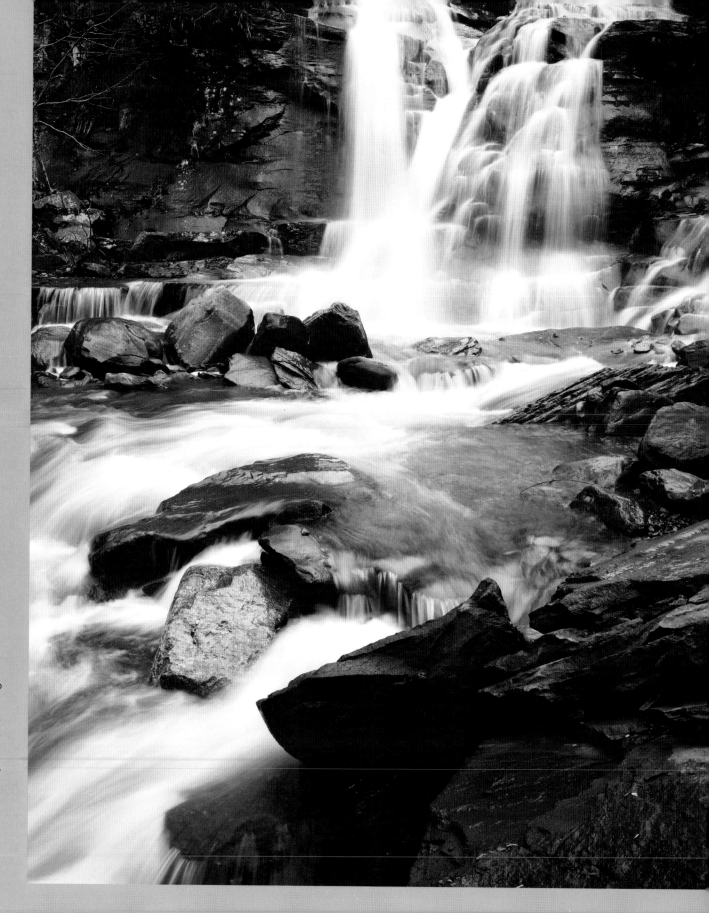

**Kaaterskill Creek,
New York State, USA**

Camera: Mamiya 645AFD
with ZD digital back
Lens: Mamiya 35mm
(wideangle)
Filter: Polarizer
Exposure: 1/2 sec at f/16,
ISO 100
Waiting for the light:
1 hour
Post-processing: None

The avoidance of large areas of bleached-out highlights, as discussed on page 132, also applies in reverse. Expanses of dark, featureless tones should also be excluded, particularly monotonous grey or black rocks; the lack of detail on their surface will detract from a picture's appearance. Colourful or lighter-toned boulders should be used whenever possible.

The combination of richly coloured rocks and flowing water is potentially very powerful, and can look striking when photographed with the right composition. This is particularly so when the rocks are positioned directly in front of the camera, with the viewpoint looking along the length of a cascading river and the water flowing forwards. The best positions are nearly always the most inaccessible, and this is certainly the case when photographing waterfalls. Knee-length waterproof boots are as essential as a sturdy tripod.

The importance of having the right equipment should not be underestimated. I recall an occasion when I was standing knee-deep in water in the middle of a river in Scotland. It was a good position and undoubtedly the best place to be if the strongest images were to be made. There was another photographer standing at the edge of the river working enthusiastically with his camera mounted on a robust-looking tripod. He seemed to know what he was doing, but kept glancing in my direction with what seemed to be a slightly wistful expression. His adherence to what was unquestionably an inferior position puzzled me until I realized he was wearing lightweight shoes. My fellow photographer had no choice but to remain at the side of the river; doubtless his lack of basic equipment directly affected the quality of his images on that occasion. I urge you not to find yourself in a similar situation: always be adequately equipped for the environment in which you are operating.

Polarizer (fully polarized)

• The polarizer served two functions. It increased exposure by 2 stops, which enabled me to use a shutter speed of 1 sec. This gave the water a soft and silky smoothness, which would have been lacking with a shorter exposure. The filter also reduced surface reflections on the wet foreground rocks, which has strengthened their colour.

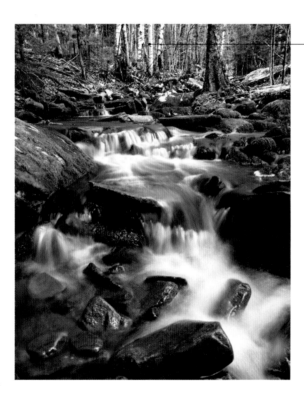

> **TIP:** Avoid including the sky in this type of image. The only highlights should be the cascading waters.

• No post-processing adjustments were undertaken.

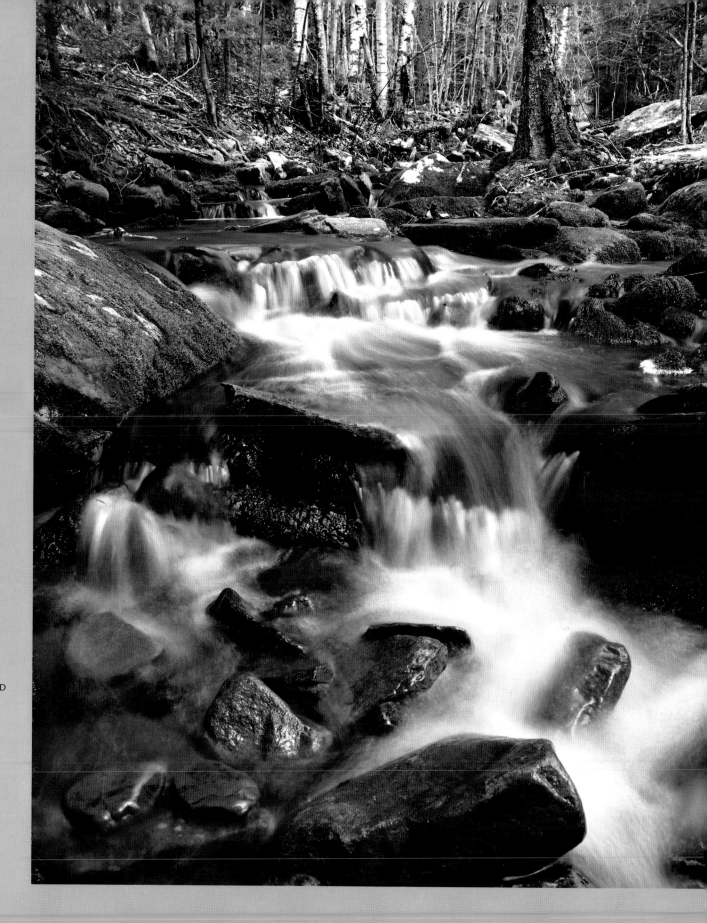

**Batavia Kill River,
New York State, USA**

Camera: Mamiya 645AFD
with ZD digital back
Lens: Mamiya 35mm
(wideangle)
Filter: Polarizer
Exposure: 1 sec at f/22,
ISO 100
Waiting for the light:
2 hours
Post-processing: None

> LAKES, RIVERS AND WATERFALLS USING FILTERS

There are only a small number of filters that can, if used properly, improve the appearance of a landscape image. The polarizer is the most versatile of these; it should be in every photographer's kit bag because it can transform many pictures.

The filter works by absorbing polarized light; this reduces reflections from everything except metal surfaces. Reflections are everywhere, although they might not always be apparent. Light reflects off water droplets that are present in the sky and on grass, vegetation and foliage and, when moisture is present, on pretty much everything else, including water itself. The filter is a very effective means of saturating and enriching colour. It will darken a blue sky without affecting the appearance of clouds, and can strengthen the colour and contrast of many landscapes, particularly when shiny-leaved foliage is present.

The absorption of reflections gives the polarizer the apparently magical ability to make water appear transparent, particularly along the edge of a lake, for example, where the water is shallow. Submerged rocks and pebbles can be made to almost leap out of the water to make a strong and compelling foreground. Maximize their presence by positioning your camera as close as possible – stand in the lake if necessary, your tripod won't mind getting wet! – and make the most of attractive foreground features. Build your images around it and your photography will take on a new dimension.

A side effect of the polarizer is that it absorbs approximately 2 stops of light. This can sometimes be a disadvantage, but it can be beneficial in some situations. Bear this in mind when using the filter, as a longer shutter speed (or larger aperture) will be necessary.

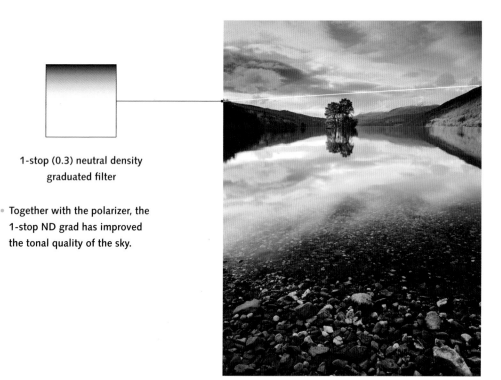

1-stop (0.3) neutral density graduated filter

- Together with the polarizer, the 1-stop ND grad has improved the tonal quality of the sky.

Polarizer (fully polarized)

- The polarizer has reduced surface reflections on the foreground pebbles. It has also strengthened the sky's reflection on the lake's surface as well as improving the appearance of the sky.

- No post-processing adjustments were undertaken.

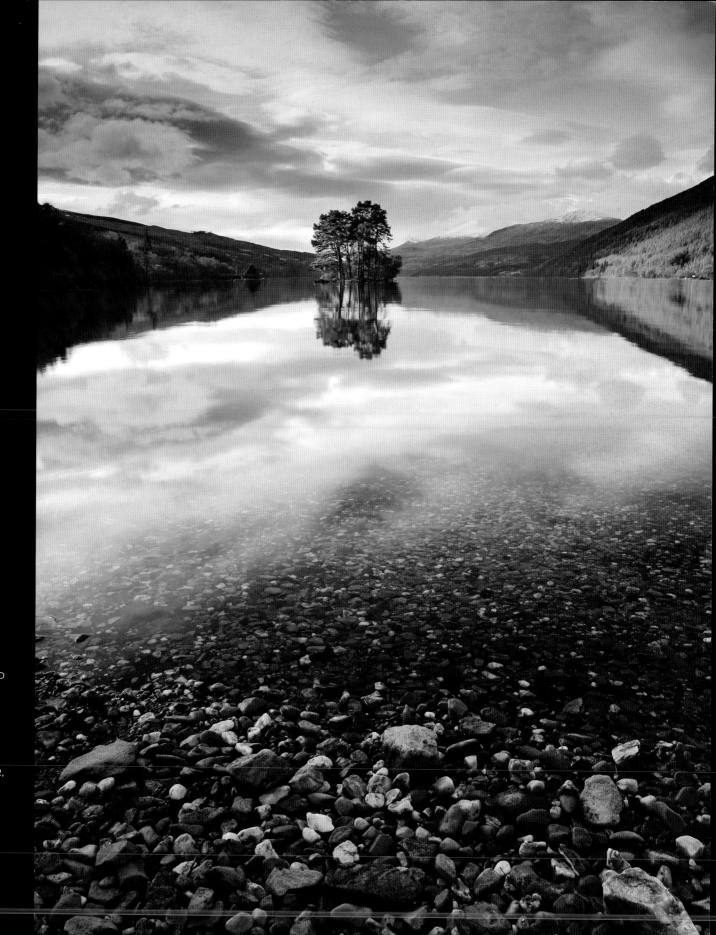

Loch Tay,
Perthshire, Scotland

Camera: Mamiya 645AFD
with ZD digital back
Lens: Mamiya 35mm
(wideangle)
Filters: Polarizer, 1-stop
ND graduated
Exposure: 1/4 sec at f/22,
ISO 100
Waiting for the light:
3 days
Post-processing: None

> LAKES, RIVERS AND WATERFALLS USING POLARIZERS

The polarizer is a very effective – sometimes almost magical – filter. It can be an indispensable aid and can make a vast difference to certain types of subject. There are occasions when it can transform an image to the point of elevating it from the mundane to the magnificent. This is the result of the filter's unique ability to polarize light; as this cannot be achieved or successfully replicated in post-processing, the polarizer is as important today as it was on its first introduction over 50 years ago.

The combination of a blue sky, white clouds and the calm surface of a tranquil lake will always benefit from being polarized. With this type of picture, the filter boosts colour and impact and enhances the appearance of the sky by accentuating the presence of the clouds. However, caution must be exercised because unbroken expanses of cloudless sky and water are prone to uneven or over- darkening. The presence of clouds

helps to minimize the effect in the sky, as does using a portrait rather than a landscape format. Water, however, is another matter. If there are deep blue reflections on a lake's surface they can, when polarized, darken to such an extent that they become almost black. To a degree this can be prevented by reducing the amount of polarization (i.e. by turning the filter just half a rotation). Another solution is to fully polarize the image, then adjust the dark areas in post-processing.

In the picture opposite I chose the latter option; I lightened the water in the foreground by using a combination of Curves and the Shadows/Highlights tool. By fully polarizing the image and then pulling back the over-darkened water, the photograph displays acceptable tonal rendition across all areas. This enabled all parts of the lake to be captured at their glorious best.

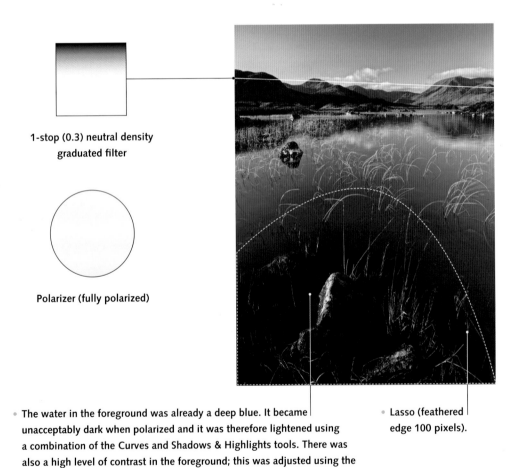

1-stop (0.3) neutral density graduated filter

Polarizer (fully polarized)

• **The water in the foreground was already a deep blue. It became unacceptably dark when polarized and it was therefore lightened using a combination of the Curves and Shadows & Highlights tools. There was also a high level of contrast in the foreground; this was adjusted using the Curves tool. The area was first selected by using the Lasso tool to prevent other parts of the picture from being affected by the adjustment.**

• **Lasso (feathered edge 100 pixels).**

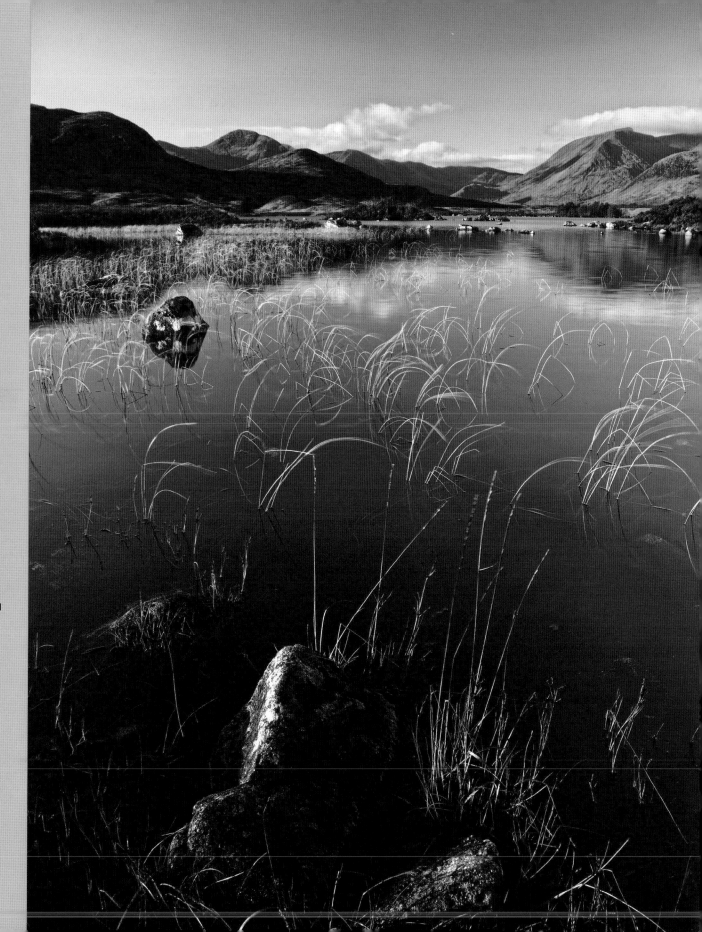

**Loch Nah Achlaise,
the Highlands, Scotland**

Camera: Mamiya 645AFD
with ZD digital back
Lens: Mamiya 35mm
(wideangle)
Filters: Polarizer, 1-stop
ND graduated
Exposure: 1/2 sec at f/22,
ISO 100
Waiting for the light:
10 days
Post-processing: Selective
curves, and shadows/
highlights adjustments

> LAKES, RIVERS AND WATERFALLS ACCEPTING THE CHALLENGES

The Scottish Highlands are truly majestic. Home of Britain's highest mountains, it is a vast region of moors, lochs and glens and a magnet for landscape photographers. Undoubtedly one of the most magnificent parts of the UK, it is also one of the most frustrating to photograph. The problem, as you might have guessed, is the weather. Cloud and rain are never far away and conditions can often be challenging. We shouldn't complain, though, because without the rain there would be no lakes or moorland, fewer rivers and less varied flora. The Highlands needs rain as much as we need air, and its weather, frustrating as it can be, is an essential feature of the awe-inspiring Highland experience.

The idyllic sunset pictured here had been preceded by almost a week of howling gales and heavy rain. As the wind relented and the sun finally emerged from hibernation, the long, frustrating days of waiting were quickly forgotten as I set up my camera to record the glorious moment. The glowing embers quickly peaked and then just as quickly faded, but it didn't matter because those precious seconds had been safely captured, and a glimpse of the Highlands at their most resplendent preserved for eternity. This sunset was going to live another day.

1½ stop (0.45) neutral density
graduated filter

> **TIP:** Use a polarizer to improve the transparency of a lake. This will help to reveal submerged pebbles and add interest to the foreground.

- There is usually a difference of 1–1½ stops between sky and water. A 1½-stop ND grad was therefore used to balance the two exposure values. The filter has enabled an exposure setting to be used that has allowed some detail to be recorded in the foreground rocks.

- The sky was partly warmed by strengthening just the red portion using the Selective Colour tool. I felt this was preferable to a general warming of the whole image, as I liked the contrast of the red sunset against the cool tones of the sky and lake. The ability to undertake selective colour adjustments is one of the advantages of making changes in post-processing rather than at the time of capture.

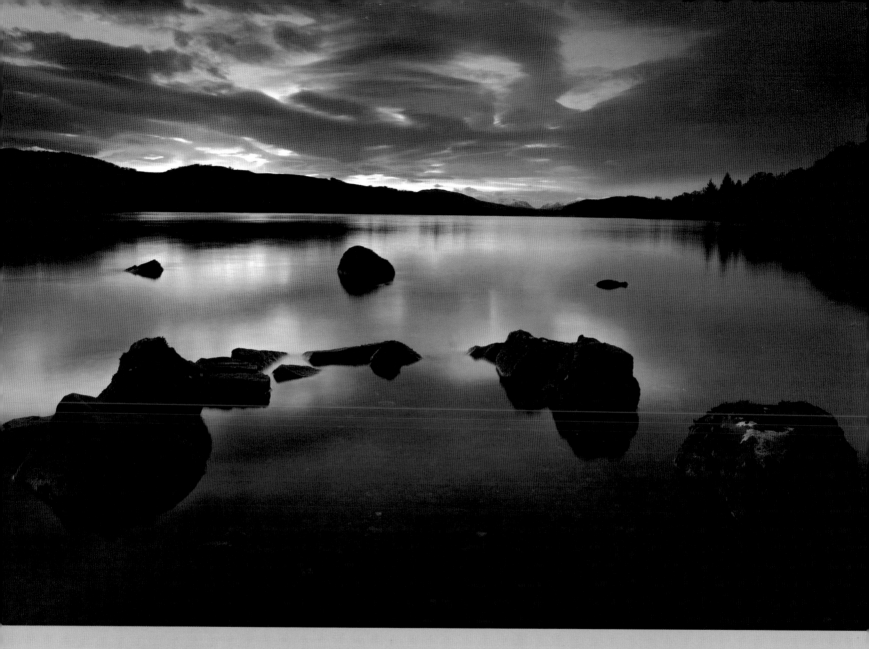

Loch Rannoch, Perthshire, Scotland

Camera: Mamiya 645AFD with Phase One digital back
Lens: Mamiya 35mm (wideangle)
Filter: 1½-stop ND graduated
Exposure: 6 sec at f/22, ISO 100
Waiting for the light: 6 days
Post-processing: Selective colour balance adjustment

One of the benefits of digital capture is the ability to assess the image at the time of exposure. In the days of film, it was usually necessary to bracket exposure by taking three or four pictures of different aperture/shutter speed settings in quick succession in the hope that one of them was accurate (it wasn't quite as hit and miss as that, but there was often a degree of uncertainty). Now, in the digital age, the histogram enables the image to be instantly viewed and analyzed. This is useful for exposure purposes, and also allows colour balance and contrast levels to be assessed. This is a tremendous aid when photographing outdoors where lighting cannot be controlled by the flick of a switch. It provides invaluable information and gives the photographer the opportunity to take immediate corrective action.

I am an ardent fan of the histogram. I find it very helpful, and indeed reassuring, to be able to study graphic information of a newly taken photograph. It tells me if my expectations of the image are likely to be met or not, and helps me to consider what improvements could be made. The ability to do this in the field, at the time of capture, is a huge step forward; I would encourage every photographer to embrace this marvellous tool. Use the histogram regularly and the results will show in your photography.

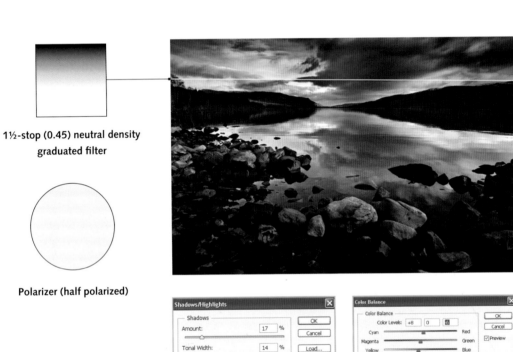

1½-stop (0.45) neutral density graduated filter

Polarizer (half polarized)

• Careful analysis of the histogram enabled both exposure and contrast to be accurately measured. There were different exposure values in the sky, water, distant hills and foreground and the extremes of these exceeded the latitude of the image sensor. Using a combination of a 1½-stop ND grad and a half-strength polarizer reduced the contrast levels (the polarizer also reduced bright reflections on the lake's surface); this was further refined in post-processing using the Curves and Shadows & Highlights tools. The histogram was a great help in ensuring that detail was recorded across the entire tonal range of the image.

• The picture has been warmed by slightly increasing red and yellow via the Colour Balance tool.

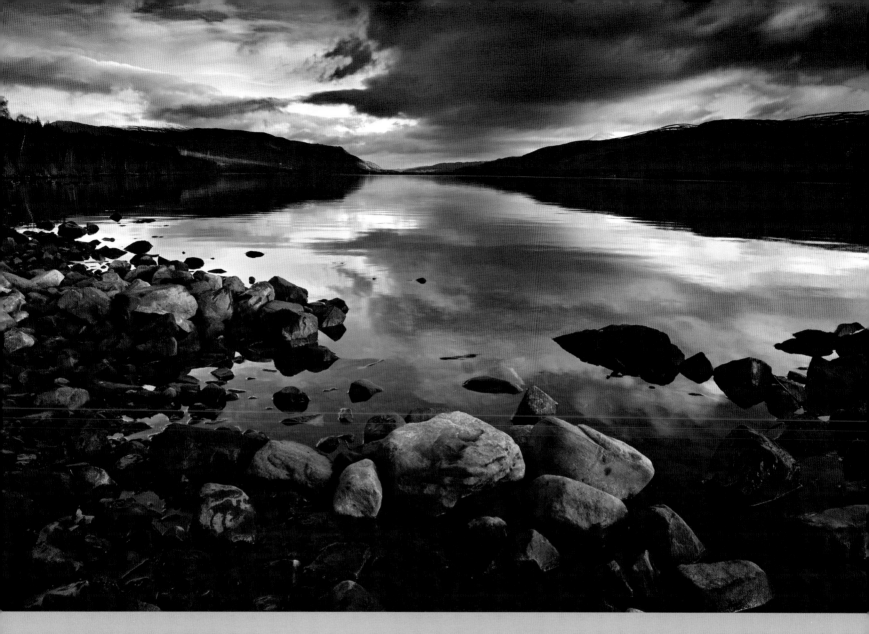

Loch Rannoch, Perthshire, Scotland

Camera: Mamiya 645AFD with ZD digital back

Lens: Mamiya 35mm (wideangle)

Filters: Polarizer, 1½-stop ND graduated

Exposure: 1 sec at f/22, ISO 100

Waiting for the light: 5 days

Post-processing: Curves, shadows/highlights and colour balance adjustments

> LAKES, RIVERS AND WATERFALLS FOCAL POINTS

The importance of including focal points in images of large, sweeping views has been discussed in an earlier chapter. In the previous pictures, focal points were shown to be an essential feature because of their ability to draw the eye into a photograph, create scale and depth, and act as a visual anchor for a picture's other elements. Although they are most commonly used in scenic views, focal points can also play an important role in other types of landscape image. Although their presence might not be immediately apparent, they can improve other, slightly smaller-scale, subjects. This includes rivers and waterfalls, particularly when there is some depth and distance in the photograph.

A flowing river with an attractive and balanced combination of cascading water and colourful, shapely rocks is, in theory, simple to capture. The basic requirements – soft light, a slow shutter speed and careful focusing – are straightforward and relatively easy to master, but these are just the practical, tangible aspects of image-making. They are meaningless on their own because a photograph must display more than just sound technique. If it is to succeed, a picture must also have aesthetic appeal to enable it to engage with the viewer and draw the eye. It must have that intangible quality: impact.

Success hinges on the creation of powerful composition. A very effective way of achieving this is to include a strong, eye-catching focal point. This will act as a centrepiece around which the picture can be built, and its presence will give the image a balanced and cohesive appearance. This alone will boost its impact and appeal and at that point a flowing river can, at the click of a shutter, be transformed into a distinctive piece of visual art.

Polarizer (fully polarized)

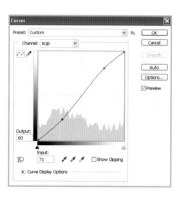

• Contrast was very low and was therefore increased using the Curves tool.

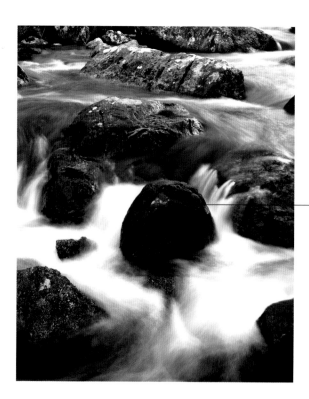

• The centrally positioned boulder is the essential feature in this image. It is crucial to the picture's success because the surrounding river, although attractive, requires a specific focal point to draw the viewer's attention.

> **TIP:** Colour will always draw the eye; distinctively coloured objects can therefore make very effective focal points.

**Woodland Creek,
New York State, USA**

Camera: Mamiya 645AFD
with ZD digital back
Lens: Mamiya 80mm
(standard)
Filter: Polarizer
Exposure: 1 sec at f/20,
ISO 100
Waiting for the light:
Immediate
Post-processing: Colour
balance adjustment

► LAKES, RIVERS AND WATERFALLS STILL WATERS

Water doesn't have to be flowing vigorously to make a fine photograph; in fact it doesn't have to be flowing at all. Still water often makes an excellent subject, particularly when there are other features present: colourful pebbles, for example or fallen leaves. In these situations, water can become a supporting element. It need no longer take centre stage and can act as a platform upon which a picture can be built.

In the photograph opposite, a circle of rocks has produced an oasis of perfectly still water at the edge of a gently flowing river; this, combined with a dense canopy of overhanging trees and the time of year, has created a striking portrayal of autumn at its most colourful. I caught a glimpse of the river from a distance as I was trekking through the surrounding forest. It looked promising and I hoped that I would be presented with an image-making opportunity. It was, as always, an exciting and heart-lifting moment.

As I approached, my excitement grew because it was becoming apparent that an abundance of all the elements were there: a colour-rich foreground, followed by an attractive group of textured, rounded boulders, which then led onto a serenely flowing stream bordered by a steep bank of resplendent woodland. There was plenty of water, but most of it seemed to be falling from the sky! The rain showed no sign of abating, so I had no alternative but to return the following day, weather permitting.

Thankfully the weather did permit and the photograph was captured without difficulty. The only minor hindrance was a slight ripple on the water's surface, which was the result of a persistent breeze. To avoid any blurring of the foreground leaves I increased the speed of the image sensor to ISO 200. This enabled a relatively short shutter speed of 1/5 second to be used, which was fast enough to prevent any movement being recorded. Other than that my only task was to compose the picture, focus the lens and release the shutter. When nature does everything for you, it really is quite simple.

Polarizer (fully polarized)

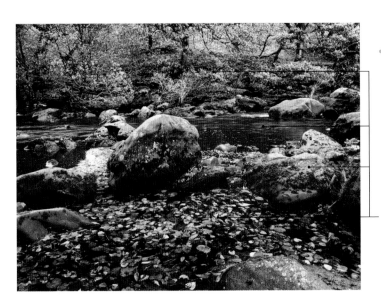

• The image consists of four distinct elements, starting with the foreground leaves, then building in horizontal bands to the boulders, the river and finally the background trees. This layering of elements from foreground to background maintains visual interest in all areas and produces a finely balanced picture.

• The image was warmed by adding a small amount of red and yellow via the Colour Balance tool.

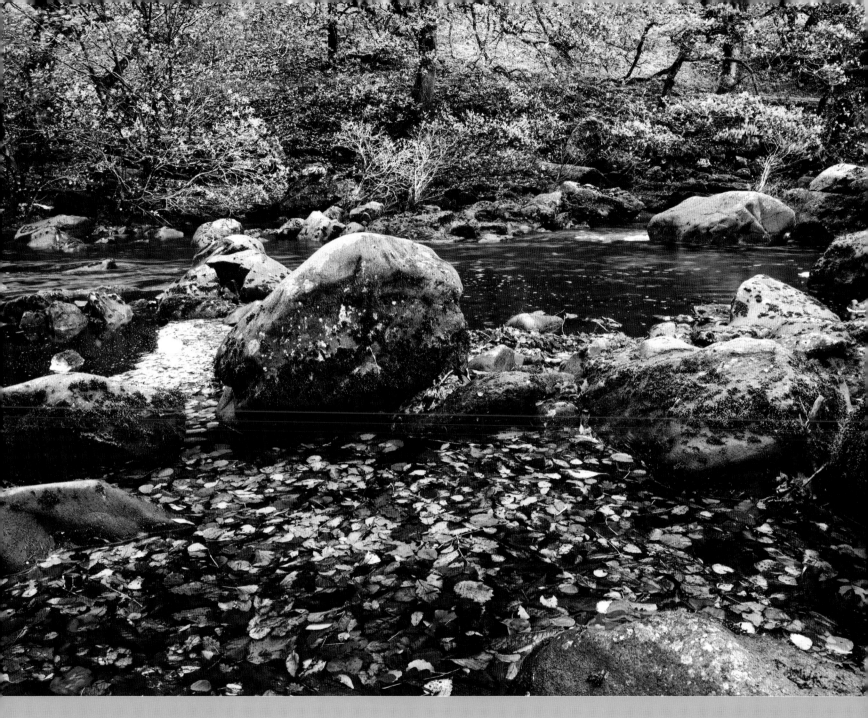

Afon Elan, the Elan Valley, Wales

Camera: Mamiya 645AFD with Phase One digital back

Lens: Mamiya 35mm (wideangle)

Filter: Polarizer

Exposure: 1/5 sec at f/22, ISO 200

Waiting for the light: 1 day

Post-processing: Colour balance adjustment

> MOUNTAINS, MOORS, FORESTS TAKING A DIFFERENT APPROACH

For a photograph to look realistic it often needs depth. This enables the image to engage the viewer, draw the eye in and invite closer scrutiny. But depth is not essential. There are no rigid rules when portraying the landscape, and some types of subject require a different approach.

This viewpoint of the colour-laden, tree-filled slope of Plateau Mountain is distant. It would have been possible to move in closer and include an area of foreground, but this would have changed the perspective and angle of the picture. I would have had to point the camera upwards, towards the mountain peak, which would have brought the sky into view. This is undesirable with this type of subject and it would have fundamentally changed the appearance of the image. The theme of this photograph is simple: it is all about large-scale, sprawling colour. Depth and foreground have no role to play; simplicity is the key.

Polarizer (fully polarized)

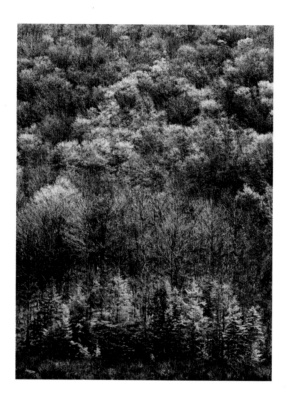

Contrast has been increased by introducing an S in the Curves tool.

- The distant viewpoint necessitated the use of a telephoto lens. One of the effects of using a longer focal length is the flattening of perspective. Depth shrinks as a result, and this can create an abstract appearance that suits certain types of subject.

- There was a hint of mist in the air, which was more noticeable in the distance. It had the effect of reducing contrast and diluting colour. The polarizer helped a little, but it was also necessary to increase contrast using the Curves tool and to increase colour saturation slightly. It is always tempting to boost colour, but it can be easily overdone so the picture begins to look unnatural. When increasing saturation, minor adjustments are generally all that is required.

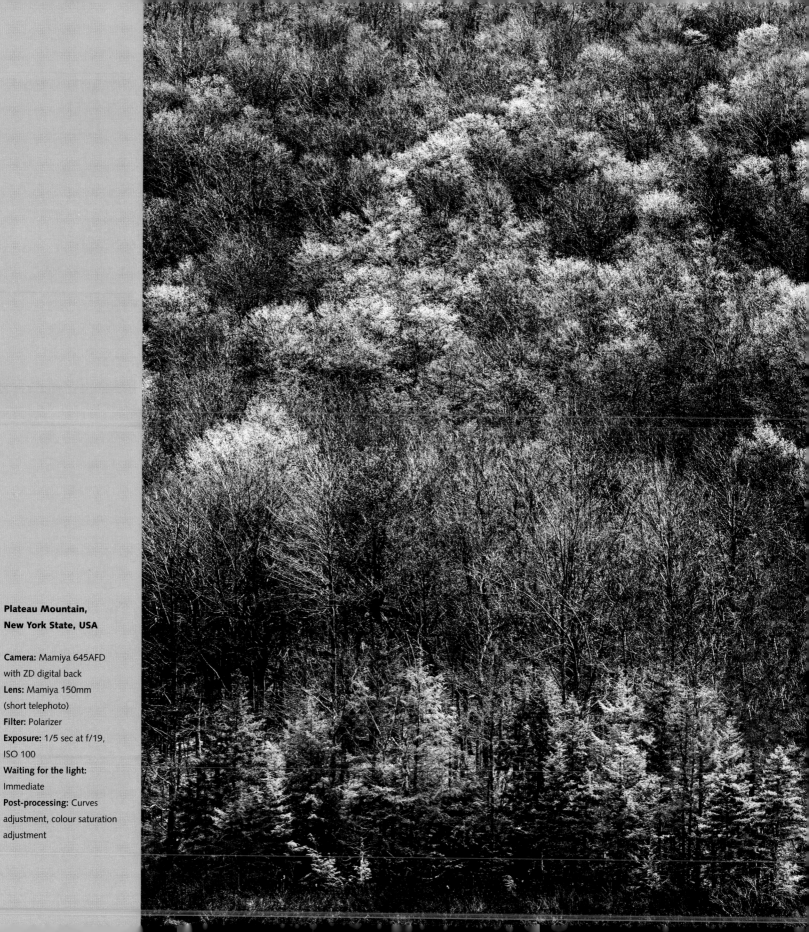

**Plateau Mountain,
New York State, USA**

Camera: Mamiya 645AFD
with ZD digital back
Lens: Mamiya 150mm
(short telephoto)
Filter: Polarizer
Exposure: 1/5 sec at f/19,
ISO 100
Waiting for the light:
Immediate
Post-processing: Curves
adjustment, colour saturation
adjustment

There was such a varied conglomeration of colour radiating from the slopes of the towering Catskill Forest that I was compelled to photograph it. Although of a pronounced variegation, the colours here are subtle, pastel shades rather than bright, bold hues. In many ways this is preferable in an image because a picture's other, more subtle elements will not become overwhelmed. In the photograph opposite the variation of texture and shape is as important as the colour. The picture was captured shortly after dawn, and the lingering overnight mist enhances the serenity of the image. The hazy atmosphere has reduced contrast and has had an attractive, softening effect on the autumnal trees, as has the gentle light from an overcast sky. Imagine this forest on a clear day in bright sunshine; it would be transformed, but not in a beneficial way. It would degenerate into a jarring display of disorganized foliage, which would rest uneasily on the eye.

The theme of the photograph is tranquillity, and this is portrayed by soft, muted tones enveloped in a completely still, timeless landscape. Strong light and vibrant colour therefore have no role to play. In this instance, soft, shadowless light is much preferable.

- The sky was excluded because it would have been a distraction. It has no role to play in this type of photograph.

- Notice how the telephoto lens has compressed the depth of the forest. The contraction of the elements has tightened composition and prevented the inclusion of dead space in the picture. Here every part of the subject makes a contribution and helps to give the image a sense of balance and completeness.

- Although distance has been compressed, depth is still apparent because of the diminishing size of the trees from front to back. This helps to convey the size and scale of the forest.

- Part of the image is, as you can see, not in sharp focus. This is the result of the relatively large aperture, f/11, and the long focal length of the lens. This was my mistake, because a smaller aperture would have increased the depth of field and would have brought all parts of the photograph into focus.

- No post-processing adjustments were undertaken.

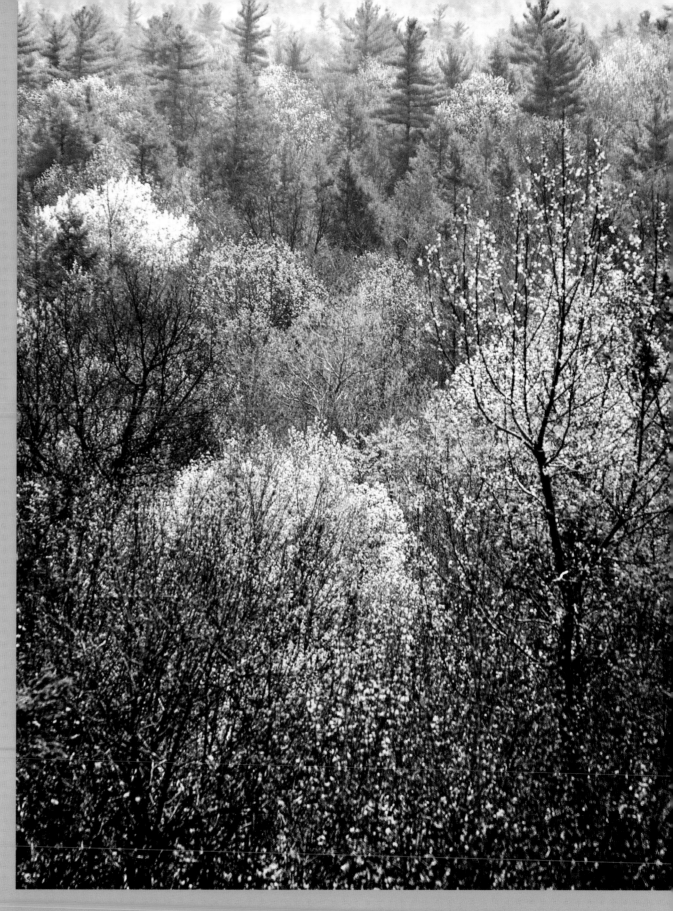

**Catskill Forest,
New York State, USA**

Camera: Canon EOS 7D
Lens: Sigma 17–70mm OS
Filter: None
Exposure: 1/15 sec at f/11,
ISO 100
Waiting for the light: 30 minutes
Post-processing: None

› MOUNTAINS, MOORS, FORESTS PATIENCE IS REWARDED

The distinctive, pyramid-shaped mountain Buachaillie Etive Mor can be seen from the road that crosses Rannoch Moor on the way to and from Glen Coe. It is an enticing view and one that is seemingly irresistible to photographers, myself included. Having said that, my efforts to capture the majestic mountain had until recently been a spectacular failure. My lack of success was purely the result of not making a determined effort. I hadn't given the location sufficient time and had done no more than stop briefly when passing through on the way to somewhere else. That, of course, is a guaranteed recipe for failure, or at best mediocrity. So, somewhat belatedly, I made the decision to spend an unbroken two weeks in the area and give priority to capturing the so-far elusive Buachaillie Etive Mor. The target was finally in my sights and I was determined that this time it would elude me no longer.

I based myself in Tyndrum, a small village at the southern end of Rannoch Moor. I established a routine and every day I would venture north towards Glen Coe. This took me past the mountain where I would stop, watch the sky, the weather, the movement of clouds and then wait. As you might imagine, there was a lot of waiting. It was a long, slow process, but fleeting opportunities did occur and eventually a number of pictures were captured. After two weeks, I had four images of the mountain. At an average of three and a half days per photograph, that is not particularly productive, but it was better than I expected. Make the effort, give your subject sufficient time, and success will eventually follow.

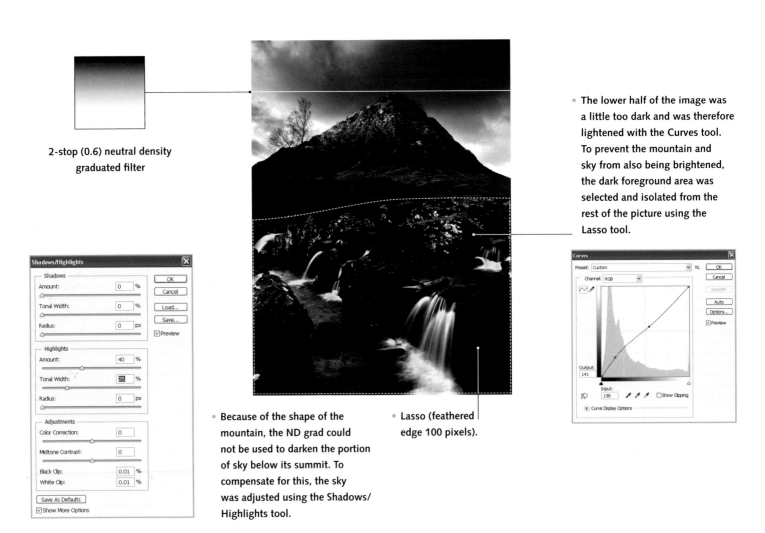

2-stop (0.6) neutral density graduated filter

- The lower half of the image was a little too dark and was therefore lightened with the Curves tool. To prevent the mountain and sky from also being brightened, the dark foreground area was selected and isolated from the rest of the picture using the Lasso tool.

- Because of the shape of the mountain, the ND grad could not be used to darken the portion of sky below its summit. To compensate for this, the sky was adjusted using the Shadows/Highlights tool.

- Lasso (feathered edge 100 pixels).

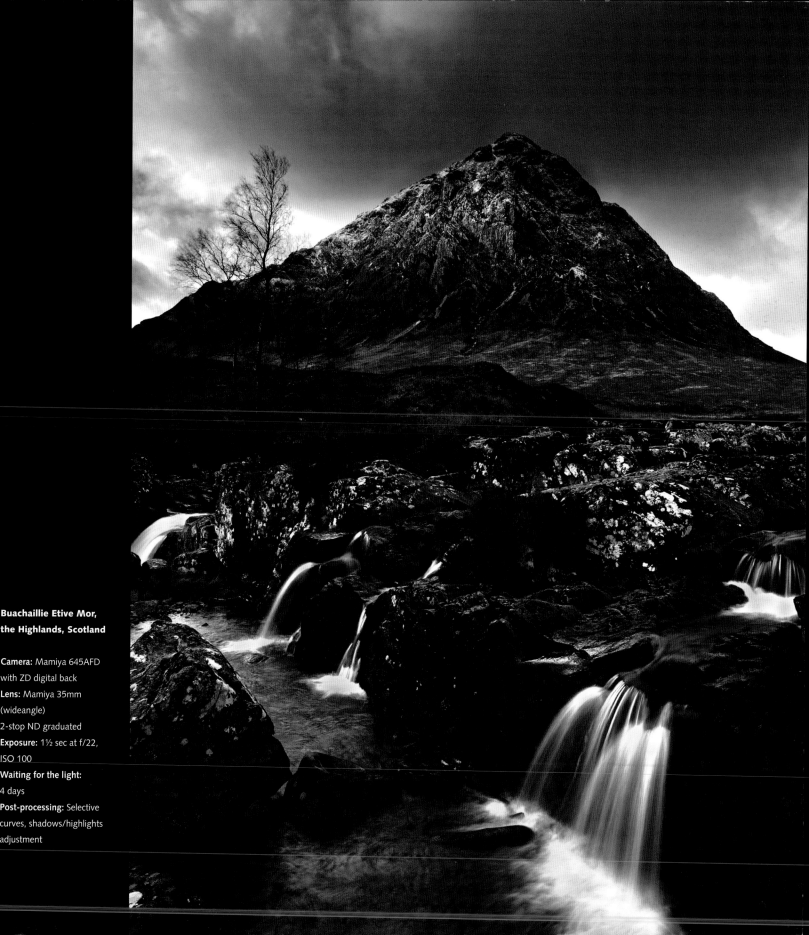

Buachaillie Etive Mor, the Highlands, Scotland

Camera: Mamiya 645AFD
with ZD digital back
Lens: Mamiya 35mm
(wideangle)
2-stop ND graduated
Exposure: 1½ sec at f/22,
ISO 100
Waiting for the light:
4 days
Post-processing: Selective
curves, shadows/highlights
adjustment

> MOUNTAINS, MOORS, FORESTS CLOUD PERFECTIONIST

I am not easy to please as far as skies are concerned. My pedantry is cloud-based: as with farmers and rainfall, I want a specific amount; too much is no good and too little is just as bad. Everything has to be exactly right. While my prayers are not answered as frequently as I would like, the sky does excel itself from time to time. Having said that, perfect cloud structures are elusive. They can suddenly materialize then just as quickly disappear – and the transformation can be dramatic. I have known a heavy blanket of rain-filled cloud to suddenly evaporate to leave nothing but a void expanse of featureless blue that can be guaranteed to cause frustration and stifle creativity.

Some cloud – any cloud – can make a world of difference. I was therefore fortunate that my subject on this clear and sunny Highland day was the majestic Buachaillie Etive Mor. Mountain peaks attract cloud like a magnet, and the tiny white splash across the tip of the summit was sufficient to allow me to capture the image. I would have preferred more cloud, but, as I say, I am difficult to please and nature rarely pampers to the whims of an obsessively pedantic photographer. I should be grateful for small mercies – at least it wasn't raining!

Polarizer (half polarized)

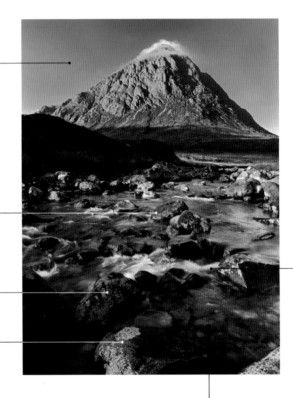

- Because of the scarcity of cloud, I used the polarizer at half-strength to prevent over-darkening the sky.

> **TIP:** When photographing rivers and streams, choose a viewpoint that includes stones of diminishing size that recede into the distance. This enhances depth and scale.

- No post-processing adjustments were undertaken.

> **TIP:** Because of the close foreground, maximum depth of field was required to ensure that all parts of the photograph were sharp. This was achieved by using the minimum aperture and focusing on the point indicated by the arrow. This is the hyperfocal point and was only 6ft (1.8m) from the camera. This might seem very close, but when using a wideangle lens the point of focus is never distant; it is always just a few paces beyond the closest foreground.

- The polarizer has improved the clarity of the water in the foreground.

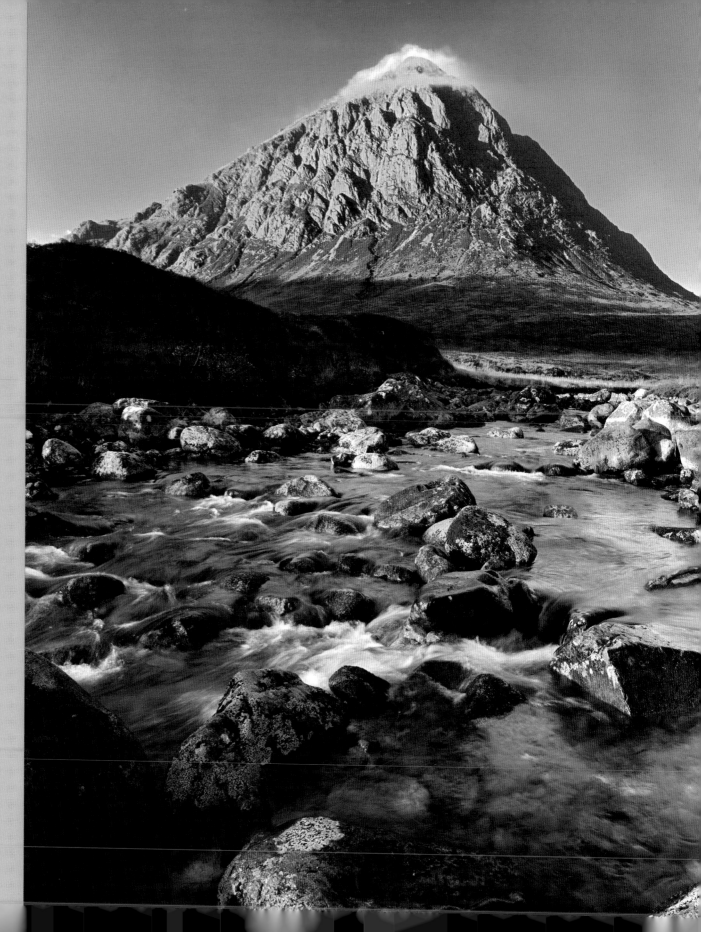

**Buachaillie Etive Mor,
the Highlands, Scotland**

Camera: Mamiya 645AFD
with ZD digital back
Lens: Mamiya 35mm
(wideangle)
Filter: Polarizer
Exposure: 1/4 sec at f/22,
ISO 100
Waiting for the light:
5 days
Post-processing: None

> MOUNTAINS, MOORS, FORESTS MAKING THE MOST OF MOORLAND

Moorland can be a rich and varied source of brightly coloured grasses, but their flat, gently undulating contours can make them a challenge to photograph. Focal points can be few and far between, but they do exist and strong compositions can be found with careful searching. The right type of light is also essential, because the flat landscape needs to be lit in a specific way if it is to be successfully captured. Low, relatively strong sunlight will be required because acute angled light will penetrate the fabric of the moorland and produce a strong three-dimensional appearance. Sidelighting with a hint of backlight is likely to be the most successful; this creates shadows in front of prominent features as well as to the side. This type of 'semi-backlighting' (the sun is slightly in front of the camera) can be quite heavenly, and it is my preferred light for most open views.

Interesting foreground elements might be scarce on remote moorland, but even a modest foreground, if photographed close up with a wideangle lens, will benefit from the probing effect of this light. In the picture opposite there is no foreground as such, but the effect of the light is so strong that visual interest flows from front to back, starting from just a few inches from the camera and continuing all the way to the distant group of trees. This is solely the result of the quality of light. It is undoubtedly the single most important feature in this image; without it this moorland view would not have been worth capturing.

2-stop (0.6) neutral density graduated filter

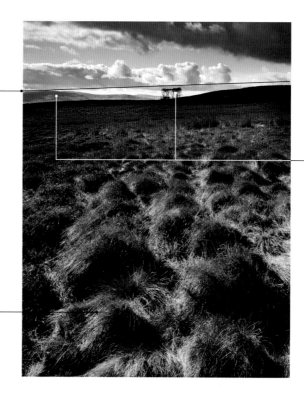

• The unbalancing effect of the sloping landscape is avoided by the presence of the distant hills. The hills also help to draw the eye to the far-off group of trees. They are an important feature because they help to prevent the picture being dominated by the foreground grasses.

• The strong side/backlighting gives shape and depth to the colourful grass; this has greatly enhanced the appearance of the moorland.

• No post-processing adjustments were undertaken.

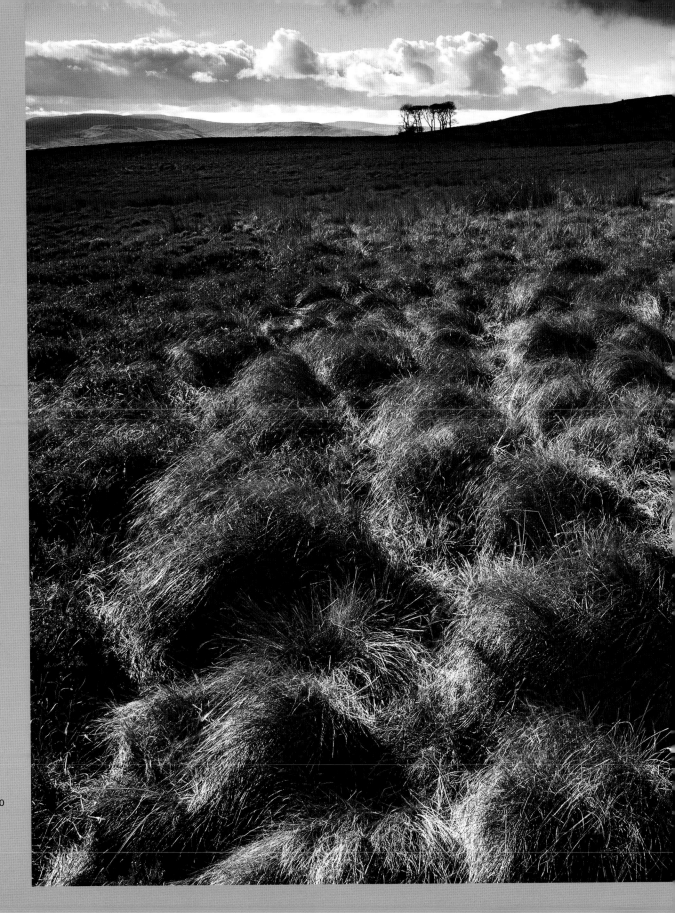

**Askrigg Common,
the Yorkshire Dales, England**

Camera: Mamiya 645AFD with
Phase One digital back
Lens: Mamiya 35mm (wideangle)
Filter: 2-stop ND graduated
Exposure: 1/2 sec at f/22, ISO 100
Waiting for the light: 50 minutes
Post-processing: None

> MOUNTAINS, MOORS, FORESTS GO WITH THE CROWD

This must be one of the most photographed cottages in Scotland. I generally avoid popular locations, but in the Scottish Highlands that means ignoring some of the most alluring and charismatic places on earth, and that is a price I am reluctant to pay. So, I joined the crowds (actually, I was completely alone; even the sheep gave me a wide berth), set up my tripod and waited for the light and the sky.

Selecting the viewpoint and composing the picture was simple: there was only one obvious position with few alternatives. Perhaps this is why the photograph is so popular. It is readily accessible and requires little creative input; it is therefore only the light and sky, and of course the time of year, that can affect the appearance of the image. These are, however, powerful elements and, given the number of permutations possible, I was hopeful of producing an original picture.

Two hours after setting up my camera, the photograph was captured. I decided to make the cottage and surrounding trees the main subject; to achieve this, it was necessary to have a subdued background. I have seen versions of this image where the mountains are brightly lit, with the cottage in shadow, but I preferred to keep the focus of attention closer to the camera. This meant that the cottage and foreground had to be bathed in sunlight. A break in the clouds eventually materialized, which enabled bright light to throw the landscape into sharp relief against the dark background. This, to my eye, gives the picture both impact and depth.

I am satisfied with this photograph. It is a reasonable portrayal of the location but I have, I readily admit, seen better. Perhaps I will return one day and take yet another version.

2-stop (0.6) neutral density graduated filter

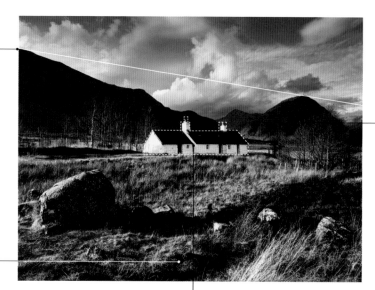

- **The correct distribution of light and shadow was essential. Had the distant mountains been brightly lit they would have competed with the cottage and trees and there would have been no specific focal point.**

- **The light is the most important element in this image. The landscape is brightly sidelit, but not too strongly. There are therefore no harsh shadows and the picture's tonal range has been captured without loss of detail.**

- **Lasso (feathered edge 100 pixels).**

- **To avoid overexposure of the white cottage walls they were subdued slightly by using the Shadows/Highlights tool. To prevent other parts of the image also being darkened, the cottage was selected with the Lasso tool.**

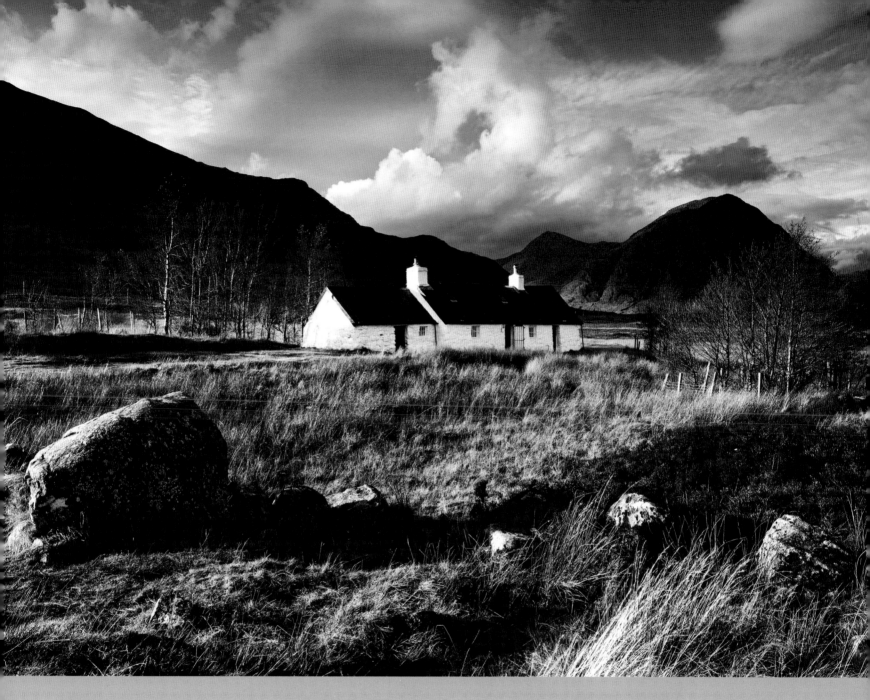

Glen Etive, the Highlands, Scotland

Camera: Mamiya 645AFD with ZD digital back

Lens: Mamiya 35mm (wideangle)

Filter: 2-stop ND graduated

Exposure: 1/8 sec at f/22, ISO 100

Waiting for the light: 5 days

Post-processing: Selective reduction of highlights

> MOUNTAINS, MOORS, FORESTS CREATING A FOREGROUND

Although rich in texture and vibrant colour, the flat terrain of a moorland expanse can be challenging to photograph. Strong foreground usually consists of easily discernible shapes and patterns and flowing lines that can be used to create depth and distance. Such elements are not commonly found in moorland, but don't despair, because all is not lost.

The absence of the more obvious types of foreground can be overcome by trawling the landscape and searching for areas that, although flat, have a distinctive and variegated appearance. Long grasses and surface water, in particular, can enrich the fabric of moorland and can be used to draw the eye into a picture and then on towards the horizon.

In the photograph opposite, the viewpoint was carefully chosen so the moorland could be depicted as a group of distinct, horizontal bands. These layers of receding bands engage the eye and take the viewer on a journey across the moor towards the distant mountains. This landscape contains such a diverse variety of flora that it invites close and careful scrutiny. Together with the mountain range it epitomizes the character and unique beauty of the Scottish Highlands, but, unlike the photograph on the previous page, it was not taken from a well-known viewpoint. This picture was captured from an obscure stretch of remote land, way off the beaten track, and with no indication of the riches it held. Delve into a moorland, search and leave no stone unturned and you will discover images.

2-stop (0.6) neutral density graduated filter

• The sunlight falling on the central mountain, Buachaillie Etive Mor, is an important feature. It draws the eye and prevents the image from being dominated by the foreground.

• A sense of order has been imposed on the moorland by building the image around four quite distinct horizontal bands. They provide foreground interest and, by receding into the distance, they create depth.

• No post-processing adjustments were undertaken.

> **TIP:** Parts of Rannoch Moor are very wet, very muddy and very deep! Navigating its bogs and marshes can be difficult, particularly when weighed down with a camera and tripod. To explore the area thoroughly you will need adequate clothing, particularly strong, waterproof boots.

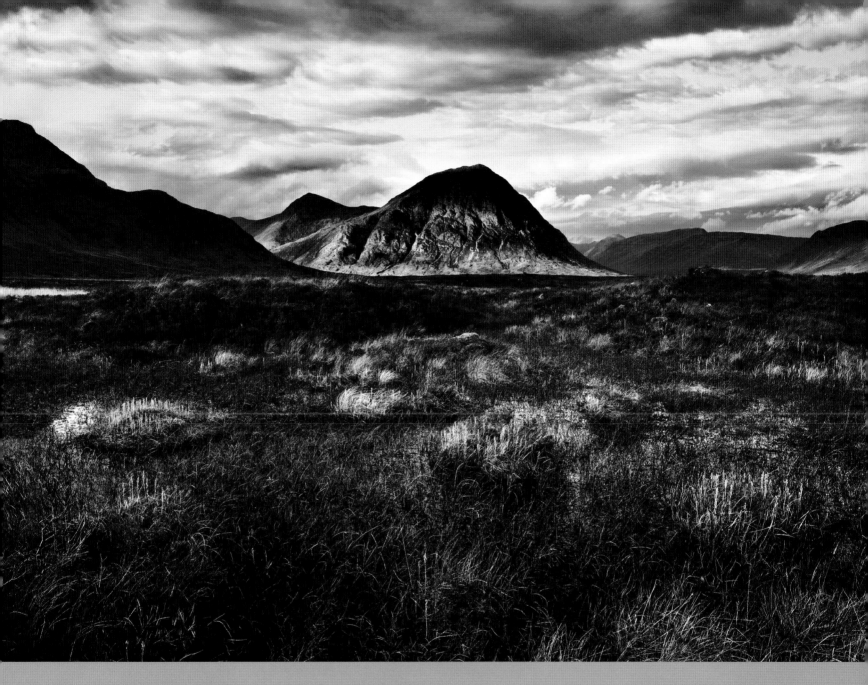

Rannoch Moor, the Highlands, Scotland

Camera: Mamiya 645AFD with Phase One digital back

Lens: Mamiya 35mm (wideangle)

Filter: 2-stop ND graduated

Exposure: 1/4 sec at f/22, ISO 100

Waiting for the light: 6 days

Post-processing: None

> COASTAL

The ebb and flow of the tide over a rocky coastline can be fascinating to observe. The repetitive, rhythmic motion of waves, if studied intensely, can become a mesmerizing, almost hypnotic, experience. Here, at the meeting point of land and water, there exists a marvellous opportunity to make original and creative images. This brings a new and potentially rewarding dimension to the coastal experience.

The perpetual motion of the sea and the immovable stillness of the shoreline is a unique combination of elements that can form the basis of many intriguing photographs. Finding the right composition can be a little frustrating, however, because one of the main subjects – the flowing waves – is never still. The waves' size, shape and speed are always changing, and timing is therefore critical. But choosing the exact moment to release the shutter is hindered by the unpredictable nature of their movement. Often a specific volume of water will be required because too much will result in other features (and, I can confirm from experience, sometimes also the photographer!) disappearing under a deluge of frothy foam, while too little will spoil the balance and impact of the picture. The only solution is to make several exposures and view the results on your camera's display screen. The image opposite was captured after four failed attempts, which is a lot fewer than I was expecting.

2-stop (0.6) neutral density
graduated filter

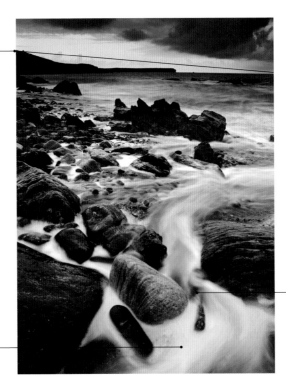

The success of this image depended upon capturing the right combination of rocks and water. The wave needed to reach the near foreground but without obscuring the colourful rocks. It also needed to have a rhythmic shape and definition. Speed and volume of water were therefore the critical elements in this picture.

> **TIP:** To portray the flowing motion of waves, use a shutter speed of 1 sec or longer. This softens the water and creates an attractive contrast with the solid rocks and boulders.

To compensate for a blue cast, which is often present at the coast, particularly on overcast days, the image has been warmed by adding a small amount of red and yellow via the Colour Balance tool.

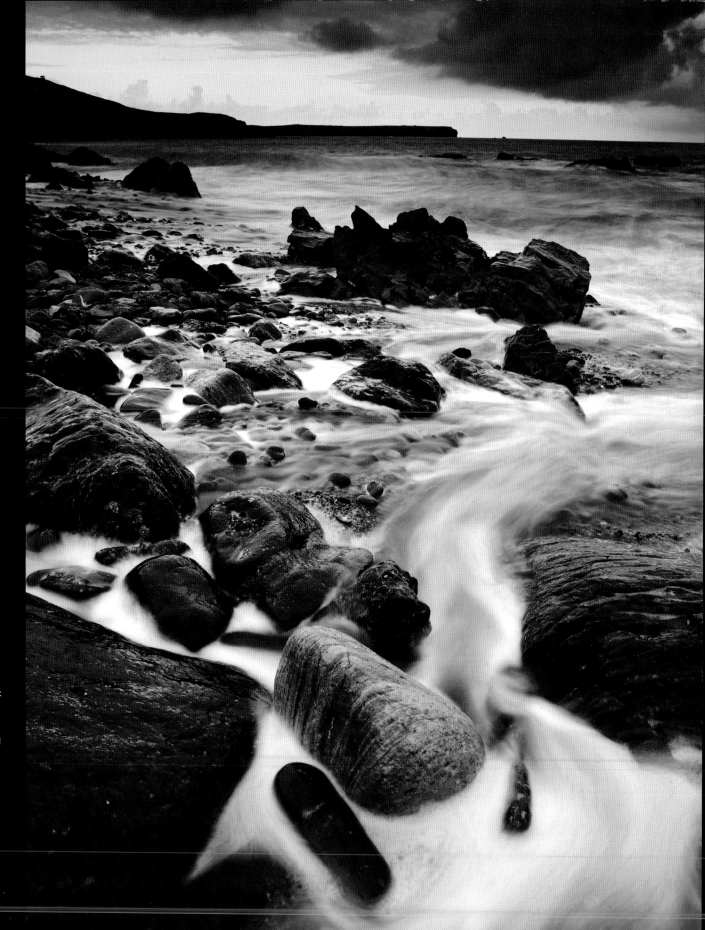

**Freshwater West,
Pembrokeshire, Wales**

Camera: Mamiya 645AFD
with Phase One digital back
Lens: Mamiya 35mm
(wideangle)
Filter: 2-stop ND graduated
Exposure: 1½ sec at f/22,
ISO 100
Waiting for the light:
Immediate
Post-processing: Colour
balance adjustment

> COASTAL FAVOURITE PLACES

The geology of the Pembrokeshire coast is remarkable; several millennia of weathering have transformed it into a photographer's paradise. Along with Cornwall, it has become my favourite coastal location. I have visited the area many times and have always found something new to photograph. There are always enticing discoveries and original images to be made – and that was certainly my experience the day I visited Freshwater West and its adjacent beaches.

The weather was favourable, if a little windy, and I was able to enjoy several hours of uninterrupted photography. It was mid-October and by late afternoon the softly fading sunlight was beginning to creep across the rock-covered shoreline to penetrate every crevice, nook and cranny of the rugged bay. For most of the day I had been concentrating on close-up images, but it was now time to capture an open view.

Conditions could not have been better and, given the location and choice of vantage points, I was hopeful of making a spectacular image. The picture certainly should have been spectacular but, sadly, the one I produced doesn't live up to my expectations. It looks a little unbalanced; it is bottom-heavy, with the distant cliff face failing to live up to the promise the foreground suggests. The image peters out beyond the middle distance, and this is the fault of my composition. Looking at the photograph now, I can see that my judgement was impaired by the seductive foreground rocks. I should have resisted their charms and taken a more objective view. After all these years, I am still learning!

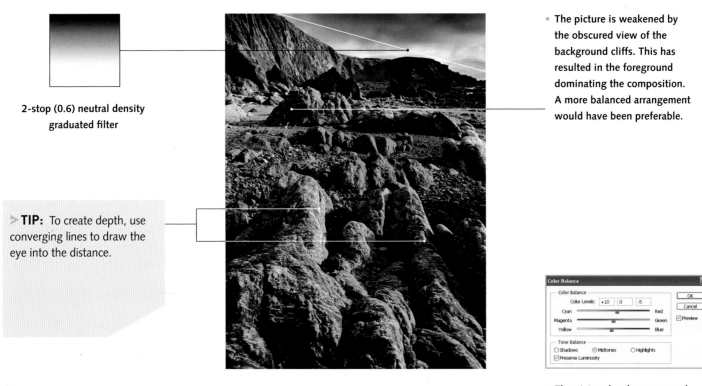

2-stop (0.6) neutral density graduated filter

• **The picture is weakened by the obscured view of the background cliffs. This has resulted in the foreground dominating the composition. A more balanced arrangement would have been preferable.**

> **TIP:** To create depth, use converging lines to draw the eye into the distance.

• **The picture has been warmed slightly by adding a small amount of red and yellow using the Colour Balance tool.**

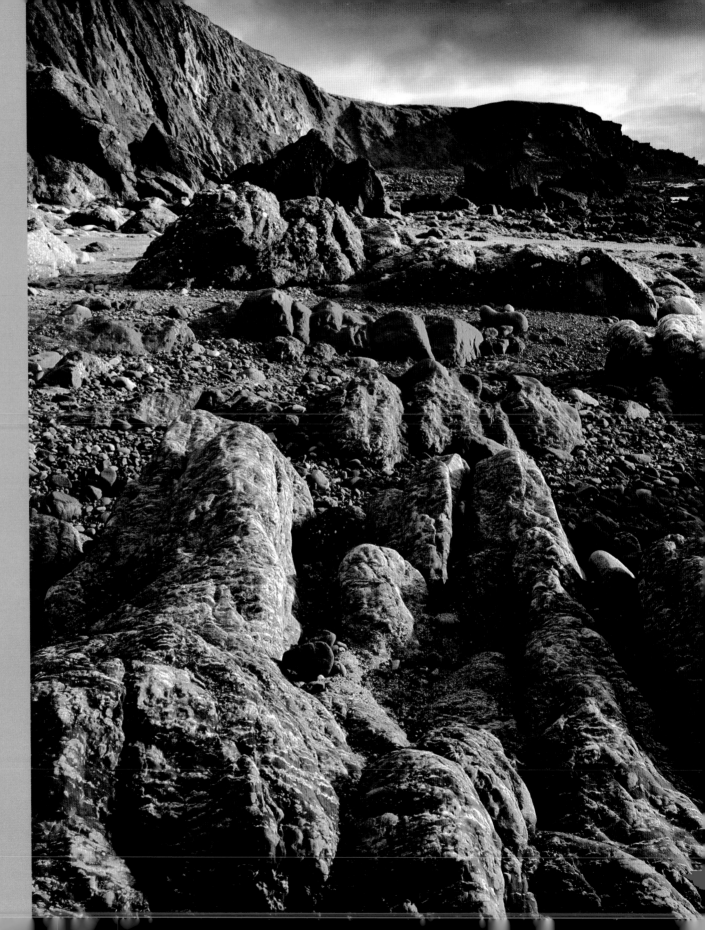

**Great Furzenip,
Pembrokeshire, Wales**

Camera: Mamiya 645AFD
with Phase One digital
back
Lens: Mamiya 35mm
(wideangle)
Filter: 2-stop ND
graduated
Exposure: 1/8 sec at f/22,
ISO 100
Waiting for the light:
30 minutes
Post-processing: Colour
balance adjustment

> COASTAL THE BEAUTY OF DECAY

The corrosive qualities of salt water can be the bane of coastal defences, but, from a photographer's point of view, the decaying process brings with it a wealth of intriguing opportunities. They may not be obvious to the untrained eye, but where there is a sea-ravaged coast there will undoubtedly be images. Close scrutiny and perceptive observation will reveal them and, once discovered, they can be very rewarding and relatively easy to capture.

The sea wall along the Wirral banks of the Dee Estuary no longer holds back the tide. The days of the River Mersey flowing vigorously through this part of the estuary are long gone, and the wall is therefore no longer actively maintained. Its unhindered ageing has revealed the intrinsic beauty of decay, and where there is intrinsic beauty there are often intriguing and original subjects waiting to be photographed.

In this type of picture there are two methods of portraying the subject. One is the abstract approach, where the composition is tightly framed and the main elements isolated from their surroundings. This can be very successful, but there are occasions when a wider composition might be preferable; it can be the better option if there are other features present that can also make a contribution. This was the case with the image opposite. The wall is the main subject, but the assortment of rocks and stones is also important. They provide a base onto which the photograph can be built and introduce an added dimension.

Pictures like this are not restricted to the coast and can be found virtually anywhere. Train your eye to observe them and you will be rewarded with many fine images.

1-stop (0.3) neutral density graduated filter

- A 1-stop ND graduated filter was placed upside down over the light-coloured rocks. This reduced their light value and prevented them from being overexposed.

> **TIP:** Don't reject a potential subject because it doesn't suit your camera's aspect ratio. Consider cropping to a panoramic or other format. This simple act can create opportunities that would otherwise be missed.

- Contrast was increased slightly by making an S in the Curves tool.

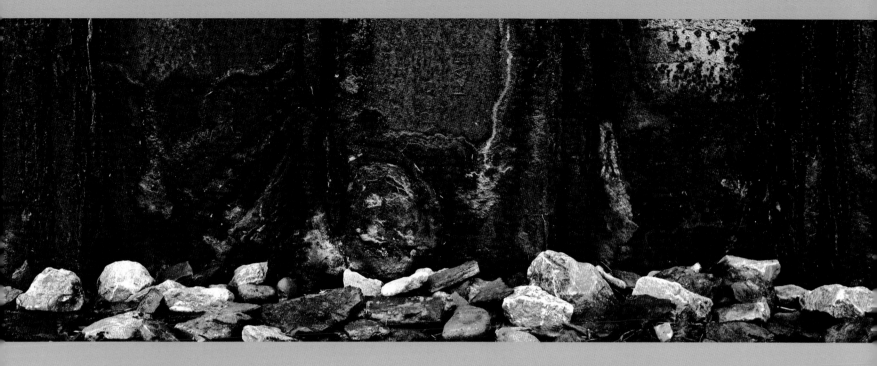

The Dee Estuary, the Wirral, England

Camera: Mamiya 645AFD with Phase One digital back

Lens: Mamiya 35mm (wideangle)

Filter: 1-stop ND graduated (inverted)

Exposure: 1/4 sec at f/22, ISO 100

Waiting for the light: Immediate

Post-processing: Curves adjustment, cropping

> COASTAL NATURAL BEAUTY

Although somewhat older than the coastal wall in the previous picture, the seashells in the photograph opposite are rather more resistant to the passing of time; they show signs of neither age nor corrosion. With their unique combinations of colours, textures, shapes and patterns, seashells are the epitome of natural beauty and are worthy of study. They are the jewel in the coastal crown, and their twists, curls and curves offer endless opportunity for creative image-making.

I spent the best part of an afternoon rummaging through a shell-strewn stretch of Holden Beach, along the Atlantic coast, looking for eye-catching combinations of colour and shapes. Hazy cloud filled the sky and had a softening effect on the sunlight, which was fortunate. I would normally use flat, shadowless light when capturing bright hues, but these shells have a pronounced ribbed surface that responds well to angled sunlight. The shadows cast by their grooves emphasize a shell's

flowing lines and impart a three-dimensional quality that heightens the picture's aesthetic appeal. Hazy sunshine is perfect for this; light that is too strong creates harsh contrast that will interfere with the depiction of tonal range and texture.

In this photograph the light was fairly soft, but bright enough to produce subtle highlights and shadows; this enabled the full spectrum of the seashells' visual qualities to be recorded accurately. My only regret was my failure to remove a few scattered specks of sand. At the time they seemed to improve the image, but now I think they detract from the picture's purity and look a little unsightly. It might be possible to remove them using the Clone tool, but I don't like to alter a photograph in such a fundamental way. I will therefore live with my mistake and make sure I learn from it.

Polarizer (fully polarized)

• A polarizing filter was used to help saturate colour. It has also increased contrast slightly, but as the sunlight was soft the shadows retain adequate detail.

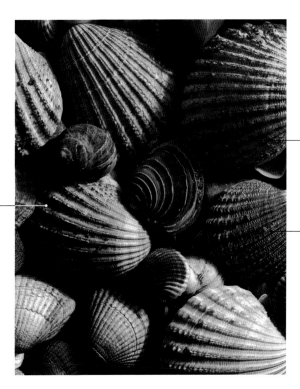

> **TIP:** Shells photograph well under hazy sunlight. It should be strong enough to cast soft shadows, but without creating high contrast.

• The sand is a distraction and should have been removed.

• No post-processing adjustments were undertaken.

**Holden Beach,
North Carolina, USA**

Camera: Mamiya 645AFD
with ZD digital back
Lens: Mamiya 80mm
(standard)
Filter: Polarizer
Exposure: 1/2 sec at f/22,
ISO 100
Waiting for the light:
Immediate
Post-processing: None

The direction of this view of Mumbles Head is perfect at sunrise. I had wanted to capture it for some time but had always been thwarted by the weather. I knew that it was just a matter of time and, during a recent trip to the area, a fine dawn was at long last forecast. I had visions of capturing a silhouetted outline of the headland against a spectacular, glowing sky complete with a subdued but colourful foreground of shapely, sea-weathered rocks.

That was the plan, so, full of enthusiasm, I arrived at my pre-planned viewpoint the following morning in good time for the sun to rise. The minutes ticked by and dawn duly broke, but to my dismay there was not a hint of sunlight. The sun was there, but so was a deep,

impenetrable bank of cloud. So much for my spectacular image! It looked like a lost cause, but I decided to wait. If the sky has one persistent quality, it's that it can change very quickly. Having been caught out on previous occasions, I never assume the worst and leave a location prematurely. This strategy paid dividends: half an hour later the cloud began to fragment; the dawn warmth was starting to fade, but the sky was still attractive. It was partly mottled with a noticeable marbled quality and, with a small but important orange splash of sunrise still lingering, it was all beginning to look rather splendid. My early rise had been rewarded and Mumbles Head could finally be crossed off my 'to-do' list. I might return, however, as I have a lingering feeling that I still haven't seen this location at its absolute best.

2-stop (0.6) neutral density
graduated filter

• A 2-stop ND graduated filter was placed at an angle across the sky. This has darkened it and enabled the delicate detail in the cloud structure to be recorded accurately.

• The subdued light on the foreground has prevented it from dominating the photograph.

• No post-processing adjustments were undertaken.

> **TIP:** Don't leave a location until you are absolutely certain that conditions will not improve. The sky can change quickly and it often pays to wait that bit longer. A photograph might be just minutes away.

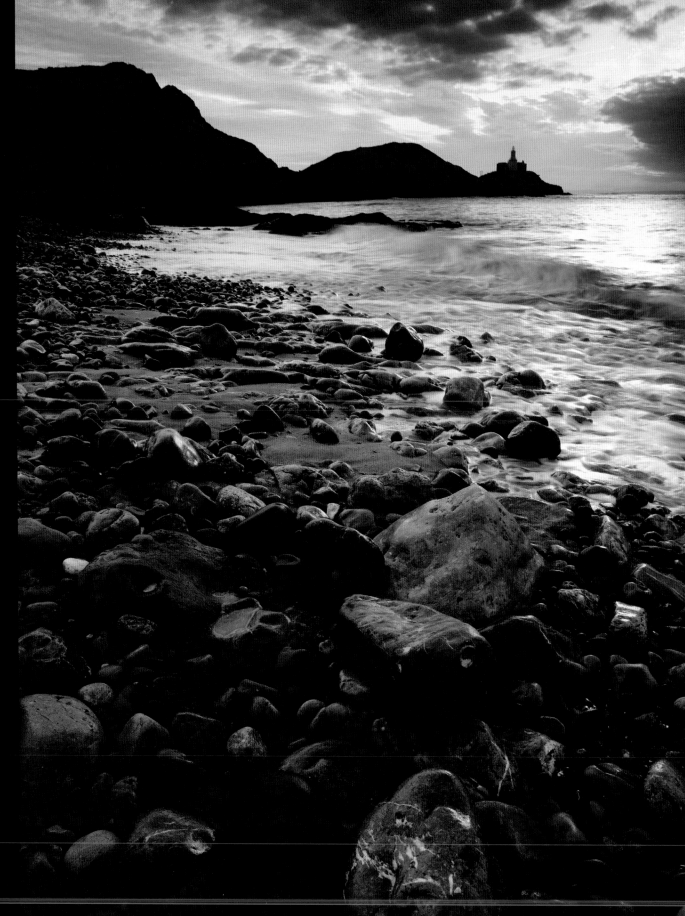

**Mumbles Head,
Pembrokeshire, Wales**

Camera: Mamiya 645AFD
with Phase One digital back
Lens: Mamiya 35mm
(wideangle)
Filter: 2-stop ND graduated
Exposure: 1/2 sec at f/22,
ISO 100
Waiting for the light: 1 hour
Post-processing: None

> COASTAL CAREFUL PLANNING

Unlike the dawn I experienced at Mumbles Head (page 172), here the sun burst into view with precision timing. This time there was no delayed start to the day, and I was able to pick my moment as the light skimmed across the waves to bathe the rocky coastline in a heart-warming glow. It was fortunate because the tide was at its lowest point. Within half an hour of taking this image, water was swirling around the base of the rocks; had dawn been any later, the photograph would not have been possible.

Timing was critical in the making of this picture, and careful pre-planning was necessary. If you are considering a trip to the coast, it is important to study the times of the tide and also sunrise/sunset and then schedule your trip accordingly. Look also at large-scale maps of the area, as they will enable you to calculate the direction of the sun. With all this information you will be able to make an informed decision when arranging the timing of your visit.

When you arrive at your destination, plan your images in advance if possible. Visit the location, choose your viewpoint and composition, and then try to imagine what the scene will look like at the beginning or end of the day. One can never be certain, but having an idea of what to expect will save time when the moment comes to take the photograph. A few minutes – even seconds – saved can make the difference between success and failure.

**2-stop (0.6) neutral density
graduated filter**

> **TIP:** When photographing at the coast, use a spirit level mounted on the camera's accessory shoe to check that the horizon is straight.

- Although a 2-stop ND graduated filter was positioned across the horizon to prevent the sky from being overexposed, highlights also had to be reduced with the Shadows/Highlights tool.

> **TIP:** Study tide and sunrise/sunset timetables prior to visiting a coastal location so you arrive at a time when low tide and sunrise or sunset coincide.

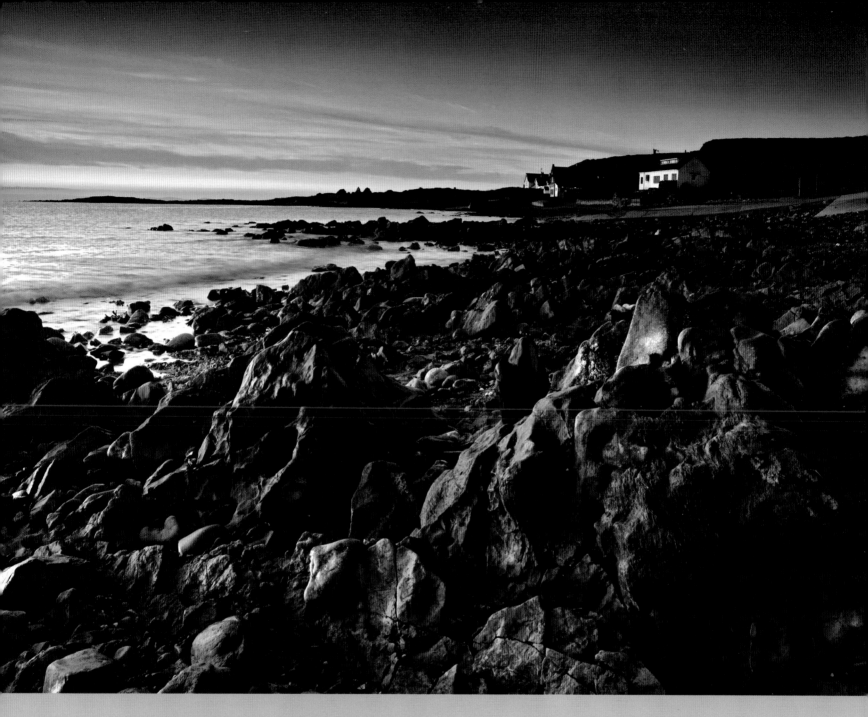

Port Eynon, Gower Peninsula, Wales

Camera: Mamiya 645AFD with ZD digital back

Lens: Mamiya 35mm (wideangle)

Filter: 2-stop ND graduated

Exposure: 1/8 sec at f/22, ISO 100

Waiting for the light: 4 days

Post-processing: Highlights adjustments

> COASTAL COMPOSITIONAL CHOICES

This picture might look familiar; another version appears on page 45. This one, as you can see, is in portrait format and was taken from a slightly different position. Sometimes a location can yield more than one photograph. If there is sufficient variety in the compositional choices available, I don't hesitate to make additional images. They should not be too similar, however, and one way to avoid this is to capture the view in both landscape and portrait formats. This, together with a change in position and a slightly different sky, ensures that there is no repetition.

In this example, the viewpoint is more distant in relation to the building. When combined with the use of the portrait format and a slightly lower camera position, it places more emphasis on the foreground. One of the benefits of composing an image around a strong, dominant foreground is that it often enables quite different pictures to be taken by making relatively small changes to the camera position. Sometimes all it takes is a few steps to the left or right, because a new foreground effectively gives you a completely new image, particularly when there is also a change in format.

This photograph was captured several minutes after the landscape version. Although the light is still acceptable, the sky is beginning to deteriorate. The glowing hues and luminance, so attractive in the earlier picture, have faded slightly, and this detracts from its overall appearance. Conditions can change quickly at sunset and, as photographers, we are always working against the clock. We might be able to freeze a moment in time, but we cannot slow it down.

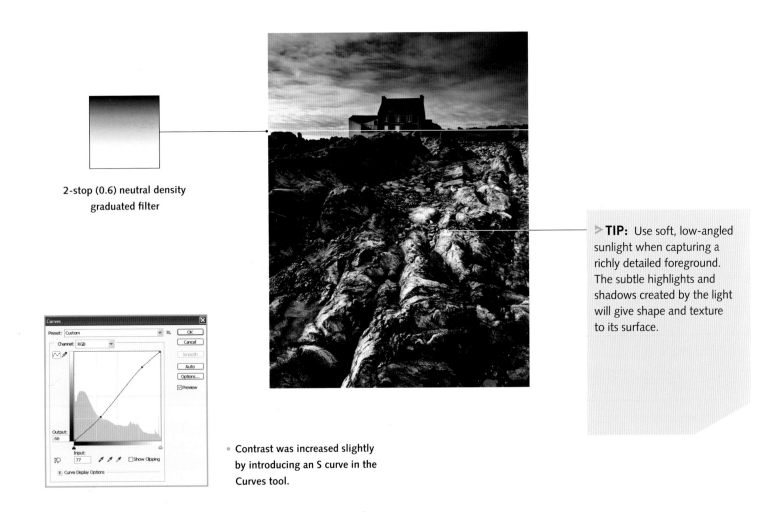

2-stop (0.6) neutral density
graduated filter

> **TIP:** Use soft, low-angled sunlight when capturing a richly detailed foreground. The subtle highlights and shadows created by the light will give shape and texture to its surface.

• Contrast was increased slightly by introducing an S curve in the Curves tool.

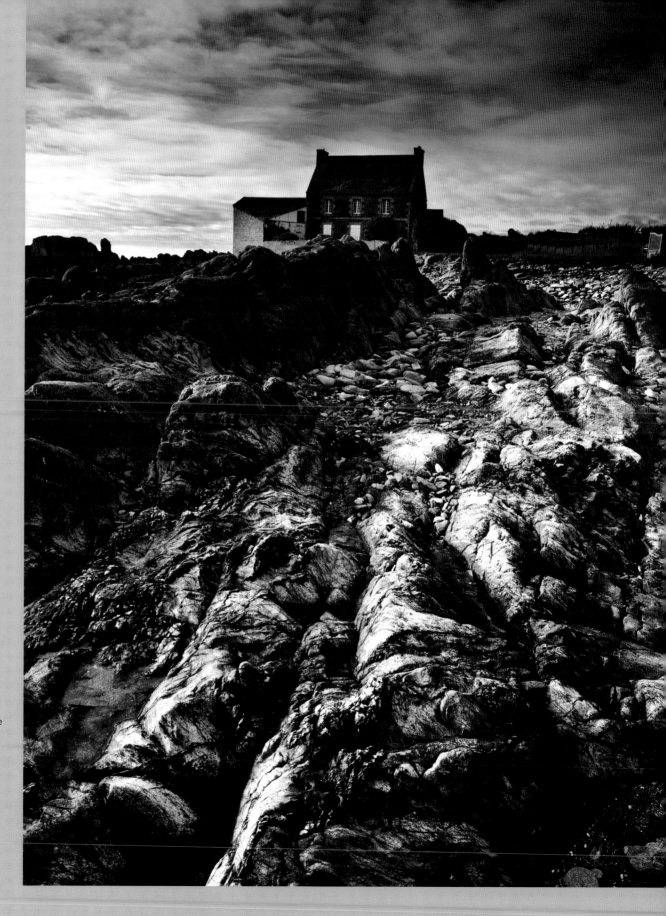

Locquemeau, Brittany, France

Camera: Mamiya 645AFD with Phase One digital back
Lens: Mamiya 35mm (wideangle)
Filter: 2-stop ND graduated
Exposure: 1/2 sec at f/22, ISO 100
Waiting for the light: 8 days
Post-processing: Curves adjustments

> COASTAL EMBRACING PROGRESS

This photograph is one of several I took of the lighthouse on Perch Rock, at the tip of the Wirral Peninsula. At the time I was still using film but also experimenting with digital capture. This exposure was made several minutes before the film versions and I thought it had been taken too early because the sky was still bright and the sunlight strong.

It was some time before I looked at the RAW file, and when I eventually processed the image it was a real eye-opener. I was surprised because two assumptions I had made were obviously wrong. My first realization was that digital imaging was no longer the poor relation of film, because the evidence was obvious from my computer screen. I also realized that the ability to view a photograph on a screen

at the time of capture (which, of course, I had failed to do) was not a gimmick; it was a significant development that would become instrumental in raising the quality of image-making, particularly in the challenging landscape environment.

The digital age had finally reached me, and it hadn't been as painful as I expected. Indeed, once I discovered the benefits of the new technology I embraced it. There is still film in my fridge, but for how much longer I'm not sure. I fear it will soon be past its use-by date.

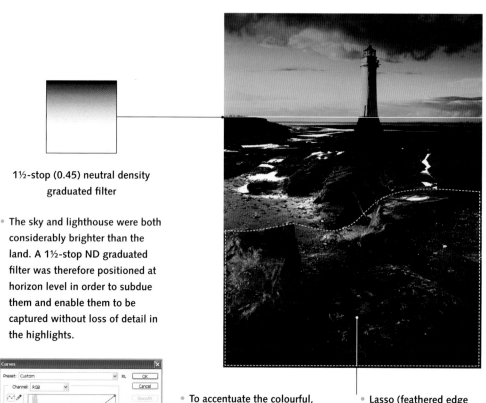

1½-stop (0.45) neutral density graduated filter

- The sky and lighthouse were both considerably brighter than the land. A 1½-stop ND graduated filter was therefore positioned at horizon level in order to subdue them and enable them to be captured without loss of detail in the highlights.

- Despite the use of the ND filter it was still necessary to reduce the highlights in the sky to prevent them from being overexposed. This was achieved by using the Shadows/Highlights tool.

- To accentuate the colourful, varied tonal quality of the foreground rocks, contrast in this area was increased slightly by making an 'S' in the Curves tool. To prevent other parts of the picture being affected, the foreground was selected with the Lasso tool.

- Lasso (feathered edge 100 pixels).

- The image was warmed slightly by adding a small amount of red and yellow via the Colour Balance tool.

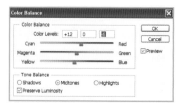

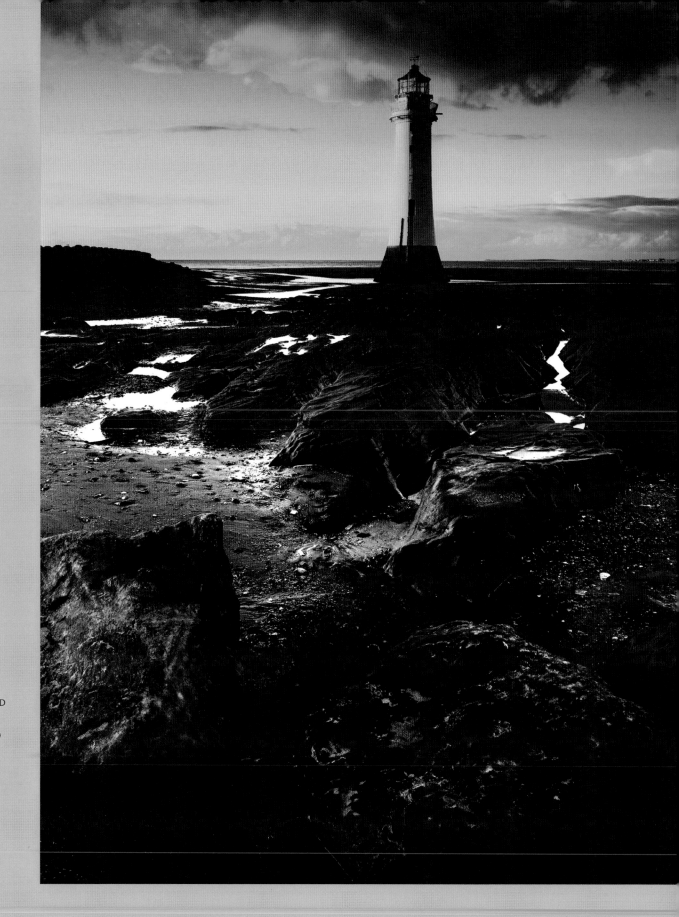

**New Brighton,
the Wirral, England**

Camera: Mamiya 645AFD with ZD
digital back
Lens: Mamiya 35mm (wideangle)
Filter: 1½-stop ND graduated
Exposure: 1 sec at f/22, ISO 100
Waiting for the light: Immediate
Post-processing: Colour
balance, highlights and
selective curves adjustments

> COASTAL CRITICAL TIMING

Image-making opportunities are often transient. This is usually due to the whimsical nature of the weather, but along the coast photographs can also be carried in by the motion of the tide. It can be fascinating and rewarding to stand and watch the ebb and flow of perpetual motion as an endless variety of watery patterns fleetingly appear and disappear. Pictures can occur on every scale, from sweeping, expansive sea and skyscapes, all the way down to close-ups at macro level. It is perhaps at this small scale that the most intriguing images can be found: another world opens up if you look closely.

In the picture opposite, a combination of strong winds and an incoming tide has created frothy sea foam, and those tiny bubbles have acted as minute prisms in the low morning sunlight. Timing was the critical factor, because there had to be a specific volume of water flowing in at precisely the right speed. If the wave was too big or too fast, as well as soaking me (somehow a common occurrence when I photograph along the coast), it created no foam. There were therefore many failed attempts before I eventually captured the perfect moment. It was gone in the blink of an eye, but, thanks to the miracle of photography, that split-second of wave-induced coastal charm has been frozen and preserved for eternity.

1-stop (0.3) neutral density graduated filter

• In order to recognize the froth as sea foam, it has to be seen in its environment. Timing was therefore critical, because a portion of the pebbled shoreline needed to be included.

• The white foam was, not surprisingly, brighter than the pebbles. To enable both to be accurately exposed, a 1-stop ND graduated filter was positioned upside down over the foam. Exposure was then based on a reading taken from the pebbles.

• No post-processing adjustments were undertaken.

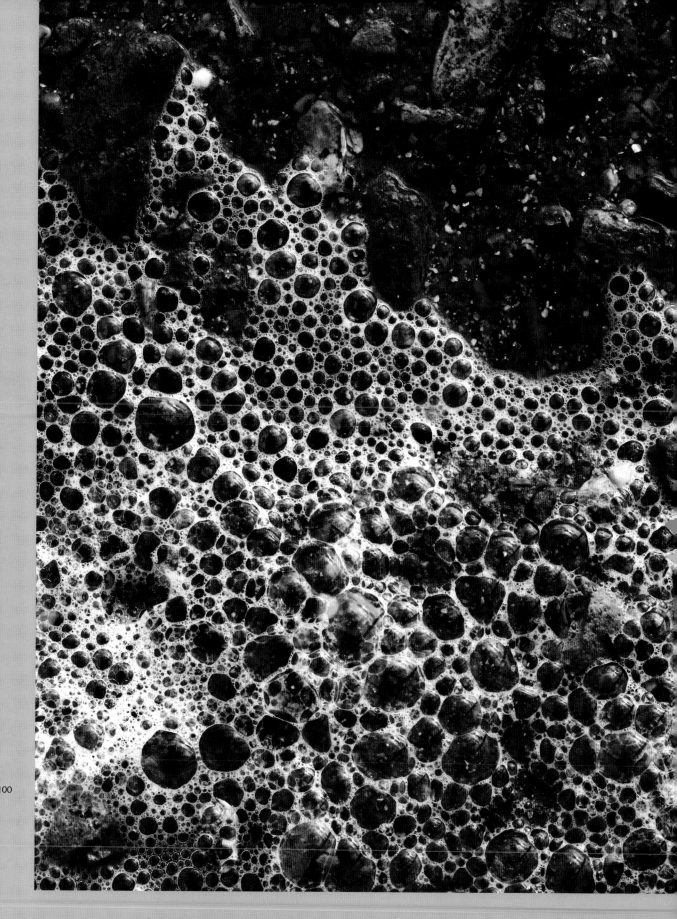

**Langland Bay,
Pembrokeshire, Wales**

Camera: Canon EOS 7D
Lens: Tokina 12–24mm
(wideangle zoom)
Filter: 1-stop ND graduated
(inverted)
Exposure: 1/60 sec at f/11, ISO 100
Waiting for the light: 1 hour
Post-processing: None

> COASTAL THE PERFECT SKY

I like nothing more than watching the sun sink slowly towards the horizon. If the sky looks promising, it can be utterly engrossing to gaze skyward with growing anticipation as the minutes, then seconds, tick by. Will the day end on a high note in a stunning display of celestial magnificence, or will it all fall flat as the early promise evaporates and succumbs to the gathering darkness?

Sunsets are difficult, if not impossible, to predict. You never know until the very last moment what they will look like; the only option is to watch, wait and be ready to capture the spectacle – if and when it materializes. The most important factor is the cloud structure. The perfect sky will have a clear horizon and a scattering of small white

clouds, which, as the sun sinks lower and lower, begin to glow with ever-increasing intensity. The peak moment can occur at any time, so the best approach is to make a number of exposures over several minutes. You can then be assured that at least one of your images will capture the sky at its best.

Often the glow continues to improve long after the sun has set. I have known a twilit sky to suddenly burst into colour, and have witnessed many photographers take their picture and depart before the optimum time has arrived. It can occur later than expected; remain vigilant and wait until the light has completely faded before leaving.

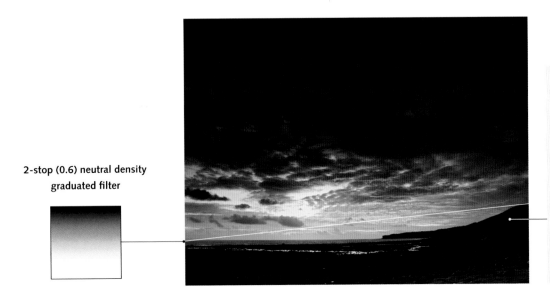

2-stop (0.6) neutral density
graduated filter

> **TIP:** When photographing a sunset, retain detail in the landscape by using a 2- or even 3-stop ND graduated filter. This balances exposure across both land and sky and enables both to be captured within the latitude of the camera's image sensor.

> **TIP:** Warm filters are often used when capturing a sunset on film, but in their absence the image can be warmed by using the Colour Balance tool. The Selective Colour tool can also be used to good effect; it can strengthen colour at the warm end of the spectrum without affecting the sky's cooler tones. This can improve a sunset but also retain a sky's natural appearance

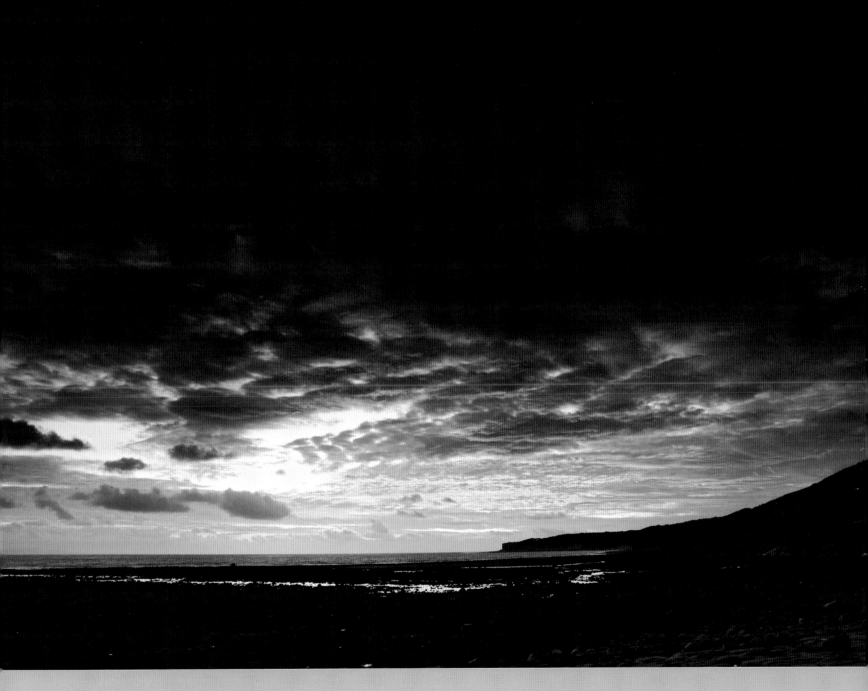

Llantwit Major, the Vale of Glamorgan, Wales

Camera: Mamiya 645AFD with ZD digital back
Lens: Mamiya 35mm (wideangle)
Filter: 2-stop ND graduated
Exposure: 1 sec at f/16, ISO 100
Waiting for the light: 5 days
Post-processing: Selective colour balance adjustments

> IMAGE GALLERY
Page-by-page guide

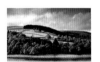

1 Carreg Ddu, the Elan Valley, Wales

2 Le Pouldu, Brittany, France

5 Near Llanbedr, Snowdonia, Wales

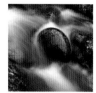

9 River Coe, Glen Coe, the Highlands, Scotland

10 Near Blairsville, Georgia, USA

13 Near Glen Coe, the Highlands, Scotland

14 Loch Etive, the Highlands, Scotland

16 Commondale Moor, North Yorkshire, England

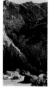

17 Freshwater West, Pembrokeshire, Wales

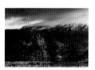

18 Near Glen Errochty, Perthshire, Scotland

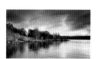

20 Loch Rannoch, Perthshire, Scotland

23 Near Franklin, North Carolina, USA

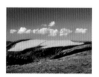

27 Manorbier, Pembrokeshire, Wales

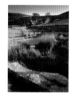

28 Near Llanbedr, Snowdonia, Wales

29 Near Robin Hood's Bay, North Yorkshire, England

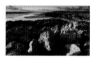

30 Rest Bay, Glamorgan, Wales

32 Littondale, North Yorkshire, England

34 Mellionnec, Brittany, France

36 Glen Coe, the Highlands, Scotland

38 The Hudson River, New York State, USA

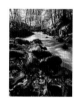

40 Afon Sawdde, the Brecon Beacons, Wales

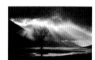

42 Loch Etive, the Highlands, Scotland

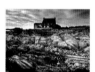

44 Locquemeau, Brittany, France

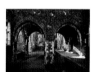

46 Neath Abbey, West Glamorgan, Wales

48 Near Reeth, the Yorkshire Dales, England

50 Mewslade Bay, the Gower Peninsula, Wales

52 Llanfaglan, Caernarvonshire, Wales

54 Abbey Cwm Hir, Powys, Wales

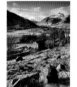

56 Langdale Valley, the Lake District, England

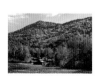

58 Nantahala National Forest, North Carolina, USA

60 Lanesville, New York State, USA

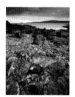

62 Bull Bay, Anglesey, Wales

64 Near Souillac, the Dordogne, France

66 Pitlochry, Perthshire, Scotland

68 Loch Tummel, Perthshire, Scotland

▷ IMAGE GALLERY

70 Kettlewell, the Yorkshire Dales, England

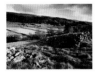

72 Near Conistone, the Yorkshire Dales, England

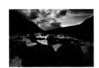

74 Loch Etive, the Highlands, Scotland

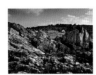

76 Locquemeau, Brittany, France

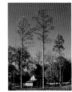

78 Peachtree, North Carolina, USA

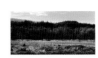

80 Inverlochy, Argyll & Bute, Scotland

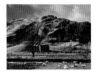

82 St John's in the Vale, Cumbria, England

84 Locquemeau, Brittany, France

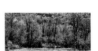

86 Near Hunter, New York State, USA

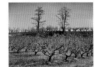

88 Near Barrytown, New York State, USA

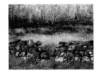

90 Near Tummel Bridge, Perthshire, Scotland

92 Church Bay, Anglesey, Wales

94 Paimpol, Brittany, France

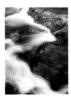

96 The River Ba, the Highlands, Scotland

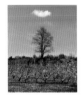

98 Near Barrytown, New York State, USA

100 Thirlmere, Cumbria, England

102 West Angle Bay, Pembrokeshire, Wales

104 Newlands Beck, the Lake District, England

106 Port Eynon, Gower Peninsula, Wales

108 Chaos de Toul Goulic, Brittany, France

110 Near Selkirk, the Borders, Scotland

112 Llyn Cregennan, Snowdonia, Wales

114 The Dee Estuary, Deeside, Wales

116 Onslow Bay, North Carolina, USA

118 Ardvreck Castle, Sutherland, Scotland

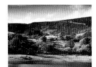

120 Carreg Dhu, the Elan Valley, Wales

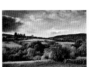

122 Near Cwm Crawnon, the Brecon Beacons, Wales

124 Near Hawes, the Yorkshire Dales, England

126 Near Arncliffe, the Yorkshire Dales, England

128 Treguier, Brittany, France

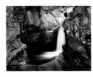

130 Falls of Bruar, Perthshire, Scotland

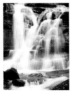

132 Kaaterskill Creek, New York State, USA

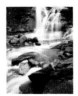

134 Kaaterskill Creek, New York State, USA

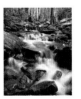

136 Batavia Kill River, New York State, USA

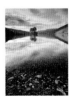

138 Loch Tay, Perthshire, Scotland

> IMAGE GALLERY

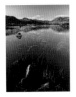

140 Loch Nah Achlaise, the Highlands, Scotland

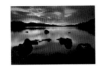

142 Loch Rannoch, Perthshire, Scotland

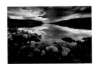

144 Loch Rannoch, Perthshire, Scotland

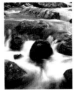

146 Woodland Creek, New York State, USA

148 Afon Elan, the Elan Valley, Wales

150 Plateau Mountain, New York State, USA

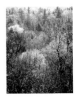

152 Catskill Forest, New York State, USA

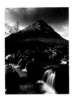

154 Buachaillie Etive Mor, the Highlands, Scotland

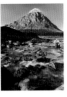

156 Buachaillie Etive Mor, the Highlands, Scotland

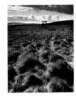

158 Askrigg Common, the Yorkshire Dales, England

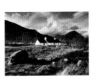

160 Glen Etive, the Highlands, Scotland

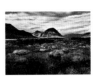

162 Rannoch Moor, the Highlands, Scotland

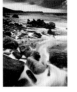

164 Freshwater West, Pembrokeshire, Wales

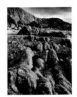

166 Great Furzenip, Pembrokeshire, Wales

168 The Dee Estuary, the Wirral, England

170 Holden Beach, North Carolina, USA

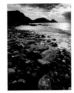

172 Mumbles Head, Pembrokeshire, Wales

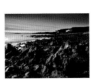

174 Port Eynon, Gower Peninsula, Wales

176 Locquemeau, Brittany, France

178 New Brighton, the Wirral, England

180 Langland Bay, Pembrokeshire, Wales

182 Llantwit Major, the Vale of Glamorgan, Wales

> GLOSSARY

Angle of incidence The angle between the incident light falling on the subject and the reflected light entering the camera lens.

Angle of view The angle seen by a given lens. The shorter the focal length, the wider the angle of view. With the subject-to-camera distance, this determines the field of view.

Aperture The hole or opening formed by the leaf diaphragm inside the lens through which light passes to expose the film or sensor. The size of the aperture relative to the focal length is denoted by f-numbers (f-stops).

Aperture priority Automatic in-camera metering of exposure based on a pre-selected aperture. Exposure is therefore adjusted by the shutter speed.

Aspect ratio The ratio of the width to the height of the frame.

Autoexposure (AE) The ability of a camera to recommend the correct exposure for a particular scene.

Autofocus (AF) An in-camera system for automatically focusing the image.

Backlighting Light coming from behind the subject shining towards the camera.

Bracketing Making a series of exposures of the same subject at different exposure settings, typically in steps of 1/2- or 1/3-stops.

Cable release A flexible cable, used to minimize the risk of camera shake, which is attached to the camera to enable remote release of the shutter.

Camera RAW A file format offered by most digital cameras. It records the picture as an unprocessed, uncompressed image. It can be considered the digital equivalent of an unprocessed film negative.

Centre-weighted metering Type of metering system that takes the majority of its reading from the centre portion of the frame. Suitable for portraits or scenes where subjects fill the centre of the frame.

Chromatic aberration Colour fringing caused by the camera lens not focusing different wavelengths (colours) of light on the same focal plane.

Colour cast A variation of the colour of light, which causes a distortion in the colour in a photograph.

Colour correction filter A filter that is used to compensate for a colour cast, the most common example being the 81 series of warming filters. *See* Warm filter.

Colour temperature The colour of light has a colour temperature. This depends on a number of factors, including its source and the time of day. It is measured on the Kelvin scale: lower temperatures produce warmer colours and vice versa.

Contrast The range between the highlight and shadow areas of a negative, print, transparency or digital image. Also refers to the difference in illumination between adjacent areas.

Converging parallels The distortion of parallel lines, which appear as converging angled lines. This commonly occurs when a building is photographed with the camera pointing at an upwards angle.

Cropping Printing only part of the available image from the negative, transparency or digital image, usually to improve composition.

Definition The clarity of an image in terms of both its sharpness and contrast.

Depth of field (DOF) The zone of acceptable sharpness in front of and behind the point at which the lens is focused. This zone is controlled by three elements: aperture – the smaller the aperture, the greater the DOF; the camera-to-subject distance – the further away the subject, the greater the DOF; and the focal length of the lens – the shorter the focal length, the longer the DOF.

Diffuse lighting Lighting that is low or moderate in contrast, such as the light on an overcast day.

DSLR (digital single-lens reflex) *See* SLR (single-lens reflex).

Dynamic range *See* Tonal range.

Exposure The amount of light reaching the film or sensor. This is controlled by a combination of aperture and shutter speed. Alternatively, the act of taking a photograph, as in 'making an exposure'.

Exposure compensation A level of adjustment given to autoexposure settings. Generally it is used to compensate for known inadequacies in the way a meter will usually recommend a reading, which may result in underexposure such as snow scenes.

Exposure latitude The extent to which exposure can be reduced or increased without causing an unacceptable under- or overexposure of the image.

Exposure meter A device, either built into the camera or separate, with a light-sensitive cell used for measuring light levels, used as an aid for selecting the exposure setting.

Exposure value A single value given for a measurement of light that indicates an overall value that can be reached by a combination of shutter speed and aperture for a particular ISO setting.

Field of view The actual dimensions of the scene that can be captured on film or sensor. This depends on the film/sensor format, the angle of the lens, and the camera-to-subject distance.

Flare Non-image-forming light reflected inside a lens or camera in an unwanted manner. It can create multi-coloured circles or loss of contrast and can be reduced by multiple lens coatings, low-dispersion lens elements or a lens hood.

Focal length The distance between the film or sensor and optical centre of the lens when focused at infinity.

F-numbers A series of numbers on the lens aperture ring and/or the camera's LCD panel that indicate the size of the lens aperture relative to its focal length. The higher the number, the smaller the aperture.

Frontal lighting Light shining on the surface of the subject facing the camera.

Highlights The brightest part of an image.

Histogram A digital graph indicating the light values of an image.

Hyperfocal distance The closest distance at which a lens records details sharply when focused at infinity. Focusing on the hyperfocal distance produces maximum depth of field, which extends from half the hyperfocal distance to infinity.

Image sensor The digital equivalent of film. The sensor converts an optical image to an electrical charge that is captured and stored.

Image stabilization An in-camera feature that compensates for any movement of the camera during exposure.

Incident light Light falling on a surface as opposed to light reflected from that surface. An incident light meter measures the light before it reaches the surface. Compare with Reflected light.

ISO rating Measures the degree of sensitivity to light of a film or sensor, as determined by the International Standards Organization. As the ISO number doubles, the amount of light required to correctly expose the film/sensor is halved.

JPEG A common file format used by digital cameras. It compresses the image, and over time these images can be affected by a degradation of image quality.

Large-format A camera that uses sheet film of 5 x 4in or larger.

Law of reciprocity A change in one exposure setting can be compensated for by an equal and opposite change in the other. For example, the exposure setting of 1/60 sec at f/11 produces exactly the same exposure value as 1/30 sec at f/16. *See* Reciprocity failure.

LCD Stands for 'liquid crystal display'. It is used in the display screen included on most digital cameras.

Medium-format Refers to cameras using rollfilm (normally 120 or 220 film), or a digital sensor of equivalent size, that measures approximately 21/4in (6cm) wide.

Megapixel One million pixels.

Mid-tones Parts of an image with tones of an intermediate value; i.e., the tonal values between the highlights and shadows.

Neutral density (ND) filter A filter that reduces the brightness of an image without affecting its colour.

Neutral density graduated (ND grad) filter A neutral density filter that is graduated to allow different amounts of light to pass through it at different parts. These filters are used to balance naturally occurring bright and dark tones. In landscape photography they are commonly used to balance the exposure values of sky and landscape.

Noise Graininess in an image that becomes apparent during long exposures and when using high ISO settings.

Panoramic camera A camera with a frame of which the aspect ratio of width to height is greater than 3:2.

Pixel Short for 'picture element', this is the basic building block of every digital image.

Polarizing filter A filter that absorbs light vibrating in a single plane while transmitting light vibrating in multiple planes. When placed in front of a camera lens, it can eliminate undesirable reflections from a subject such as water, glass or other objects with a shiny surface, except metal. It is also used to saturate colour.

Prime lens A lens that has a fixed focal length.

RAW *See* Camera RAW.

Reciprocity failure At shutter speeds slower than 1 sec, the law of reciprocity begins to fail because the sensitivity of film reduces as the length of exposure increases. This affects different films to different extents, but means that the exposure will need to be increased slightly to compensate. Reciprocity failure does not affect digital sensors.

Reflected light Light reflected from the surface of a subject. The type of light that is measured by through-the-lens meters and handheld reflected light meters such as spot meters.

Resolution The amount of detail in an image. The higher the resolution, the larger the potential maximum size of the printed image.

Shutter A mechanism that can be opened and closed to control the length of exposure.

Shutter speed The length of time light is allowed to pass through the open shutter of the camera. Together, the aperture and shutter speed determine the exposure.

Shutter release The button or lever on a camera that causes the shutter to open.

Sidelighting Light shining across the subject, illuminating one side of it. The preferred light of most photographers, it gives shape, depth and texture to a landscape, particularly when the sun is low in the sky.

SLR (single-lens reflex) A type of camera that allows you to see the view through the camera's lens as you look in the viewfinder.

Soft focus filter A filter used to soften an image by introducing spherical aberration, it is not the same as out-of-focus; a sharp image is necessary in order for the effect to succeed.

Spot meter An exposure meter that measures a small, precise area. It enables a number of exposure readings to be taken of different parts of a subject and therefore provides a very accurate method of metering.

Standard lens A lens with a focal length approximately equal to the diagonal measurement of the film format. It produces an image approximately equivalent to that seen by the human eye, and equates to the following focal lengths: 35mm for digital APS-C cameras, 50mm for 35mm film or digital cameras, 80mm for 645, 90mm for 67, and 150mm for 5 x 4in cameras.

Telephoto lens A lens with a long length and narrow angle of view. When used at a long distance from the subject, a telephoto lens can help create the impression of compressed distance, with subjects appearing to be closer to the camera than they actually are.

Through-the-lens (TTL) metering A meter built into a camera that determines exposure for the scene by reading light that passes through the lens during picture taking.

TIFF Stands for 'tagged image file format'. It is a common image format supported by most types of photo-editing software.

Tonal range The range between the darkest and lightest areas of an image.

UV filter A filter that reduces UV interference in the final image. This is particularly useful for reducing haze in landscape photographs.

Vignetting The cropping or darkening of corners of an image. This can be caused by a lens hood, filter holder or the lens itself. Many lenses do vignette, but to a minor extent. This can be more of a problem with zoom lenses rather than prime lenses.

Warm filter A filter designed to bring a warm tone to an image to compensate for a blue cast, which can sometimes be present in daylight, particularly with an overcast sky. The filters are known as the 81 series, 81A being the weakest and 81E the strongest.

White balance A function of a digital camera that allows the correct colour balance to be recorded for any given lighting situation.

Wideangle lens A lens with a short focal length and a wide angle of view.

Zoom lens A lens with a focal length that can be varied.

ABOUT THE AUTHOR

Peter Watson is a self-taught landscape photographer who has been photographing the landscape since the 1970s. He is based in England and travels extensively throughout Britain, Europe and the USA. His work is published internationally and is widely used in many forms of advertising and media.

Born in Wallasey, England, Peter's photographic career started in his teenage years when he photographed and produced his own black-and-white prints in an improvised darkroom. They were sold in a local gallery, and this early success encouraged Peter to pursue a career as a photographer. He studied art and graphic design and in 1993 obtained a diploma in photography from the New York Institute of Photography.

Before becoming a full-time professional landscape photographer, Peter worked in advertising and commercial photography. As well as continuing to practise photography, he teaches workshops and produces practical photography books and articles. He has previously written five books: *Seasons of Landscape*, *Reading the Landscape*, *Capturing the Light*, *Light in the Landscape – a Photographer's Year* and *A Field Guide to Landscape Photography*.

EQUIPMENT USED

Below is a list of the equipment used in the making of the photographs in this book:

Cameras
Mamiya 645 AFD11 with Mamiya ZD and Phase One digital backs
Canon EOS 7D

Lenses
Mamiya 35mm, 80mm, 150mm, 210mm, 300mm
Tokina 12–24mm AF PRO DX 11
Sigma 17–70mm OS HSM
Canon EF 300mm IS USM

Filters
Lee ND hard graduated from 0.3 to 0.75, circular polarizer and Lee filter holder system
(Graduated filters are available with hard and soft graduation. Hard-grad filters have a more abrupt transition from dark to light. I prefer this, although soft filters might be preferable with small sensors, particularly when using small apertures.)

Tripods
Uni-Loc Major 2300 and 1600
Benbo Mini Trekker
Velbon Ultra Rexi L

Ball and socket heads
Manfrotto 054 with quick-release plate
Uni-Loc with quick-release plate

Viewfinder
Linhof Multifocus

> INDEX

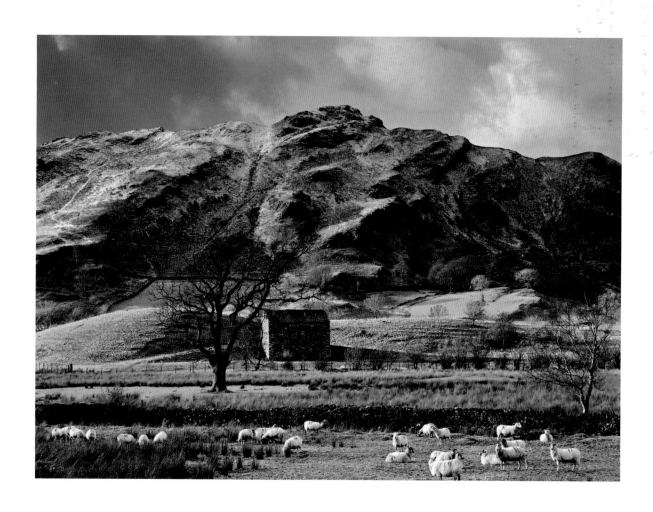

To order a book, or request a catalogue, contact:

Ammonite Press

AE Publications Ltd, 166 High Street, Lewes,

East Sussex, BN7 1XU United Kingdom

Tel: +44 (0)1273 488006

www.ammonitepress.com